DRAWING
Caricatures

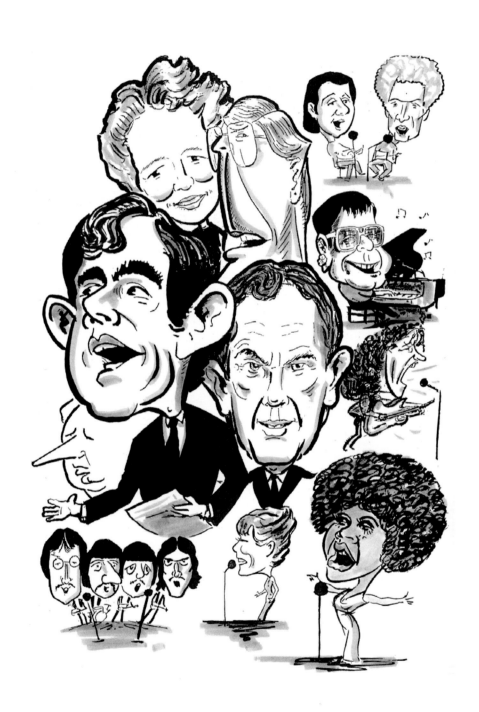

DRAWING
Caricatures

DOUG EYRE

THE CROWOOD PRESS

First published in 2007 by
The Crowood Press Ltd
Ramsbury, Marlborough
Wiltshire SN8 2HR

www.crowood.com

British Library Cataloguing-in-Publication Data
A catalogue record for this book is available from the British Library.

ISBN 978 1 86126 951 5

All caricatures and illustrations drawn and provided by Doug Eyre;
copyright retained by the artist.

Illustration on previous page: a collage of prominent twentieth-century
figures, from prime ministers to pop stars.

Typeset by Jean Cussons Typesetting, Diss, Norfolk

Printed and bound in Great Britain by The Cromwell Press

CONTENTS

Dedication

One of the most endearing of human qualities is curiosity. Striving to know more, to understand more, has enriched man's life in countless ways. I dedicate this book to my young grandson Alexander Douglas and my two great-nephews, William and Tom, our future generation, in the hope that they will be curious about people, things and places.

Acknowledgements

Firstly, my greatest thanks are due to my wife, Liz, who has encouraged and supported me every day since we met. Without her help this book would not have seen the light of day.

Other thanks span fifty years.

The 'on-the-spot' caricaturist on Margate seafront whom I watched spellbound as a child.

My parents and friends for all the encouragement they gave me in my scribbling and drawing.

Arthur Cunningham, the tutor, who shared all he knew about technical and figure drawing with me.

Bill Thacker, the cartoonist, who inspired me with the fine caricature likenesses he worked into his cartoons.

Dennis Fuller, my first accountant, who opened one door leading me towards a commercial path of drawing both cartoons and caricatures.

David Tilley, my farmer friend, who found me my first major commission.

Panasonic, the company, and in particular Lawrence Williams, who in 1986 introduced me to the electronic print board, an innovative tool that I was able to adapt to my lightning, 'on-the-spot' style.

John Dawes, an events entrepreneur, who assisted me in developing the corporate golf caricaturing aspect of my business.

Farncombe Estate Centre, Broadway, which allows me to pass on my knowledge and skills to both youthful and mature students.

To all the subjects represented in caricature in this book.

To all the other caricature artists who promote this fascinating art form in their many different ways.

PREFACE

This book does not aim to teach drawing or portraiture in great depth. Drawing, especially related to portraiture, which incorporates a detailed understanding of structure, dimensions and materials, can be produced using one of a number of precise, formal techniques. This level of technical expertise can be attained by looking to other places for instruction and inspiration, and, in any case, such techniques are not vital to caricature. Most caricaturists use freehand perspective techniques. Freehand drawing allows the caricaturist to get more freedom and perhaps, therefore, more life and more effects into his or her drawings.

The book does, however, incorporate sufficient simple techniques, described in layman's language, to allow both the artist and the hobbyist to draw caricatures. The artist may well create more detailed, more finished artwork – a technically accurate piece that reflects the genre – while the hobbyist may reflect the genre in a simplistic, stylistic way. History confirms that both have their place, since both have amused, engaged, influenced and challenged on a professional or amateur basis.

Prominent, very successful caricaturists throughout the ages have, however, all built a career upon the rock of a strong technical foundation. This foundation, honed to varying degrees, was or is subsequently overlaid by their inner drive: satire and malice or objective humorous exaggeration. Those who believe they can manage without any technical skill, hoping to make their point without any such distraction, rarely achieve the standards required to be a professional caricaturist.

Every caricaturist, from whatever background, eventually finds his or her own way. There is a wealth of examples here, drawn from life over the years, for you to look at, copy and use to help you develop your style.

The book avoids using technical, medical terms to describe facial features or underpinning structure. It is more important to have a feel for the general shapes, which can be exaggerated, than the precise anatomical details.

Throughout this book, in sections on drawing, the caricature artist, whether a hobbyist, artist or professional, is referred to as an 'artist'.

Direction of Travel of the Book

This book aims to build on the reader's skill base, at whatever level, imparting the basic knowledge needed to produce different types and styles of caricature. It will expand upon the variety of tools, materials and mediums that are available to produce the caricatures. It will help you to develop your own style. You can travel through it at your own pace. You can skip, dip and dive. Each chapter stands alone, looking at caricaturing from its own angle.

The core of the book unpicks individual features associated with a portrait. Each feature is approached from the straightforward aspect of draughtsmanship before being considered as its own canvas for caricature.

This in-depth approach to individual features is fascinatingly introspective and revealing. Examples will illustrate each point. Techniques and exercises will be incorporated, as far as possible, to enable you to draw that aspect of the caricature, gaining both confidence and speed as you practise. To ensure complete understanding, this introspection is reversed. The whole is reassembled in such a way that you are again reminded of the bigger picture. Then the hidden skill of caricaturing, achieved through dropping detail and features, is highlighted.

Adding movement, different settings, workings with groups, in a variety of circumstances are developed as themes. It is important for potential caricaturists to develop their own style to complement the type of caricature being produced. The ultimate objective is to achieve the type and style of caricature that is most comfortable, develops most naturally, and fits best to the caricaturist's own personality. It is important to remember there is no right or wrong answer, only skilled or poor technique, and astute or poor observation. The text here will tease out the psychology behind the various approaches to a caricature.

Finally, there will be a discussion of the commercial avenues open to caricaturists, covering the opportunities that are available to the artist who wishes to make the transition from amateur to professional.

Keeping an open mind, and looking at the whole before deciding on the ultimate focus, will maximize the added value that the reader will be able to extract from the book.

Exercises

The exercises in this book, which are supported by examples, will either develop your existing skills as a draughtsman or impart sufficient simple guidelines to enable you to capture then caricature features. Starting with the basic drawing skills at whatever level, moving on to caricature, is a matter of walking before running.

When you are attempting the exercises, you need to observe a few tips:

1. Involve your whole brain. Every time you learn something new you cause your brain cells to connect, and form new patterns. The more you practise, the more you will improve and develop.

2. Concentrate on your strategy. Step back from the detail and see the big picture.
3. Now move on to the landscape, key features, key detail.
4. Make memorable visual notes on paper to start with, in your mind eventually.
5. Pick up only on relevant details.
6. Make associations between past experience and new experiences.
7. Practise, practise, practise regularly.

Do not be daunted if you are a beginner in art. The exercises will help you build your level of confidence, and you can pick up a deeper level of technical training at a later date if you decide to progress with this art form and want to earn a living from it. If you are already formally trained and skilled, this book will undoubtedly enable you to reach new levels of enjoyment from your enthusiasm for art. If you are a professional artist already, maybe this book will offer you a new direction of travel to a place where, as I have discovered, life and work blur into one, and retirement becomes an impossibility.

INTRODUCTION

What is a Caricature?

A caricature is a drawing of a person that exaggerates or distorts the basic essence of that person, to create an easily identifiable, visual likeness drawn for humorous or mischievous effect. *The Oxford English Dictionary* gives a pithy reference: 'A depiction of a person in which distinguishing characteristics are exaggerated for comic or grotesque effect.'

Why a Caricature?

The draughtsmanship of a caricaturist, simplistic or detailed, communicates with its audience in a simple, succinct manner. As the saying goes, 'A picture is worth more than a thousand words.' As an outsider looking in, the caricaturist uses acute visual pick-ups as a form of communication. If he couples this skill with an ability to overlay personal attitude and emotion relating a subject's mood, character, physical form, dogma or beliefs, the result can be both revealing and a powerful commentary. The finished drawing can range from the harmonious, genial and attractive to a vehicle for pure distilled malice and graphic satire.

Caricature artists have for generations had the personal satisfaction of being able succinctly to sum up physical and personal attributes when producing a picture. The style and mode of caricaturing vary considerably from artist to artist. The motivation, commercial or personal, will hugely influence the type of caricature that is the end result.

Reaction to Caricature

Individuals rather enjoy a caricature of themselves, in the main, no matter how it turns out. It is not uncommon to see personal caricatures that exaggerate and poke fun on the walls of offices or strategically placed where they will be noticed in the home – often the smallest room, which is the place where, it is understood, many of the royals keep caricatures of themselves.

While it is not unsurprising that a humorous, gentle caricature will be appreciated by its subject, the response of those who have been treated in a crueller, vindictive manner can be equally appreciative. Maybe, as they say, 'any publicity is better than no publicity'. Politicians amaze and sometimes disappoint caricaturists with their 'fondness' for a particular unflattering rendition. Popular rumour has it that Michael Heseltine completely dismayed the creators of his Spitting Image caricature puppet – he loved it so much he wanted to buy it!

Caricature or Cartoon?

Clarifying right from the start that a cartoon is not the same as a caricature focuses the direction of this book. However, many of the techniques covered here could also be applied to cartooning. A cartoon (according to *The Oxford English Dictionary*, 'a drawing executed in an exaggerated style for humorous or satirical effect') expands on the concepts to cover anything, not just the drawing of people.

Sometimes the two are mixed – a caricature will be drawn within a cartoon or a cartoon will incorporate the essence of caricature. This book will concentrate only on drawing people, and on the art form based on portraiture. A cartoonist may not need to develop his caricature skills fully. If the public adopts the image, within the cartoon, as the known personality, why do more? The story line is the key element for the cartoonist.

The word 'caricature' comes from the Italian *caricare*, meaning 'to charge' or 'to load up or on'. It sums up exactly what the artist is attempting to do: to load exaggeration on to a personality for a variety of reasons by means of the often ludicrous distortion of parts of the face, displaying a person's characteristics. The caricaturist attempts to get as much 'loaded' on to his subject as possible, with as few lines as possible. The final picture, however, may well incorporate the subject's associated stance, apparel and effects, all of which will contribute to the prime underlying theme: communication of feature, personality, motive and character. A prime exponent of the art is Hogarth, whose pictures were so detailed and communicated so much they were like major pamphlets on a subject.

Comparison between a cartoon figure and a caricatured figure.

A Brief History

The word 'caricature' first appeared in England in Dr Johnson's first *Dictionary* in 1755, but the development and history of the art is far older. This surprisingly ancient art form has had an adventurous, sometimes stormy, passage through the centuries, before evolving to the much-admired, although not always appreciated, professional standing of today.

The art stems from many roots, some more obscure than others. In 1940, prehistoric wall art dating from about 15000BC was discovered in a cave system near Montignac-sur-Vezère in the Dordogne, in France. Primarily realistic and symbolic paintings of animals of the Old Stone Age, these representations cannot be considered caricatures, since there were few depictions of feature, but they do display an early essential element of caricature.

Caricatured pictures of Roman senators and other politicians of the day do appear on the walls in Pompeii. Leonardo da Vinci practised the shape of drawing, which could be connected with caricature, by his vision of 'ugly', and by studies on the expres-

sivity and the muscles of the face in his early works and 'cartoons'. Caricature, the formal recognized art form, is attributed to the Italian painter Annibale Carracci (1560–1609) in the sixteenth century. Carracci made caricature sketches of his friends, claiming that the pictures revealed the essence of personality far more than any portrait, although they should not be confused with the extremes of caricature seen today. Early practitioners building on his influence were famed and well rewarded for their simple depictions of members of the papal court in just a few lines.

The artists who could be considered to be the pioneers of caricature are Carracci and Bernini, the latter introducing the caricature in France in around 1665. However, it seems that the first draughtsman to practise caricature art professionally was Pier Leone Ghezzi (1674–1755). Later, Monet and many others played around with the art form. When groups of artists started to paint subjects in a realistic way – as they looked, rather than in the usual flatteringly enhanced manner – they were not producing caricatures but they were in their own way influencing the art of caricature.

Caricature based on fine art:
Beer Street *by William Hogarth*
(1697–1764).

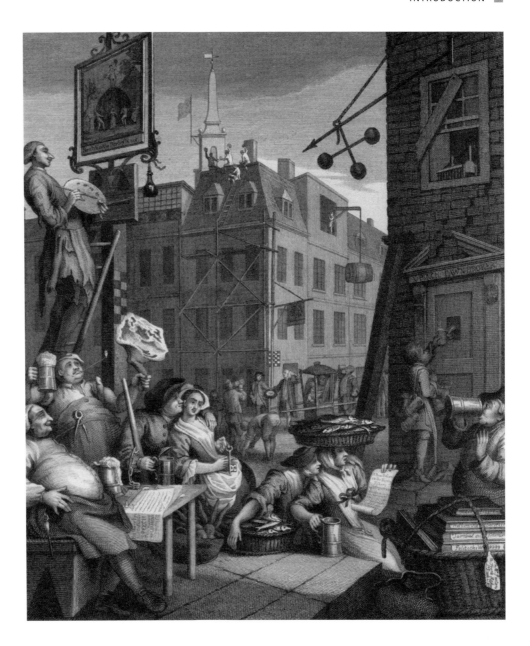

Folklore and fairy tales certainly have themes that contain an element of caricature.

An outline of the history of the art form of caricature clearly shows the cyclical and fluid nature of its development. Reflecting on significant contributors to the art will help to outline predominant styles, trends and driving influences: the artist's skill set, psychological and social drivers, bureaucratic tolerance and pragmatic necessities. History evidences some key aspects of the art form. For a more definitive guide to the subject, you should refer to one or more of a number of eloquent books, contributed to by learned authorities, on the history of caricature (*see* Bibliography).

One important lesson to be learned is that, for some, the artist's independence of direction and outcomes works fine. For others, understanding the boundaries of the commissioners is vital to success. This lesson still applies today.

Development of Caricature Art

The rediscovery of caricature began in the mid-seventeenth century. By then, Carracci's promotion of a new type of portraiture had evolved into aspects of exaggeration to become a relaxation from the enormous volume of high, fine art being produced in Italy. This element of Continental frivolity, predominantly found in Italy, appealed to the rich young travellers of the British upper class who followed 'The Grand Tour', a

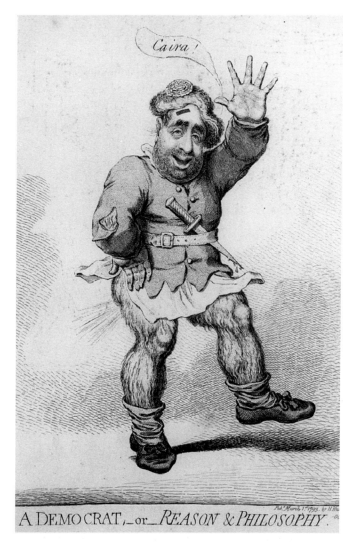

Ca ira!

A DEMOCRAT,_or_ *REASON & PHILOSOPHY*.

A Democrat, or Reason & Philosophy, *by James Gillray, 1793.*
His work bridged the gap between politics and art history.

William Hogarth (1697–1764) is considered to be the true father of English caricature art for several reasons. Despite his comprehensive and impressive range of artistic talents he chose to concentrate on the genre of caricature. However, he despised the trivial imported Italian form, insisting that caricature art in its own right was a type of fine art. He coupled this professional approach with a clear focus on subject matter. He moved on from mere conversational pieces to more moral subjects. His personal life journey had bestowed on him humanity and a real understanding of the social ills of his time, and he used the power of caricature to highlight important issues. In two contrasting prints published as propaganda to support the 1751 Gin Act – *Beer Street* and *Gin Lane* – he contrasts the good attributes of English ale versus the evil social consequences of drinking gin. The vital, vivid characters of *Beer Street* are shown in a good and cheerful state. In *Gin Lane*, the subjects are dissolute and alcoholic, neglectful and lazy. Although Hogarth's work was challenging and campaigning, in addition, it was enormously entertaining and skilful – perhaps the latter traits softened the attitude of the authorities to the former.

As political satire, stemming from its Dutch sources, began its evolution in England, Hogarth developed a range of satirical narrative styles, from elegant conversational pieces to salacious brothel scenes to embrace the concept. His strong artistic skill was hugely enhanced by his own independence of thought and action. His popularity with the public was due to his communication skills and ability to make images that spoke – to rich and poor alike – of manners, morals, political corruption and social hypocrisy. He enjoyed the same sort of popularity among artists, too, in part because of his successful campaign to pass through Parliament copyright laws that protected artists from piracy.

As the genre of political satire developed, it became clear that the artists who captured the attention of those in fashionable circles had three factors in common: a genius for likeness, a wit, and in addition the best of them were 'destitute' of tact.

The mid-eighteenth century saw caricature art develop into a social pastime, with independent amateurs increasingly entertaining their friends and amusing the world at large. Engravers and publishers supported this pastime to their own advantage. It was a profitable partnership, each skill complementing the other. The art form had now moved from the domain of the nobility and Court to the man in the street. Shops appeared with full window-to-window displays of engravings. Prints became collectable; they were often passed around the dinner table to be admired. Single portraits expanded to several characters or groups. Caricatures began to communicate, but the messages were beginning to drift beyond the mischievous. Gossip and scandal were now the domain of the common man and the concept of a victim was soon to emerge.

popular European travel itinerary that flourished from about 1660 until the arrival of mass rail transit in the 1820s. These early tourists embarked on such trips for both educational and social reasons. The art form drifted back to Britain across the Channel with the Tourists at around the end of the seventeenth century and, indeed, the Tour and the 'Grand Tourists' themselves became the butt of several whimsical caricatures!

Illustrators and painters began to turn their hand to sketches more as witty commentaries than pieces of skilled draughtsmanship. The caricatures tickled the fancy of the nobility and, on occasion, the Court. At this stage comments were aimed at friends, acquaintances and those who promoted themselves personally. Caricatures seem for the most part to have been the result of simple mischievousness, paid for by patrons and clients, with the creators happy to oblige for due reward.

The mainly hand-coloured prints of James Gillray (1757–1815) are said to have bridged the gap between political and art history. At this time it was not a long journey for fine-art engravers, primarily reproducing history paintings, to become political satirists. The former occupation made master engravers some of the most highly paid artists of the day. The latter enhanced this position.

Gillray's journey was said to be 'made more natural' because of his inability to be an exact copyist. This lack of skill was considerably compensated for by his penchant for expressive distortion, overlaid on harrowing likenesses, coupled with exact ridicule. Gillray had found the *métier* for his considerable engraving skills. He became the talk of London; both approved of and feared by the time he was forty. It is said of him that he 'fashioned himself a medium that caused England to become the House of Caricature'.

Following the execution of French King Louis XVI in January 1793, the struggle between Whig politician Charles James Fox (1749–1806) and his followers, supporters of the principles of the French Revolution against the conservative approach of the Duke of Portland, came to a head. (The Whigs were a group of politicians opposed to the religious policies of Charles II who were supporters of church reform. Their rivals, supporters of the established church and the traditional political structure, were the Tories.) One of Gillray's conservative satirical caricatures portrays Fox as a bloodstained revolutionary. It contrasts Fox's ideals with the reality of his figure, which shows the worst excesses of passion and violence. The figure is unshaven, animal-like in its hairiness and physicality. The cap of liberty, with the tri-coloured French cockade, ragged French sans-culotte, bloodstained hands, gaiety verging on drunkenness and hints of a fart say it all.

Around this time, partly inspired by Gillray's work, with Bonaparte as the prime victim, caricatures for the first time became truly international. Caricatures of 'Boney' passed from country to country: the upstart, stunted dandy or manic midget developing into the brooding Emperor, famous for his wide hat, heavy coat and stance, with one hand behind his back. Caricature was seen for its political power to undermine. The usefulness of the caricatures did not go unnoticed as governments from Russia to France lifted bans on topical and personal caricature and expanded the freedom of the press.

As soon as independence was sanctioned in France, Charles Philipon (1806–62) founded the satirical weekly *La Caricature*, and set about offending both the government and king of his day, Louis-Philippe. He was repeatedly thrown in jail for his satirical offences. Philipon's magazines were the first to portray Louis-Philippe symbolically as a pear, a reference to the shape of the king's head and also a French sexual pun. In 1831 Philipon was obliged to prepare sketches in court to convince a jury that King Louis-Philippe's head really did resemble a pear. The pear quickly became accepted as the universal symbol for Louis-Philippe and his regime, often appearing in caricatures and graffiti; wax pears were even sold as souvenirs! This is the first example of an object becoming the caricature, and vice versa.

Finally, as a direct result of Philipon's caricatures and magazine, a law was passed reducing the freedom of the press, and effectively banning political comment in this way. The powerful tool, considered useful to government, had now become too hot to handle. In France, caricature was reduced again to simple mischievousness until censorship was lifted in 1848. With the lifting of censorship, the focus had again changed. In France (and less so in England), political caricature took off again but was aimed more at the upper echelons of society than directly at the government.

Even at this juncture confidence in the power of their drawings was still lacking – to the point that artists often provided written texts to accompany their pictures – but how the crowds loved the lampooning.

With the Frenchman André Gill (1840–45), the cycle of the art form began to turn again. His focus was clearly on individuals, and the fine artistic element began to return. Exaggerated heads, strong likenesses and accentuated characteristics were the order of the day.

As photography began to challenge the art form, the new term *portrait-charge* was coined to reinforce the role of caricature in the extraction of feature and personality. Definitive shapes, less malice, more observation and fuller interpretation underpin *portrait-charge*. Debates were held about resemblance and identity (Topffer, 1841), and the opposing forces in caricature and photography were heavily discussed. Caricaturists swung backwards and forwards between competition to a curious incestuous relationship. Photography began to be used as the basis for some studio work. One or two well-known caricaturists jumped ship, shifting into photography and some combined both art forms. In the end, everything settled down into some sort of a loose professional truce. What emerged was an understanding or reassurance that photography could capture a form of reality whereas caricature's very essence transformed a reality. Caricature could delve deeper and extract more. Clearly, both caricature and photography had their place, but caricaturists were able to identify their own added value – an added edge and an ability to portray more than the eye could see.

As newspaper readership grew, sustained by more universal education and liberation, so caricature art acquired a new audience. It was an exacting medium, requiring lightning sketches to meet harsh deadlines. Nast (1840–1902), said to be the father of American political cartooning, played a dual role as both politician and journalist. Rather than reflecting issues of the day he chose to form opinion through his work.

This gauche yet capable pictorial artist on New York's largest illustrated newspaper quickly made his name as he covered the

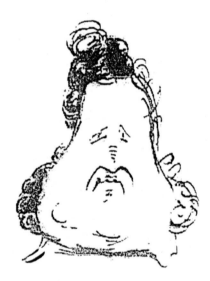

Illustration in the fashion of Charles Philipon: La Métamorphose du roi Louis-Philippe en poire (The Metamorphosis of King Louis as a pear).

Civil War. Moving on to *Harpers Weekly* in 1870, Nast grew in skill and stature, learning quickly from other artists and caricaturists of his day as he went forward, astonishing with his satirical skills and focusing on political reform.

As engraving techniques developed and newspapers became daily it became a nightmare for professional newspaper caricaturists to keep up. Again, the written word and emphasizing techniques were required to support their caricature illustrations. On this occasion the reasons were not based on lack of confidence but lack of adequate time to develop the dialogue within the picture.

Other caricaturists, such as Spy, working for *Vanity Fair* (1869–1913), were moving in a parallel universe. Satire and malice would have been unlikely bedfellows to benevolent por-traiture, which kindly emphasized the features and personality of the subjects gracing the pages of that publication. Spy (*Vanity Fair*) would have recognized this contrast, as would Max Beerbohm (*The Strand*). Light humour rather than tight deadlines was the order of the day. (It was the pictures in *Vanity Fair*, displayed in museums and books, that sparked my own passion when I was a boy.)

During the late nineteenth century and into the early twentieth century, comic and satirical caricature journals, which spun off from their newspaper sources, came and went, rising and falling in popularity and commercial success. Few were sustainable, for a variety of reasons. *Punch*, which combined both cartoon and caricature, was one of the exceptions. Most of these journals ceased publication during the First World War

Spy's caricature of Henry Herbert Asquith, 'Brains,' from Vanity Fair, *1904. (The Vanity Fair Print Company Ltd.)*

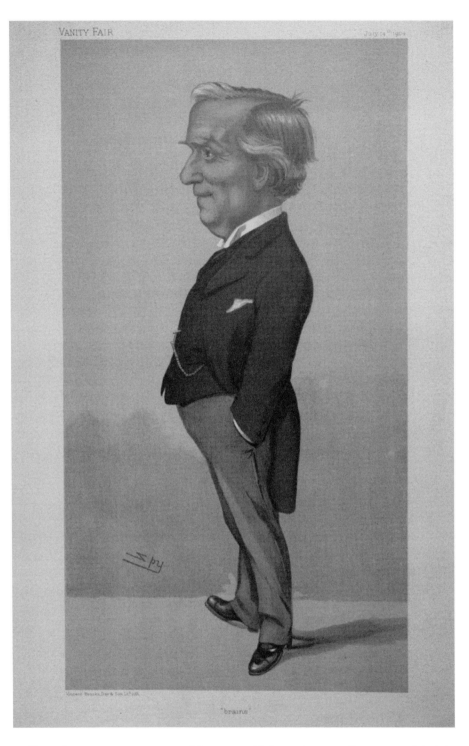

due to newsprint, staff and reader shortages, although some work became part of the war effort itself.

After the war, a number of factors emerged: the development of jazz, the growth of cinema, fewer monarchs, and less charismatic politicians, and the rise of the *New Yorker* magazines and many new names in caricature and cartooning:

- Mexican/American artist Miguel Covarrubias stunned with his highly stylized form of exaggeration. His sharp stylized geometric pen-and-ink works, sometimes completed in watercolour or gouaches, were dramatic.

- New Zealand-born Low (1891–1963), the artistic and intellectual master of political cartoon, was known for his broad-brush techniques and the *New Statesman* series of charcoal caricatures of political and literary figures.

- Al Hirschfeld (1903–2003) was still publishing simple, elegant caricatures just before he died at the age of 100. He is remembered for his love of line and the portraits of those

A comment on the Crimea in Punch, *20 October 1855, 'What we must come to.'*

associated with New York theatre. Economy of line, humour and exaggeration picked up on tiny, detailed mannerisms and expressions.

- Polish émigré Ralph Sallon (1899–1999) focused on personalities, never politics.

- 'Vicky' Victor Weisz, by contrast, the highly political cartoonist, fixed his caricatures in one drawing, typecasting political figure's characters in their particular roles.

- Searle (1920–), working to the great British tradition of Gillray, Rowlandson, Cruikshank and Newton, was one of the major satirical draughtsmen of the second half of the twentieth century. His influence has been enormous, most notably on Gerald Scarfe and Ralph Steadman, but also in less predictable quarters. Matt Groening, creator of *The Simpsons*, is a Searle fan, acknowledging his debt to St Trinian's and the dark side of Searle's work.

- Levine (1926–) commanded line, creating memorable portrayals through incisive character studies and visual puns confidently based on correctness of draughtsmanship.

- Gerald Scarfe (1936–) moves beyond exaggeration, through differentiation to pure distortion as he mercilessly transforms Britain's national heroes – from Winston Churchill to David Beckham, Delia Smith to Oliver Cromwell – into villainous outpourings.

- German caricature artist Sebastian Kruger (1963–) uses acrylics to create his surreal art, yet retain distinct likeness.

The birth of *Private Eye* magazine, in the 1970s, the evolution of television's satirical shows, from the revolutionary *That Was the Week That Was* (1962–63), the dissidence of *Not the Nine o'Clock News* (1979–82) and *Spitting Image* (1984–96), all

reshaped the British media landscape at the end of the twentieth century.

Caricature Today

Today, caricaturing seems to have many more facets. It is harder in many ways to have a satirical impact. People expect satire now, it is part of the currency and victims of satire just pick themselves up and get on with life. Fewer caricaturists approach their work through the social and moral triangle.

However, caricatures do survive and the familiarity has spawned a whole new generation of people, amateurs and professionals who are interested in drawing caricatures. Many take inspiration for their style from past generations, again building on art forms such as Art Deco, Cubism and Impressionism. Most styles are rooted in classic fine art.

Caricaturing competes increasingly with professional spin and presentation, both at a political and personality level. Even the managerial class layer learned personal presentation over true self. Photographs still rarely display multiplicity of character and, touched up, they can mislead. There will always be a place for the hand caricature, which can 'load on' character and personality through exaggerating features to help the observer to see the subject clearly through the eyes of the artist.

A historic perspective throws up several important lessons for a would-be caricaturist:

- Caricaturing spans fine art to line simplicity, detailed drawings to lightning sketches.
- The commissioner can heavily influence the direction of travel.
- Passion, conviction, deep-rooted trauma or conscience may be the driver for some. Humour, wit or playfulness may be the guiding principles for others. Neither is right or wrong.
- While some caricaturists exaggerate, condemning distortion as untrue, others distort rather than differentiate. All styles enrich. However, computer-generated distortion is not caricaturing. It is more akin to a distorted photograph.
- Time influences what is achievable.
- A caricature should ideally speak for itself without added text.
- Success does not happen overnight.
- A high proportion of caricaturists live actively to 100!

TYPES AND STYLES OF CARICATURE

Before placing pen or pencil on paper, even at this early stage, it is vital for the potential artist to understand the different types and styles of caricatures.

Types

The type of caricature will very often depend upon the reason for the caricature. There are several categories, but this book will concentrate on the following:

1. simple exaggerated portraiture;
2. exaggerated and humorous portraiture;
3. outrageous, gross exaggeration;
4. making a person look like an object, animal or plant;
5. group caricature.

Motivational Drivers Behind Type

The reason for the caricature can depend upon a commercial commission given to the artist or on a spontaneous artistic inner drive. Three important motivational drivers are the following:

1. on-the-spot work, for entertainment;
2. studio work: single or group commissions of an individual or individuals, which may or may not commemorate a specific or lifetime achievement;
3. social and/or political comment: graphic satire.

Simple exaggerated portraiture.

LEFT: Exaggerated and humorous portraiture.

BELOW: Outrageous, gross exaggeration: Mick Jagger.

LEFT: Making an object look like a person.

"It's a knock out" Team Winners

Group caricature.

On-the-Spot Caricaturing

This is pure visual entertainment. The audience admires the actual art of caricaturing, and is fascinated by the process, watching simple lines evolve into the finished product. They are amused and amazed by the craftsmanship, particularly the speed of execution. In addition, for the person being carica-tured, there is the frisson of flattery, whether the caricature is kind or cruel, exaggerates personality or physical features. This form of caricaturing requires speedy assessment and delivery if it is to be effective. To attain this standard – to be able to cap-ture likenesses in minutes or seconds – requires considerable skill and practice. It is a goal to which the artist can work, and is my own preferred style. I aim to achieve a likeness in just thirty seconds.

Studio Work

Studio work has the added luxury of time, with the artist work-

ing for a number of days or hours rather than minutes and seconds. There are several ways to approach such work (*see* Chapter 21). Working without a sitter, from photographs, can be more challenging, but the extra time does allow a variety of additional techniques to be incorporated.

The juxtaposition of caricature and sketch or illustration can be used to record a specific achievement or a series of lifetime events and achievements. Combining caricature art, which subtly captures facets of personality, with sketches of the key artefacts or memories associated with a specific or definable achievement is a common approach. The end product reveals so much more than a photograph. Ideally, such caricatures will be treasured for a lifetime. To be appropri-ate, and to satisfy the commissioner, they must balance exaggeration, humour, character and accuracy. Rarely does the commissioner or commissioning body request a bias towards mischievousness or beyond, verging on malice.

For more on artefacts and the commercial production of pres-entation caricatures, *see* Chapter 15 and 22.

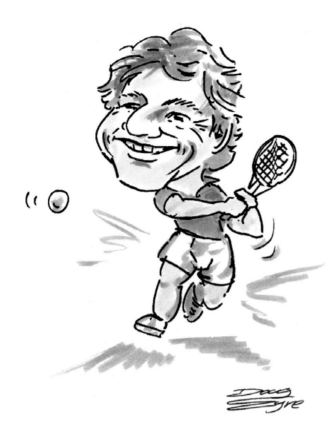

LEFT: 'On-the-spot' entertainment at an exhibition.

BELOW LEFT: Studio work: a single formal commission of Sir Geoffrey Dear as the then Deputy Lord Lieutenant of Worcestershire.

BELOW: Studio work: Lord Dear speaking in the House of Lords. Note the caricature of the body.

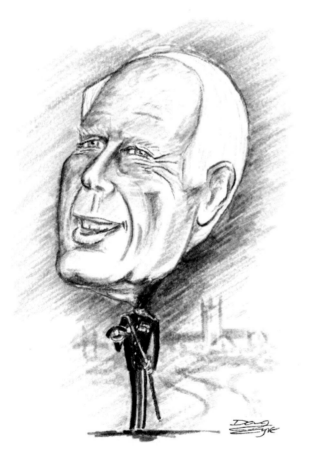

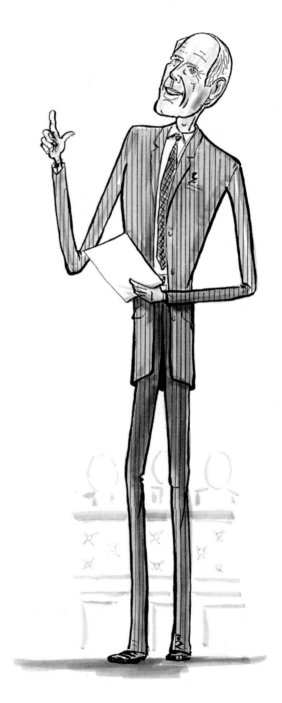

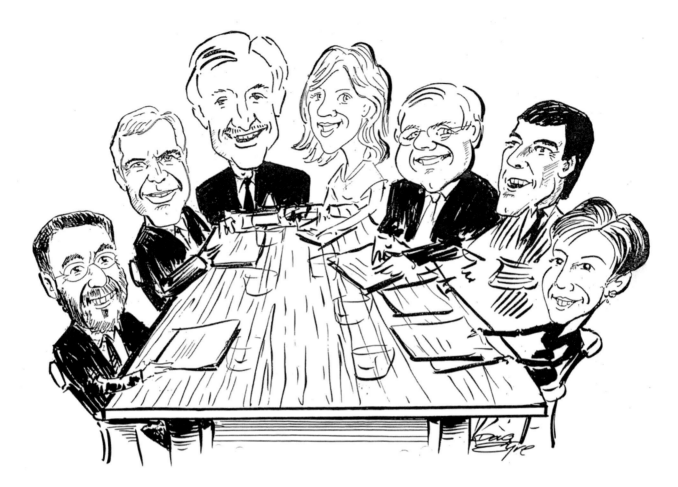

Studio work: group commission of the Chief Officers Management Group 2005.

Social or Political Comment

In an era when the majority of the population were unable to read and write, a caricature was an ideal medium for the communication of a concept, a point or an idea. It had the advantage of being far less likely to attract the attention of lawyers. The power of libel and slander could be less easily applied, in law, to the graphic author of the caricature. A caricature was therefore seen to be a much safer vehicle for making fun of people than writing. And concepts could be communicated to large numbers through easily recognizable pictures on pamphlets.

While they dealt with events of the moment, graphic satire often, as art, lasted no longer than the 'story of the day'. However, these historical political caricatures are now seen in retrospect to create a strong bridge between political history and art history.

In modern times, social or political comment is as healthy as ever. While today a caricature may seem shockingly frank, they tend to pale in comparison with the vitriolic outpourings of

Social comment: 'Now don't be greedy, young man.'

*Political comment:
'Is it all Brown or is it all Balls?'*

previous generations. Taste has been overlaid, and defecating kings have been confined to history!

Styles

Style relates to the techniques a caricaturist uses to achieve the desired effect, and they might include the following:

* minimalistic;
* complex and detailed;
* free-flowing, curvaceous;
* angular, geometric.

Use of colour, shading and cross-hatching, brush line, line strength, and even large airbrushing can all contribute to creating an individual style. Chapter 14 expands upon shading and cross-hatching techniques that help to create style. Line is covered in Chapter 2 under 'Mediums' and in Chapter 17 under 'Other Considerations'.

*Different styles:
minimalistic.*

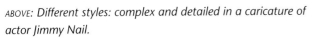

ABOVE: *Different styles: complex and detailed in a caricature of actor Jimmy Nail.*

TOP RIGHT: *Different styles: free-flowing.*

Different styles: angular, geometric.

GETTING STARTED:
TOOLS, MATERIALS AND MEDIUMS

Before you get going, you will need to understand your choices related to the tools, materials and mediums that are available.

In the art world, tools are additional pieces of equipment, such as the drawing boards, easels, carrying cases that you use.

Materials are what you work on, such as paper, electronic print board and touch-screens.

Mediums are what you work with, such as pencils, brush pens, pen and ink, airbrushes.

For your immediate needs, this chapter identifies the simple basics, and also covers equipment that will be appropriate for the practised reader. This is an extensive topic that can always be researched more fully. It is an area of evolving individual preference for any artist.

It is possible that, despite a strong interest in the subject and burgeoning skill and talent, the subject will become lost to you for ever, simply because you start with the wrong materials and medium. Organize your tools, pick a material and a medium, then learn to get used to them in the context of caricaturing. Remember, if you are not enjoying the process, you should always try other tools, materials or mediums before abandoning the art form.

There may be an extensive range of tools, materials and mediums available, but you should bear in mind that it is perfectly possible to start work with just three basic items: an eraser (the tool), a pad of paper (the material) and a pencil (the medium).

Tools

Drawing Boards

Despite the fact that most paper pads have hard cardboard backing, many caricaturists prefer to use a drawing board or an easel. As a beginner, if you can run to the expense, it is a good idea to start with a drawing board rather than an easel or pads, for several reasons:

- working on a sloping surface is easier;
- the eye can travel smoothly from the subject to the paper without having to move the head very far;
- in caricature art there are real speed and continuity advantages to having the subject's head and your eye at the same level;
- on a practical note, when you are learning and wastage is high it is preferable to use cheap sheets of paper rather than expensive hard-backed pads; and
- a drawing board is adjustable for angle and far less cumbersome than an easel.

As you progress and acquire skills you will discover you have different needs. These needs could well be influenced by your location, whether you are working indoors in the studio or outside. If you are working outside you may wish to consider an easel, but the right drawing board is still a preferred option.

There are a number of options available when looking for a drawing board.

Indoor Desktop Drawing Boards

Choose a desktop drawing board for its stability and desirable degree of angle, and make sure that it has a raised lower edge, to keep loose sheets of paper in place.

There are several different boards on the market (*see* below).

Your first step is to set up the drawing board at the suitable angle. Simply pick up a pad in one hand and sketchily scribble. You will very quickly identify the angle that is most comfortable for you, and then you can set up your drawing board accordingly.

Outdoor Drawing Boards

Working outdoors presents a number of challenges, including wind, rain and bright sunlight. In the context of drawing

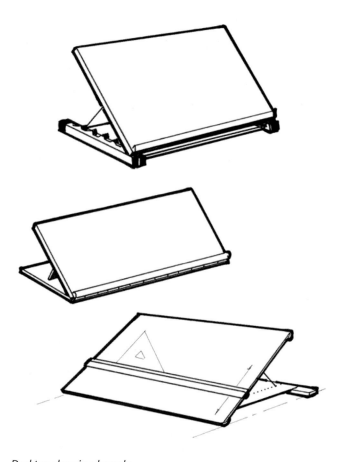

Desktop drawing boards.

boards, the recommendation is a small, lightweight easel (*see* page 32) or a shoulder-slung drawing board.

Outdoors, I use a lightweight self-supporting shoulder board, which leaves both arms free, allowing me to move around subjects, capturing nuances of feature and character with each new view. This degree of flexibility is invaluable. Like many caricaturists, I created my own particular style of drawing board.

While there are many variations on this theme, all developed through experimentation to suit individual needs, there are fundamentally two main types of shoulder boards:

• a simple hand-held board that supports paper;
• a self-contained body board, which holds all the paper and pens that will be needed, but leaves the hands free. This is ideal when a caricaturist is asked to sketch people in a crowd inside or outside (a very demanding commission).

Making Drawing Boards

To make your own simple hand-held board, buy a piece of stiff lightweight wood board, ply or MDF, at least ⅜in (10mm) thick,

roughly 16in (40cm) high by 13in (33cm) wide. Attach a strip of thin baton a couple of inches up from the bottom edge (*see below*), to prevent the paper falling off when the board is tipped. This simple hand-held board will suffice at this early stage for outdoor work and enable you to use sheets of paper rather than pads.

To make a self-contained body board, which will facilitate freedom of movement, a back webbing strap is attached to a slightly larger board. To meet the needs of the back webbing the width of this board has to be greater than its height. If the height is 15in (38cm), the width should be 20in (30cm). Make the board as before, and secure the webbing strap, made from the same material as a car seat belt, to the board in two places: top left back and to top right side (*see* below). For left-handed artists, attach the strap at the top right back and the top left side.

A small, shallow tray in the bottom left-hand corner to hold pencils and erasers will prove invaluable.

It is also possible to make a larger board with protective sides and a screen for outdoor sports events. This is a more sophisticated version, made in the same way as the self-contained body board, but even wider. It has a transparent front windscreen and weatherproof side screens, to prevent the wind disturbing the papers. As the board is larger, lighter materials are used. In addition it is designed to have adequate, comfortable working space with sufficient room for both virgin paper and completed works of an A4 size. The right-handed artist has a tray holding the completed sheets to the left; for a left-handed artist, this is

Simple hand-held drawing board.

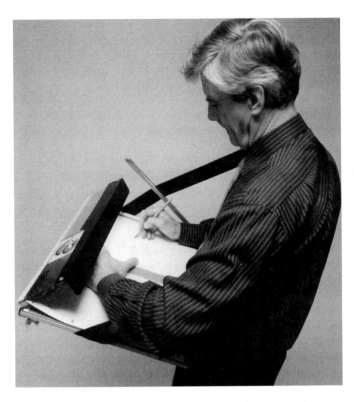

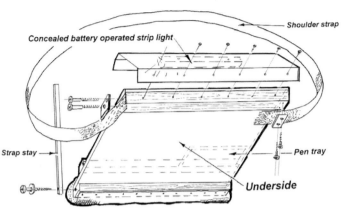

Self-contained illuminated body board.

Using an illuminated self-contained body board at an evening function.

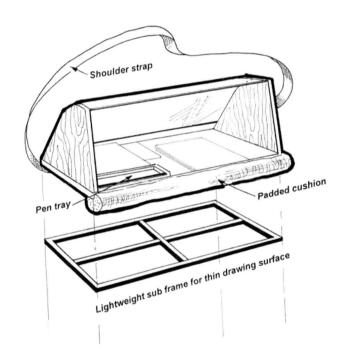

Outdoor all-weatherproof body board.

to the right. The whole board is wide enough to take two A4 pads: 24in (61cm) wide by 16in (40cm) high is ideal (*see* below).

Easels

A whole range of artist easels, from flipcharts to the more conventional wooden or metal easels, are available from suppliers. Despite being designed for portability, they can be set up permanently in the studio. The main choices are wooden or metal, and table or desktop.

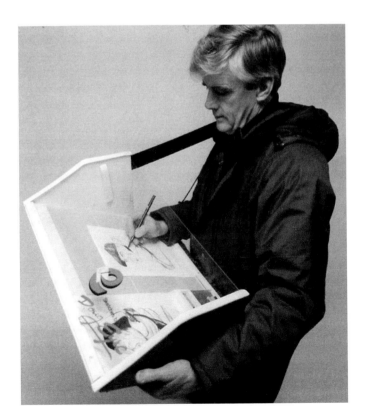

The outdoor all-weatherproof body board in action.

Many of the easels available commercially will meet your needs, although I would still recommend that you stick to working with a drawing board as you hone your talents. If you do decide to go for an easel, you need to consider why you want one, where and when you are going to use it, and how it is going to help you. You must also make sure that the easel is easy to assemble and to use. If you do not find what you want on the market, you can, as may other artists do, create your own to suit.

A drawing board and a desktop easel may seem similar but, generally, the desktop drawing board will be heavier and more stable. This is very important if you work in a very fast, energetic manner.

Wooden Easels

Over time, as you progress, if you decide on a wooden easel

you need to ensure that it is made of hardwood. The fittings should be made of brass or steel rather than a softer metal, which will wear out on use. Before you make a purchase, check the easel's manoeuvrability to ensure that it can be angled exactly as you would wish. If you want to use a wooden easel for this purpose the most useful type of wooden easel that is simple to assemble and use is the tripod.

Metal Easels

Metal easels are usually lighter than wood, more portable and more stable. When folded, they are more compact, and easier to assemble and adjust with their tubular legs. They are flexible in that they can be used both inside and outdoors.

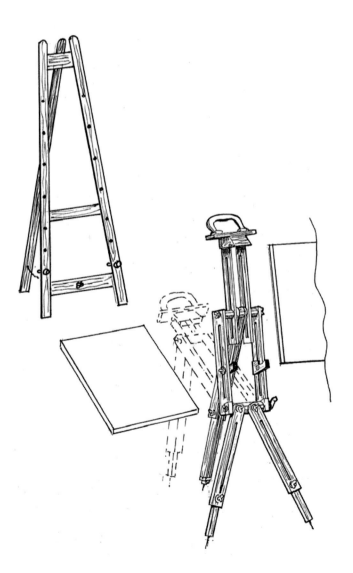

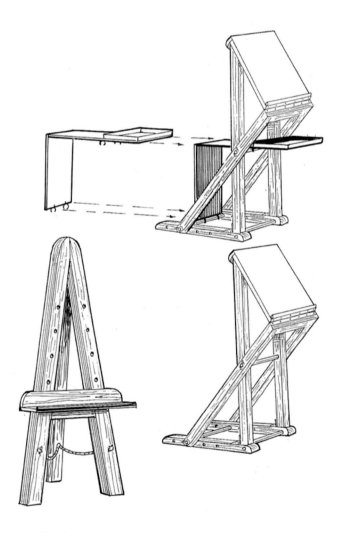

ABOVE: *Wooden easels: a heavier version should be more stable.*

LEFT: *Wooden easels: the lightweight 'A' frame type may be too upright.*

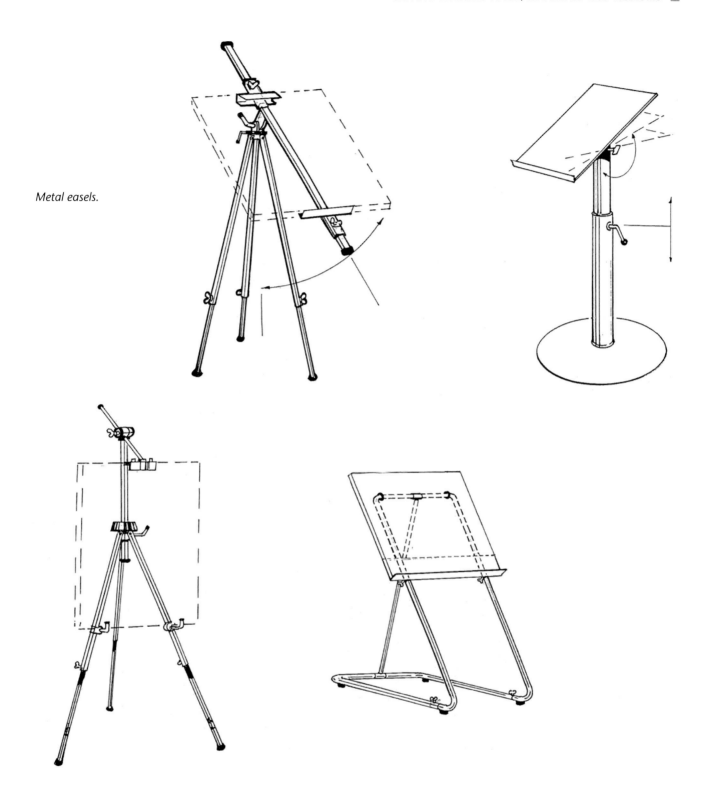

Metal easels.

Added Extras

Carrying Case

If you are working outside you may need a portable stool and probably a functional carrying case. If the carrying case is large enough – for example, able to accommodate the shoulder-strung drawing board – it could also act as a seat. Again these are all personal choices.

Whatever you use as a carrying case, you must exercise some discipline in organizing the carrying space. Everything must be in its place, especially if you are out and about.

Eraser

An eraser is a faithful friend to the caricaturist. It has two uses: altering line and producing an effect. When creating the impression of glass, as in glasses, add cross-hatching, then use the eraser to remove pencil lines and create highlights. Once you get going you will be amazed how often the eraser is used for both purposes even in the production of a quick caricature.

Artist's erasers come in several types, and will be of soft putty or firm yet flexible. You need a good-quality, firm, pliable eraser, about 6cm in length.

Light Box

This is a simple sloping wooden or plastic box with a frosted glass top and a light beneath. I use mine mostly for minor alterations to drawn pictures. The original drawing is placed on top of the light box and the likeness is traced on to a second piece of paper, thereby making the alteration possible.

A light box may be helpful to some cartoonists who are never going to invest time in developing their caricature skill. They might copy a photograph and use a light box to trace the likeness from the photocopy. Once they have the simple, rough

likeness in a few lines they have enough for their needs and the public soon associate this likeness with the personality in the cartoon.

Caricaturists, if they develop their skills fully, should not need to trace photographs in this way. Any professional caricaturist with a free flow and good style of drawing will never trace a photograph.

You can buy or make a light box.

High-Quality Photocopier

You need access to a photocopier that can enlarge and reduce and produce good black images. A colour copier is even better.

Reducing Glass

A reducing glass, purchased from an optical supplier, is a valuable tool, enabling the artist to view their work from a distance without moving. I would recommend it to any artist, beginner or experienced. When close to your work it is difficult to get an overall view. If you are drawing a person a metre away, the reducing glass will enable you to optically reduce your work to a suitable size for comparison to your actual subject. Any errors will be amplified by looking through the reducing glass.

Dimensions of a light box.

Materials

Paper

Background

The most popular material to work on is paper. There are about sixty different types of paper, not all for drawing. If you are really interested in the subject, consult the website www.biltpaper.com, which describes a fair few. Initially, as a beginner, you can use copy paper to practise on. The only restriction, if you are working with pencil, is to avoid very smooth paper. Later on, when you have honed both your skills and confidence, you can move on to drawing paper. Most people use acid-free cartridge paper.

Originally, paper was made from material, linen and rags, and this type of paper had a particularly long life. Around 1850, paper began to be produced from ground-up wood pulp, which contains a substance called lignin that gives trees and plants their strength. Over time, lignin discolours and causes the paper to disintegrate. To protect the paper it is generally coated with a waterproofing substance, which is acidic. This acidic coating, however, will cause the paper to self-destruct

The principles behind the use of a reducing glass.

but after a much longer period. Artists tend to choose specially produced papers that are qualified as being acid-free and guaranteed to have an even longer life.

Texture

Texture of paper is important, as it can have an impact on both speed and style. As a background it can enhance or distract.

For beginners there are three main choices in terms of texture: smooth, semi-rough and rough. Semi-rough is ideal, as less-experienced artists will find that their pen or pencil slips if the paper is too smooth. Any excessive friction between the pen or pencil and rough paper can slow up the artistic process. Speed is the essence for a quick caricature; pencil on semi-rough paper produces just the right effect.

Later on, you can experiment with a range of textures, from flat, fine hard-grained to smooth handmade paper, including more distinct textures to enhance your finished products.

Weight

When you buy paper, it has a weight value, measured in 'gsm' (grams per square metre). The higher the gsm value, the stronger the paper. The standard weight for most paper that is used for copying or general rough work is 80gsm, 90gsm or 100gsm. Cartridge drawing paper starts at about 125gsm, and weights can go up to 300gsm, and occasionally more. The average that is recommended for artwork is 130gsm. Pen and ink work requires stronger paper and if your drawing is going to take a colour wash, you will need to go up to 250gsm, to reduce the risk of the paper buckling. A studio presentation piece that will be framed and hung must be on good-quality paper, but beginners need to use basic papers to practise on.

There is a paper called ingress paper, which is used mainly for pastel work, but it can also be used for pencil work, facilitating white highlights.

Format

Most manufacturers supply good-quality paper in pad form, which is ideal for the caricaturist. Avoid spiral-bound pads if you are working from life, producing caricatures at speed to be presented instantly to your subject. In order to produce an immediately available, tidy, finished picture you need to draw on a clean sheet from a gum-topped, non-spiral pad. When drawing instant caricatures from life, there is no time to trim the paper. A sheet from a spiral-bound pad has a rough, perforated top

edge. Spiral pads come into their own when you are making reference sketches that you are going to keep, and not give away.

Once you have some experience, you will need both.

Electronic Screens

There are, on the market, all sorts of touch screens and electronic boards that can be used by professional caricaturists. They are not commonly seen, but they represent none the less a fascinating medium to work on, being speedy, interactive and reactive.

Electronic White Board

I use an electronic white board for some of my work – a unique technique in a class of its own. The main difference between this medium and more conventional surfaces is that the image on the screen, which is created by a dry whiteboard pen, is a black dust deposit. Because the dust is very temporary this is a highly skilled process. Unlike pencil or ink on paper, when you use a dry whiteboard pen, as one line crosses another it removes particles deposited by the previous line. It actually takes out the line. There is, therefore, a high degree of skill needed to create a complete picture with all the lines intact.

Most electronic whiteboards are equipped with a printing mechanism, which will reproduce the picture on to A4 paper. Once the image is on the A4 paper, tints and shading can be added by brush pen. While the image is still on the screen further copies can be printed. Many of the life drawings in this book are original 'on-the-spot' pictures.

Touch Screens

Touch screens look like any other PC monitors but respond when you touch the screen. They are triggered by insertion or withdrawal of the fingertip. The touch function does away with the keyboard, mouse and the touchpad for a normal PC user. For a caricaturist it cuts out the use of any other mediums – pens, pencils, paints. This is a technological step that allows the caricaturist to work live in one place and instantly send pictures easily to another, even to another country.

The tool is still evolving and is not yet used universally, but the potential is fascinating. There are a number of advantages and disadvantages to the technology. It is not certain whether the resolution will ever satisfy the subjects where specific commissions are concerned, or whether the speed of delivery of the

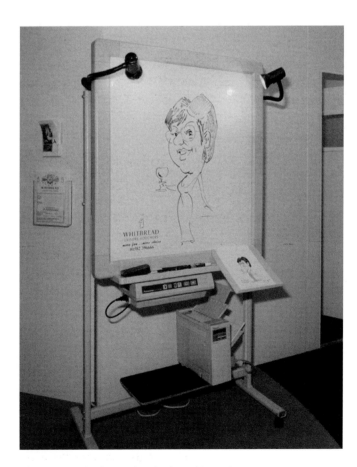

The Panasonic electronic print board in action.

Drawing of political broadcaster John Sergeant, produced on a large display touch screen.

finished picture will ever match that of a lightning caricaturist working a crowd.

Computer Graphics

The hand caricaturist may be rather reluctant to discuss computer graphics and caricature in the same breath, but it is the twentieth-first century and there is some great artistic talent and innovation supporting the programmers who produce graphics for the film and gaming industry.

One of the ultimate goals of computer graphics is to develop techniques to create a wide variety of artworks, such as drawings, paintings, sculptures and animations. Development of these techniques requires a good understanding of the common tools used in visual arts abstraction, simplification and exaggeration. These are tools that a good caricaturist can employ with ease.

Exaggerated computer graphic imagery usually has strong financial backing. Simplified figures created by the IT gurus blossom in the artist's hands. There is no doubt the effects can be stunning, but nothing yet seems to have captured the nuances that can be produced by the hand caricaturist. In just a couple of minutes a good caricaturist can rattle off a likeness incorporating a few or many features, with just a few lines, from all three angles: full-face, profile and three-quarter.

Automatic Facial Caricaturing

This research seems to stem from a desire to use mobile phones for nonverbal communication. Facial expressions are a natural and immediate means for human beings to communicate their emotions and intentions. If facial expressions can realize more smooth emotional communication, they can be harnessed in a number of commercial ways.

The complexity of using automatic caricaturing system concerns the many characteristic points on the face and facial parts. To apply the caricaturing system on a mobile phone, it seems to be better to use fewer characteristic points in order to reduce the computational effort to produce a facial portrait.

Caricaturists understand how to drop the detail and still get a likeness. It seems machines cannot quite achieve this yet, although one company has an automatic facial caricaturing process for two-dimensional realistic portraits. Their technique breaks down the extraction of face and facial part regions from a facial image in order to preserve features of the person in a caricaturing portrait, using regions of the skin, hairs, eyes, mouth, irises and nasal cavities from the facial image. A caricature of a facial portrait is then based on a set of characteristic points on the extracted face and facial part regions.

Their results are interesting, although there is still some way to go. Interestingly, they missed out on the eyebrows; missing out eyebrows can lead to losing the likeness. The technology will surely have its uses in time, and it is worth searching the Internet if you want to see how it is progressing.

Many processes seem to have achieved single feature definition but at an average quality level. Whist some really sophisticated work has been done to capture two-dimensional portraits, the three-dimensional versions seem to be particularly difficult to achieve. Neither does any of the work to date address the multitude of styles found in the commercial caricature world. Will it ever be possible for such a process to pick up mood, personality and character? Then there is the humour to consider. There is a generosity of spirit in most caricaturists. For the time being at least, the death of hand caricaturing will be grossly exaggerated.

Mediums

The Line

Graphite Pencil

The degree of softness of the pencil is very important. A soft pencil will move over the paper more smoothly than a hard pencil, depositing the graphite more easily.

It is vital to understand pressure when using a pencil. Pressing hard creates friction, which slows up the stroke and cuts down on the flow you are trying to achieve. Friction causes the picture to lose its flexibility of line and its flow.

If you want a darker line, instead of pressing hard, use a softer pencil – it really will achieve a darker line – but always maintaining a light stroke. If you want a thicker line at some point in the picture, use the side of the pencil. An appropriate thickness for your objective is a 2B: 2, 3, or 4B are all soft pencils.

You may find a short pencil easier to use, as it enables you to manoeuvre the pencil with much more flexibility. Hold a short pencil at right-angles in your hand between your thumb and forefinger (*see* page 38) as if you were holding a piece of charcoal or chalk. Compare this in terms of the level of agility you have to holding the same pencil alongside the thumb, as you would a pen. This angle tends to restrict the movement of the hand (*see* page 38). Practise on scrap paper until you get used to using a short stubby pencil.

To create short pencils, simply break a conventional pencil into two equal pieces and sharpen it at both ends. When you cut or break your pencils in half in this way remember to mark the unmarked half with the number of the pencil (2B, 3B, for example). Flatten the edge with a blade and mark the edge with a ballpoint pen.

Hard 3H = Very thin line.

Medium HB = Normal pencil line.

*Soft 2B 3B 4B = Soft drawing pencils.
Very effective when used on their sides.*

*Graphite Aquarelle Soft Medium & Very Soft =
Ideal sketching tool when used with pale brush
pens or water wash.*

Different line effects.

*Handling a short pencil: the conventional way versus the short
pencil approach.*

EXERCISE: **COMPARING SHORT AND LONG PENCILS**

Try out both the normal and the short pencil, to compare them. Fill a whole page by scribbling circles, using both methods to ascertain which is the most comfortable for you.

Interestingly, physically disabled artists can be extremely dextrous and have a number of clever tricks to maximize their flexibility despite physical disadvantages.

Learn to use different angles of the pencil: the broad edge for broad strokes, and the tip for fine lines, hatching and shading. These different effects can all occur within one picture.

Water-Soluble Pencils

Water-soluble pencils may be used in a similar way to black lead pencils. The feel is very similar but, because they are water-soluble, they add a completely new dimension to a sketch. The water added over the finished line – the 'wash' – dissolves the 'lead'. If this method is used, you will need a good-quality paper of at least 200–250gsm.

The most convenient way of achieving this same effect for a caricaturist is to use a water-based brush pen in either clear or pale grey. Do not get carried away with pots of water and brushes in the early stages, although you may want to come back to this method for use in the studio. Some caricaturists do use it all the time, but obviously it does take longer to complete a picture.

Marker Pens

Marker pens come with a large bullet end or an angled tip, in various widths and colours. If you are working on A3 or A2 pieces, these pens really come into their own. The bullet point has just one thickness of line, whereas you can vary the width

of line with the chisel edge. The chisel edge certainly provides for more flexibility and variability. These pens give the finished picture flow and life but tend to be used by more experienced caricaturists; one major drawback is that it is more difficult to make quick corrections.

Pen and Ink

Any type of pen may be used – fountain pens, drawing pens, older-style conventional inkpot and nib pens such as you might use for calligraphy – but when it comes to caricaturing this medium is slow. If using a pen to create the final image, most caricaturists incorporate a lot of lines and cross-hatching. It is generally considered more time-consuming to create such a picture – indeed, it can quadruple the time – but the finish is excellent, especially when finer features such as hair are being drawn.

Various thicknesses of pens can be used, and the end result will be particularly influenced by the width of the nib.

Pen and ink is more commonly used in the studio, as carrying around the necessary equipment is somewhat cumbersome. However, although it is a less useful medium outside the studio, there are those who do use it.

EXERCISE: **TRYING OUT DIFFERENT NIBS**
Play around with thick and thin nibs, varying the pressure, teasing out different line thickness.

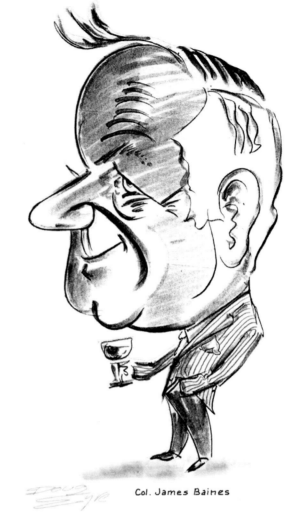

Col. James Baines

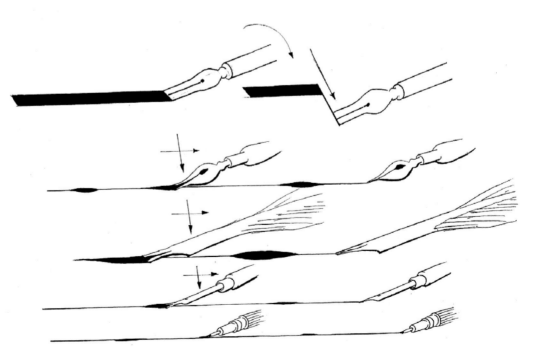

TOP RIGHT: *A picture illustrating different pencil and pen effects: line strength, hatching, shading.*

BOTTOM RIGHT: *Using pressure to achieve different thicknesses of line with a nibbed pen.*

The materials most suited to pen and ink are smooth-coated papers or boards, which are much more expensive than paper. It is a balance.

Added interest can be achieved by a wash over the line, or shading.

Pen and ink is the medium used by legendary British caricaturist Ronald Searle, whose technique evolved using nibs and pens. One major feature of the medium, which translates strongly into his work, is its scratchiness, and the noise his pen makes as he works is an important aspect of his delivery. The audible aggression and energy that accompany his drawing are visible in the finished work.

Pastel and Charcoal

Pastel and charcoal are good mediums for the caricaturist, but they can be soft and messy for a beginner. Specialists can achieve excellent work in both mediums.

The Infill

Adding a Wash

This is a watercolour technique that is added once the outline has been established in permanent ink. The line must be in *permanent* ink and *thoroughly dry* before you start to add a wash. Normal watercolour techniques are applied, using either a brush or water-based brush pen. Brush pens are far more convenient in fast caricature work, particularly on-the-spot work, as they do not require a reservoir of water. This colour process is mainly done in the studio for finishing pictures requiring full colour.

Brush Pens

Brush pens are excellent. The medium, especially the grey, pale grey or clear pens, are used to soften a line or drawing produced by a water-soluble base such as pencil or charcoal. It is the water-based ink in the brush pen that dissolves the black 'lead' immediately, giving the soft finish. In addition to softening the line, because the liquid overlaps the line it can create an added grey shade effect alongside the line.

Brush pens may be used to add further shading or tone to a picture. Even the simplest cartoon or caricature is enhanced by the addition of such shading.

As the name implies, the brush pen has a soft fibre brush tip at one end with a centre barrel, which is the reservoir for the ink. Some manufacturers offer double-ended pens, incorporating an additional fine, hard felt tip and caps at both ends. One or two manufacturers make pens with permanent ink. These

A caricature produced using only a brush pen.

pens are ideal for quick sketching, especially if the artist is making 'on-the-spot' thumbnail sketches for a larger picture. You can get down an enormous amount of detail in a 3 × 2in (7.5 × 5cm) area using a fine brush such as this. One version, cartridge filled with permanent ink, is designed like a fountain pen but has extremely fine brush tips only.

Work the brush pen over the lines quickly to avoid excessive bleeding; you will achieve a cleaner picture.

Soft Brush and Water

This technique – the application of a tinted wash – is used only in studio work. A soft watercolour brush, usually sable and a number 4 to 6, should be adequate for the purpose, although, occasionally, caricaturists do use larger brushes. Water-colouring techniques are used to create a full wash or enhance the line created by permanent ink or pencil (*see* above). The soft shade effect can give a particularly pleasing finish.

Airbrushing

Airbrushing is a skill requiring specialist equipment, which comes into its own in the hands of a specialist. The equipment is quite expensive, but the technique has become a well-known medium, used by many caricaturists to tremendous effect. Today, of course, the medium is forced to compete with the superb effects that can be achieved using computer graphics.

Framing and Mounting

There are many types of frame that may be used for hanging caricatures, and the choice will have an important impact on the caricature itself. Too ornate a frame will often detract from the style of the caricature. A popular shape, because of its simplicity, is the 15mm black-cushioned frame, which comes with a mount. Alternatively, a simple clip frame can be used, generally without a mount.

Where a mount is used, its colour should reflect the colour in the shading of the picture.

Avoid non-reflective glass, which masks the finished picture.

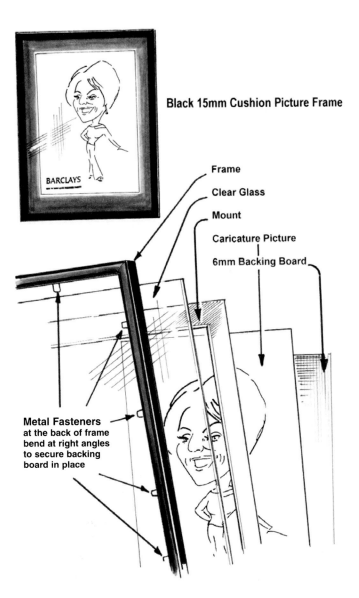

Black 15mm Cushion Picture Frame

Frame

Clear Glass

Mount

Caricature Picture

6mm Backing Board

Metal Fasteners at the back of frame bend at right angles to secure backing board in place

Black cushion frame and mount.

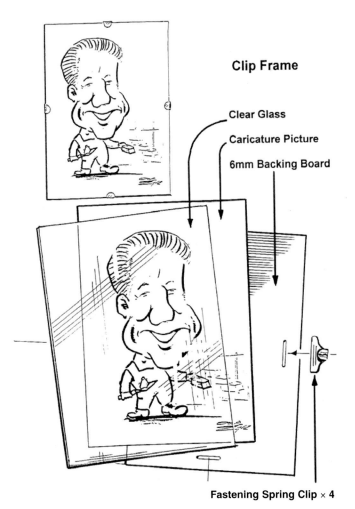

Clip Frame

Clear Glass

Caricature Picture

6mm Backing Board

Fastening Spring Clip × 4

Clip frame.

GETTING STARTED: THE THREE KEYS TO CARICATURE ART

Caricaturing builds on three key skills, and it is vital to understand these before putting pen to paper:

1. the artist's ability to use whatever degree of technical draughtsmanship underpins his work skilfully to capture an appropriate number of distinguishing features, or at the very least to create convincing shapes upon which to build a caricature;
2. the artist's ability to read people, to see the person primarily in the face, stance and pose, and to get inside their character and personality; the ability to understand type and mood;
3. the artist's ability to 'see the wood for the trees', in order to link the brief or inspiration to the finished product.

Speed of application coupled with an ability to calmly work under pressure, a pictorial memory, humour, wit, and insight into social and political matters of the day are all added attributes that, depending on circumstances, could play a significant role, whether completing a commission or approaching the subject as a hobbyist. Patient friends and family could be an added requirement, as most caricaturists soon become addicted to the art form!

Capturing Distinguishing Features

Fundamentally, caricaturing is similar to portraiture, although a portrait is perhaps more serious. While portraits usually avoid the exaggeration of feature, which is caricature, flattery may well be a factor within the work. Portraits may seem to involve more details, but caricaturists through the ages have shown that this is not necessarily the case. The intricacies of some works, such as Hogarth's Gin Lane, clearly show the investment of significant time and detail, with many individual lines being used to achieve a highly detailed finish.

The caricature, often a black and white detailed line drawing, usually incorporates techniques such as line strength, cross-hatching and shading rather than soft line, paint effects and colour.

Those caricatures drawn from life, 'on the spot', display an additional skill set. Here, a key skill is the caricaturist's ability speedily to evaluate a mass of distinguishing features and take in the many aspects of personality and character, yet distil the many into the few that infer and imply the whole. The likeness is captured with economy of line. The style can be seen to be a function of the available time.

With either approach, to differing degrees, there may be a need, subsequently, to overlay context or detail, to make a point or expand on the story. However, the starting point will always be bold line exaggeration: the larger nose, the bigger chin or the wall-to-wall smile. Details and shadows follow later.

Whichever approach is used, the focus must be on features, personality and character intertwined.

Features are real, obvious and tangible. Before learning to caricature it is necessary to have a basic level of familiarity with the general proportions of the human face and how to draw each individual feature. Good draughtsmanship, restrained by economy of line, is the ideal base from which to move into caricatures, but it is not absolutely essential. The ability simply to create a convincing shape, preferably from memory, as well as acute observation skills, underpin the work. Fascinating work, as history shows, has been achieved by professional artists and hobbyists alike, although to differing degrees.

For more on the degree to which a caricature artist needs to be a draughtsman, see Chapter 4. It outlines very simply the basic proportions of the head and face in such a way that the most prominent features – those most noticeable to most observers – can be comfortably positioned.

Chapters 5 to 12 cover the following, in the context of a specific feature and its related sub-features:

- observation of the basic features and their associated shapes. Pointers are given about simple straightforward

Capturing distinguishing features in a detailed line drawing.

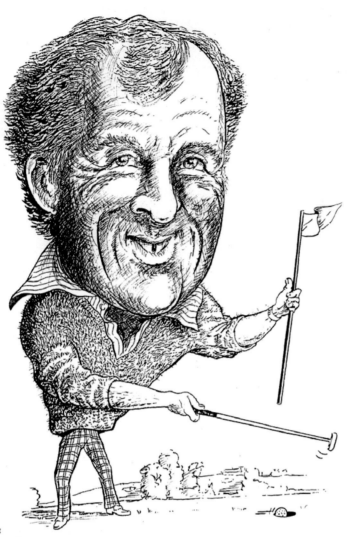

DOUG EYRE

Capturing the likeness with economy of line.

drawing techniques (trained artists already used to observation and having basic drawing skills may choose to skip some of the sections);

• basic caricature interpretation, using concepts that underpin the genre: the need to retain likeness, the power of economy of line, and the freedom of extreme artistic licence, inspiration; and

• techniques that will strengthen the skill level.

Examples are given to illustrate each point, and there are suggestions for exercises that will build confidence and speed.

As you work through the chapters on features it may be handy to have a mirror by your side. Unless you are trained in portrait art or draughtsmanship, or are particularly observant, you are unlikely to have seriously studied the structure of the human face in any detailed way. A mirror will help considerably.

Reading People

Physiognomy hypothesizes that the study of a person's outward appearance, primarily the face, may give insights to their character or personality. The theory seems to have been taught in the early universities in England until the time of Henry VIII, who banned it (along with palmistry) in 1531. Absolute predictive physiognomy, which implies that there is a 100 per cent correlation between physical features (and especially facial features) and character, has been disproven. Perhaps this is unsurprising, since any theory that believes that the high, wide brow is always a sign of great intelligence, and the square jaw always indicates determination and courage, is bound to fail. There are numerous medical conditions that may account for physical changes, and a study of the faces of men who have won medals for heroism does not reveal a preponderance of square jaws. The dogmatic approach of absolute predictive physiognomy is not helpful.

There is another branch of physiognomy that suggests that there are rough statistical correlations between facial features and character traits, due to a person's physical preferences. This concept is underpinned by loose genetic mixing correlations. This approach is equally unhelpful.

I have been caricaturing too long to believe that there are certain structural features that indisputably give clues as to the character and personality of the subject. The judgement of such subtle concepts as character and personality can never be attained from such rigid rules. What can caricaturists do, then, to get that little bit of extra life and reality into a picture, and to receive that most satisfying of comments: 'You have not only captured him but somehow his personality, too'?

There are no simple courses. Neither art school nor life can teach an artist how to read faces, features, stance or pose, dress and demeanour sufficiently well to be judgemental. However, over time and with experience, it is possible to use all your skills – visual, verbal and intuitive – to pick up a flavour of mood, character and personality. It is quite possible to tune in to visual and verbal clues, especially if you are setting out to do so. Being an intuitive type helps.

A number of techniques will work well to help you observe type, and understand mood, character and personality:

• reading the facial lines and body stances and poses to pick up on current mood;

• listening to surrounding conversation for mood and personality clues;

• looking for signs from clothing and other artefacts, whilst chatting to your subject;

• engaging in conversation to draw out aspects of mood, personality and character. The ability to ask questions and listen carefully to the answers is very important. You may have to sift out facts from the answers that you wish to put into the picture;

• being particularly observant and conversant with the perceptions of connected others;

• the ability to forget self.

In contrast, there are a number of factors that can work against you:

• the validity of language. Bear in mind that language can be a means not only of expressing truth but also of disguising it;

• the need in some corporate environments to mask the self. The corporate or public image is all. Capture that aspect sometimes; get behind it on other occasions. Live or corporate caricaturing warrants the former on most occasions; editorial newspaper caricaturing probably requires the latter;

• a raft of artefacts employed to create an image – focus in on the critical;

• the controlled image of personalities and politicians.

As in any other profession that demands an understanding of personality and character, the artist (professional or amateur) has to have or develop his own mechanisms. Hogarth used his own drawings, and those of Raphael, Caracci and Leonardo to prepare material, to demonstrate the difference between character and caricature comparing the pictures to develop the art form.

Creating your own mental crib sheet and honing your interpersonal skills really is worth doing! Although hard to acquire,

Unpacking the component parts as in wine tasting.

skills relating to observation of character, accessing and capturing aspects of character and personality, and picking up on the immediate mood, are invaluable. Their acquisition is one of the keys to becoming a successful caricature artist.

Although we are surrounded in modern life by friends, family, acquaintances, work colleagues and neighbours, few consider this need to engage and observe. Considering the pace and number of interactions we have with people daily, we should be experts, but it is none the less necessary to stress the need to develop these skills in order to develop the skill of caricaturing.

It is important to understand the difference between looking and listening, and *really* looking and listening. It is important to get past that feeling that everyone observes every day, making judgements and picking up on character naturally. It is important to take on board the fact that, if you want to be a very successful caricature artist, you do have to learn to be a particularly keen observer, in all senses, of people.

It might help you mentally to link the art of observation with the skill of wine tasting. When a glass of wine is picked up, the drinker thinks he understands the contents. But in the hands of a master of wine those contents can be revealed and unpicked,

so as to reveal layer upon layer of fascinating complexity and interest previously obscured to the layman.

How does the layman move from sipping or glugging to engaging with the contents of his glass? There are several steps:

- unpacking the component parts;
- analysing each component;
- cross-referencing to previous experience;
- packing the detail 'back in the box';
- forming a judgement;
- highlighting the key points.

In the case of a wine taster, certain physical actions, a learned specific vocabulary, and spoken or written communication are the outcome. It is the same with caricature art. Through observation – unpacking character, analysing components of character, cross-referencing experiences, looking back at the whole, highlighting key points then using specific learned techniques – the essence of a concept or person is captured.

Some specific learned techniques, incorporating these steps, which support the observation of type and understanding personality and character, and picking up on mood are covered in Chapter 18.

'Seeing the Wood for the Trees'

Once the key features of a subject – those relating to the face, the personality and the character – have been observed and mastered mentally, the artist will, depending on the commissioner's wishes and the time available, have to decide what to include and what to leave out of the final picture.

Dropping detail is a skill in its own right. It requires confidence on several planes: in draughtsmanship, observation and the artist's interpretation of the brief. Caricaturists not only ignore unimportant details, but also very selectively exaggerate features. They know which they can and which they cannot exaggerate. It is that aspect that makes their subjects unique.

Good caricaturists both portray and invent. Possessing only one of the required skills is half a story. Many works communicate and are powerful, showing clearly the artist's own inner drive. In such works, feature lines and expression are part of a much bigger story.

There are several techniques that can help in pulling the caricature together out of the mental overload of initial stimuli towards the finished work.

In Chapter 12, I will take you through my own formula, but ultimately every artist has to find his own route.

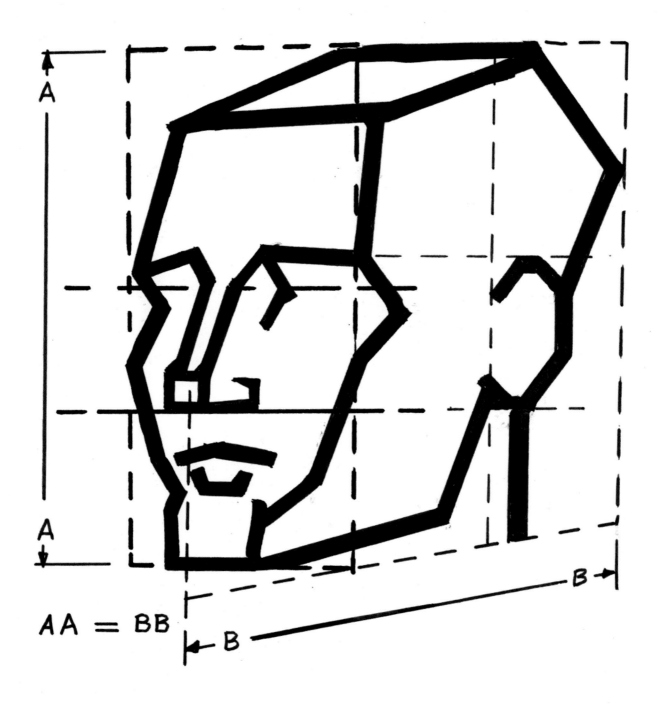

AA = BB

FEATURES:
DRAWING THE FACE AND HEAD

Creating a convincing shape upon which to build a caricature is the first step. This necessitates an element of technical draughtsmanship. It is important to begin by looking carefully at the head and the position of the facial features as a whole: in full-face, profile and three-quarter, 45-degree angle. Then you can consider the individual aspects of the head or those of its individual features.

As a generalization, to the layman, a head appears round, slightly flatter at the back than at the front. This is understandable, as it is the front that carries the profile and the shape of the back of the head is masked by hair.

Over the centuries, a number of pictorial principles and precepts have been invented to help artists make pictures. Man has worked long and hard accepting and rejecting concepts to achieve the principles of proportion in order to facilitate drawing. Whilst precise geometric rules have evolved, resulting in basic proportionality underpinning drawing, nowadays most figurative artists tend to make such judgements by hand and eye.

While detailed technical training can be particularly valuable to caricaturists, early historical notes and bibliographies confirm that caricaturists do not need to be fixated on these precise technical details. It is possible to achieve a likeness without them, but it is necessary at least to be familiar with them.

The whole process of caricaturing, despite involving exaggeration and possibly distortion, must remain true to likeness, so some basic knowledge of proportionality in relation to features is needed.

Starting to Draw

Two exercises will help before you start drawing. They are designed to enable you to loosen up, achieve flow and improve your feel for shape.

When they start to draw, most people commit a number of common faults. Generally they hold the pencil too tightly and press too hard. Lines are thus created in very small, short strokes, resulting in stiff and clumsy line. The whole approach is lacking in energy and flow. To overcome this, in the same way an athlete prepares for a sport, the artist must loosen the wrist and arm.

EXERCISE: **LOOSENING UP**

Hold the pencil lightly and, on a large sheet of paper, practise bold, circular motions all over the paper, round and round and round in large loops. This will free any stiffness in the wrist and increase the flow of line. Repeat again on a second piece of paper, creating a variety of shapes, to achieve speed and smooth, flowing lines. Feel the energy and flow in the pencil when you do this.

Secondly, with pencil in hand and paper before you, clear your mind and close your eyes. Focus on a fairly simple, rounded, imaginary object: for example, a lamp base or a vase. When you can see it clearly, concentrate on it. Hold the imaginary object in your mind for a few seconds before opening your eyes and putting pen to paper to draw. The drawing will resemble the object. This exercise will give you a much-needed burst of confidence, as you have shown that you can carry a shape in your imagination and get it down on paper. How much better will it be when you are using real life observations to prompt you?

Two-Dimensional Views

The starting point when considering the drawing of a head and the position of features could be an oval, almost the shape of an egg, with the base being narrower. Although the oval has been used for a long time as the construction basis, some people prefer a block, deeming the oval insufficiently sophisticated to handle the three dimensions. For some, building on a block is an easier basis for measurement.

The Two-Dimensional View – Full-Face

The basic canvas for the frontal features builds upon the frontal bilateral symmetry of the head – a vertical line in the centre of the oval divides the head into equal parts, opposite and complimentary. The position of the right eye matches to the left, and the two halves of the nose are symmetrical, as are other features such as the mouth, teeth and jaw.

The following exercise uses the grid principle, on an oval, to overcome the need for precise measurement and facilitate the positioning of the individual features. This works well two-dimensionally.

The two-dimensional first step is to take a a blank piece of paper, and draw an oval freehand to represent a head. Drawing a well-balanced oval freehand may seem to be a difficult task, but if you try the following exercise you will be amazed at the ease with which it can be achieved.

EXERCISE: **DRAWING A FREEHAND OVAL**
Take two pencils or pens of equal size, hold one in each hand and position them with their tips touching at the top centre of the proposed oval. Now, simultaneously, with both hands, draw

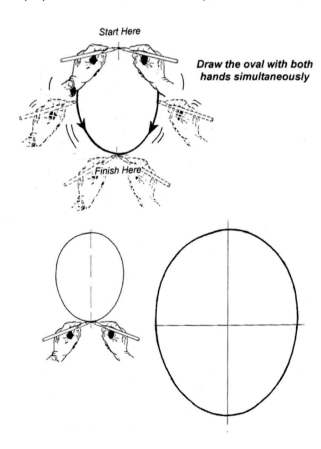

The blank canvas: creating a good oval freehand, adding the main gridlines to guide the positioning of features.

the oval. Try it, it does work! Finish at the bottom centre with both pencils or pens together. Admire your good oval. It works because the left hand (if you are right-handed) automatically follows the right.

EXERCISE: **POSITIONING THE FEATURES ON THE FACIAL PLANE**
Pass a line, dividing the oval from top to bottom, to represent the centre facial line from the middle of the forehead to the jaw. Fix a point halfway down the first line on the oval and draw in a horizontal line dividing the top and bottom into two equal halves. These are the first steps to creating a facial grid.

Using your mirror, continue with the exercises, constantly referring to the features of your own face, and particularly to the position of the eyes. In a portrait or a caricature, position of the eyes on the face is a matter of mathematical proportionality. With this grid in place, position the eyes on either side of the vertical line, above and below the horizontal line. Confirm the instruction by looking in your mirror.

EXERCISE: **PLACING THE EYE**
At this stage, very simply add two single curves, one above and one below the line either side of the line. The distance between these two eyes is approximately the width of one eye. Chapter 7 will expand on this simple approach.

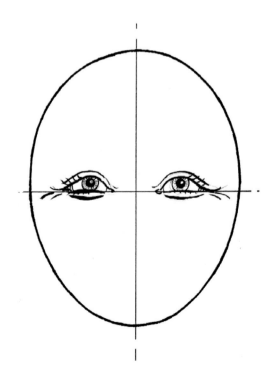

The oval showing the position of the eyes on the grid.

Getting the eyes in the correct position is critical. Without instruction, lay observers very often place the eyes too far up the head and far too wide apart. They get confused with the bottom of the hairline and the top of the head.

EXERCISE: **PLACING THE NOSE**

Now divide the lower section of the oval equally to achieve the position of the bottom of the nose. Further details about noses are covered in Chapter 8.

EXERCISE: **PLACING THE MOUTH**

Divide the lower section again, creating a line between the bottom of the nose and the bottom of the chin. The mouth is generally considered to lie centrally above and below this line.

However, I always slightly raise the mouth above the line because most artists, when drawing a face, even in portraiture, tend to lengthen the nose. Further details are covered in Chapter 9.

The eyebrows sit above the eyes.

The bottom of the ear lobe is roughly in line with the bottom of the nose and the upper section of the ear in line with the eyebrows.

Adding the hair completes the face.

If you have practised drawing the flat full-frontal face using the guidelines and measurements, you should by now feel reasonably comfortable that you know where things go. One final point: no two sides of the face are the same. Make sure you identify the points of difference, as these may well be areas that are worthy of highlighting in the caricature. Differences, apart from the obvious broken nose, may be very subtle.

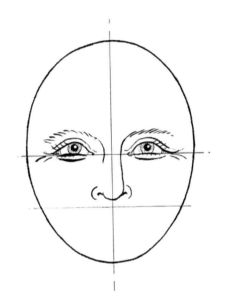

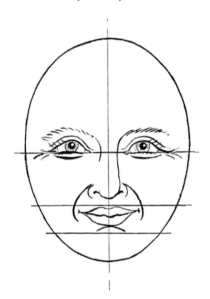

LEFT: The oval showing the position of the eyes and nose on the grid.

RIGHT: The oval showing the position of the eyes, nose and mouth on the grid.

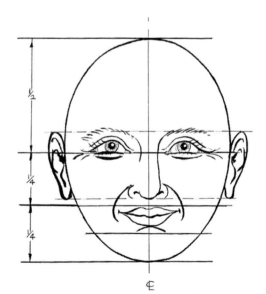

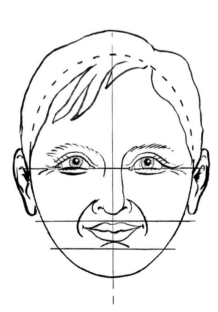

LEFT: The oval showing the position of all the features on the grid.

RIGHT: The oval showing the completed face with hair.

The Two-Dimensional View – Profile

EXERCISE: **ACHIEVING AN ACCURATE PROFILE BEFORE CARICATURING**

Draw a continuous line to represent the line over the brow, nose, mouth and chin to the neck, as you see it. Use light pencil because this line will only give you the basic shape of head from which to work. From this line, the drawn profile line, the caricature of profile will be developed (see Chapter 5). The accuracy of the profile line must be checked.

Using a ruler, draw on top of the drawn profile line a straight vertical line touching the tip of the nose. Ensure the line is truly vertical. This check line is a guide for the learner. An experienced caricaturist is more likely to eye up the line without having to draw it in.

Once the check line is in place, compare this check line with your subject's actual profile, using a pencil or straight edge. Hold the drawing in one hand at arm's length. In the other hand, hold a pencil in front of the right eye at arm's length. Align the pencil with the subject's actual profile line in front of the nose. Compare the line of the pencil against the profile with the check line in the drawing against the profile in the drawing.

If there is a difference, adjust your drawing of the profile line accordingly.

Follow the exercise to achieve an accurate profile check line. Note that the distance from the forehead to the chin roughly equals the distance from the bridge of the nose to the back of the head. The bottom of the ear is roughly in line with the starting point of the neck.

Eyes are simpler in profile. Concentrate on the curve of the upper lid, the curve of the lower lid and the curve of the eyeball. Make sure the lower lid does not protrude as far as the upper lid and that the eyelashes are very simple; they can be drawn in just a few lines. The eyelash detail is not seen from the profile as it is from the front. Women's eyelashes in profile are usually much longer than men's. The lower lash line is smaller than the upper lash line.

The lines around the eyes will be noticeable in profile. Lightly draw them in.

Below the nose the lips should be drawn in to show their curves. Watch the juxtaposition one to another. Which lip protrudes the most? Note that the upper lip in a man is often flatter.

EXERCISE: **PRACTISING FULL PROFILES**

Before moving on to caricature, practise drawing full profiles, including the forehead, eyes, eyelashes, nose, lips, ears, back of the head and hair.

Once the profile on the paper looks like the subject's, you can move on to extending, expanding and stretching any number of the features in the profile.

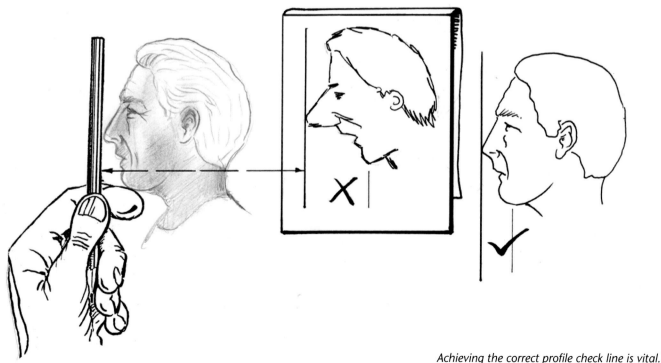

Achieving the correct profile check line is vital.

The Three-Dimensional View

Few drawings of heads are flat. Most caricatures show the subject from a three-quarter angle, as drawing the head from this angle gives more depth to the picture. The end result is more natural looking. It is important to move on from the two-dimensional view to the three-quarter view and, when appropriate, the profile.

The relevant distance between each facial feature on the facial plane and the facial plane and the back of the head is important.

EXERCISE: **LOOKING AT AND APPRECIATING THE THIRD DIMENSION**

Take your mirror and look carefully at the main areas on the face: the chin, the forehead, and the brow. Consider their relative position to the facial plane. It is important to understand how to create this three-dimensional view. This technique is based on a block rather than the oval.

EXERCISE: **CREATING THE BLOCK**

Draw several blocks on a page. Top and bottom should be a square, between an oblong. On one face of the oblong add in the grid (see page 50) to achieve the positions of the facial features along the facial plane. One you have the block grid, (see the illustration below), add in the features.

The height of the facial plane to the back of the head is roughly equal.

Mentally divide the side of the block – the longer section – into two, and continue the line at the bottom of the nose. The bottom of the ear is on that line; the top of the ear is in line with the eyebrows.

EXERCISE: **PRACTISING WITH BLOCKS AND OVALS**

Practise over and over again, using individual blocks and ovals, as a canvas upon which to draw the main features of a head.

With practice, using the principles underlying the two grids, even without prior artistic training, you should be able to draw both two- and three-dimensional representational pictures of a head. Once these basic proportions are firmly in your mind, you should have sufficient grounding to enable you to draw a caricature.

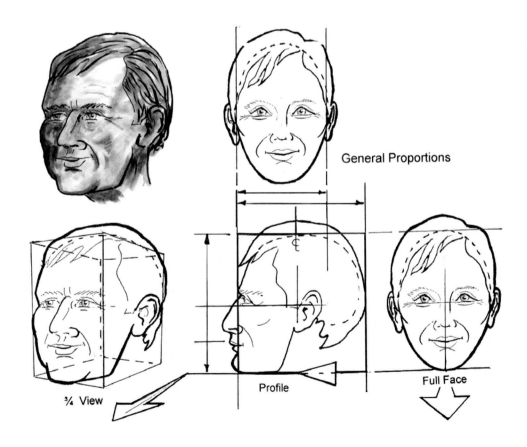

Compare the proportions of the block and the oval. Look at the full facial features on each plane: full-face, profile, three- quarter view.

General Proportions

¾ View

Profile

Full Face

FEATURES: CARICATURING FULL-FACE, PROFILE AND THREE-QUARTER VIEW

Even with a caricature in which you are grossly exaggerating one or two prominent features, the remaining features must be in some semblance of proportion in order to maintain a convincing likeness. When you exaggerate some features you may have to minimize others.

Most subjects tend to recognize themselves full-face. Once you move away from full-face you are making your life more difficult. A profile or three-quarter caricature is, however, much more satisfying and very likely to be recognized easily by others.

great in profile because of a large chin, big nose or Neanderthal forehead.

Once you have an accurate profile line (*see* Chapter 4), move on, being sure to adjust other features to keep the overall likeness. This is done by continuing to use the check line principle to ensure that your exaggeration is truthful. A more

Altering the shape of the face to accommodate the wide smile; when starting to draw the outline of the face, go out, not down.

Caricaturing Full-Face

From the full-frontal view, noses are not prominent. Targets that are more likely to be obvious are the eyes, possibly protruding ears, certainly the head above the level of the eyes, possibly the mouth and lower jaw. If you are looking at a person from the front you can exaggerate the general shape of the head. If the face has a beaming grin, the cheeks could be protruding far outside the outline.

There are many occasions when the big smile will be obvious both in profile and in full-face. A really big smile should be captured in full-face. The impact will be lost from the profile view unless of course huge lips accompany the smile, or another feature is more dominant. These choices are all part of the initial judgements.

Caricaturing Profile

Look at the side view carefully. Try to caricature profile only when profile warrants it: when the subject's shape of face looks

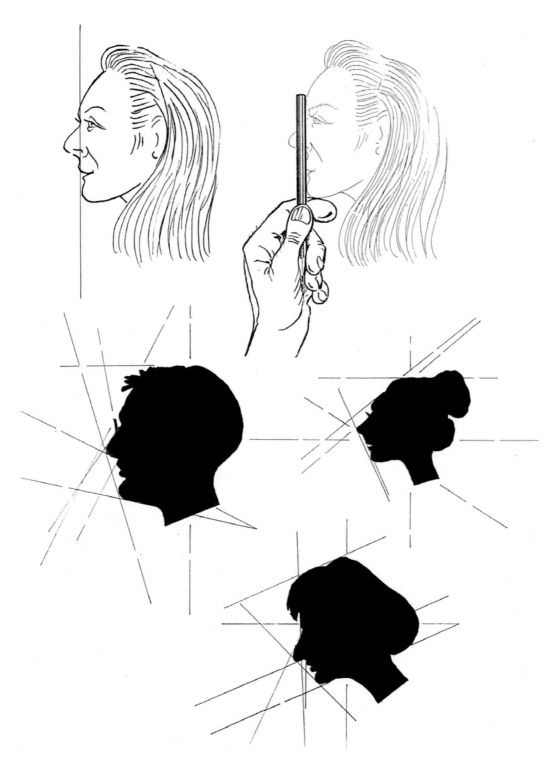

Several profile check lines may be needed to ensure the likeness is captured.

experienced caricaturist would go through these steps auto-matically without putting pen to paper, relying on eyeing up the lines.

Many students when drawing a caricature in profile have dif-ficulty in lining up the forehead and the chin. To get the full profile line correct, draw a line in pencil down the profile of the

forehead, continuing in an arch down the page. This will give you a rough idea of where the chin should be.

Be aware of the following points:

• do not attack every feature. Remember that some of the lines need to match and not everything can be caricatured;

- watch out in particular for the angle of the forehead;
- consider counterbalancing one feature to another;
- in the right circumstances, the profile could be the caricature;
- look closely at the angle from the tip of the nose to the chin to determine the position of the upper and lower lip.

Caricaturing the Three-Quarter View

The leap from two-dimensional caricaturing to three-dimensional caricaturing must be made early on in the development of a caricaturist. Life and energy, vital to successful caricaturing, stem from the depth that can be put into a three-quarter angled picture. This angle picks up features that cannot be seen in profile or in full face. A high percentage of faces are drawn from the three-quarter angle and the examples used throughout this book are mainly three-quarter caricatures.

There are a number of top tips to follow when drawing from this angle:

- the eyes, the angle of the bottom of the nose and the mouth are all leading features;
- the angle of the underside of the nose is a fixed angle, which must be true even in caricature;
- the eyeball is a round object; when it is viewed at this angle, part of the eyelid will vanish over the other side of the eye;
- the pupil of the eye should be in a position that shows that the eye is looking directly at the viewer, whether the face is to the viewer's left or right;
- do not forget the hint of a protruding ear on the far side with some three-quarter angles;
- hair going in different directions is clearer in a three-quarter view; it is very important it flows in the correct direction.

When you attempt the exercises in the following chapters, you should try full-face, profile and three-quarter views. That is to say, repeat each exercise for each angle. It is hard but it is a necessary evil if you wish to succeed. Genius is 99 per cent perspiration, 1 per cent inspiration, even if you have a natural talent!

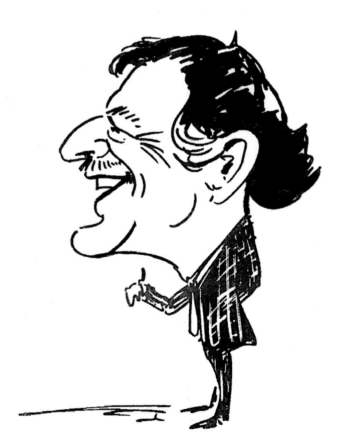

A larger-than-life character with a great profile.

A three-quarter view of Daniel Craig, the latest 007.

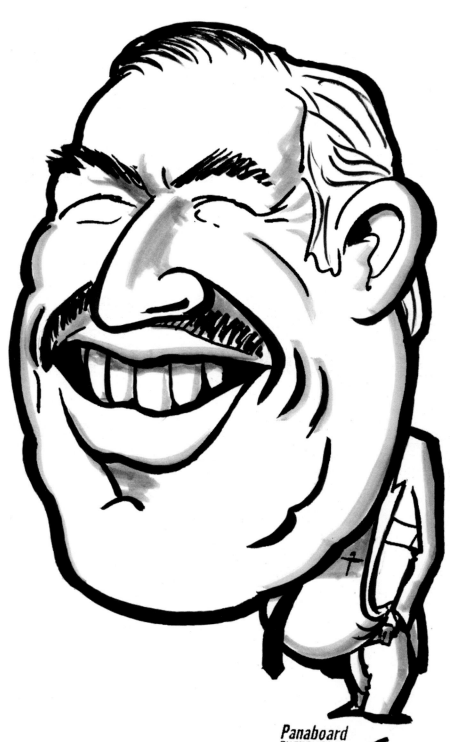

Panaboard
SKETCHES BY

FEATURES: CAPTURING AND CARICATURING KEY ASPECTS OF THE HEAD

The Head

There are many features of the head that could contribute to an individual's caricature. Each one of these, if a key feature, would need to be executed with a degree of accuracy to capture the final picture.

Always consider all the proportions of the head – its width and length and depth front to back – when producing a drawing. Heads are typically longer than they are wide, the length equalling one and three-quarters times the width. The depth, however, is typically equal to the length. Narrow heads can appear longer from the front and tend to protrude more at the back. What very often confuses the lay observer is the degree to which the hairstyle influences the shape.

The Underlying Skull

The skull, with its heights, ridges and depressions, also defines the head. Rarely does the skull rise and fall smoothly. There are undulations across the dome, and occasionally the top of the skull rises almost to a point before sloping backwards into the back of the neck.

The cheekbones are set back from the facial plane about one-third of the distance from the ear. The height and shape of the cheekbones, and whether the cheeks are full or hollow, are all important. This is only a minor aspect but one that can make or break the likeness.

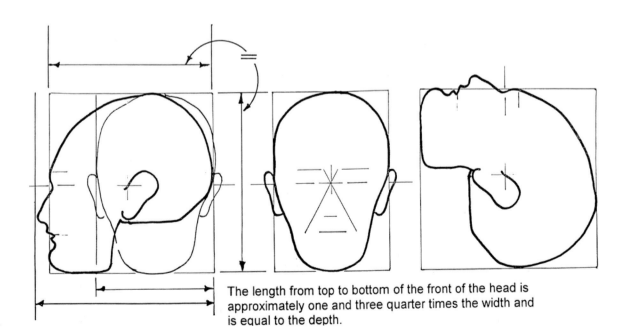

Understand the proportions of the whole head.

The length from top to bottom of the front of the head is approximately one and three quarter times the width and is equal to the depth.

Jawbone and Chin

Jawbones vary enormously and have a considerable impact on perceived character and personality. Because of the underlying bones, the proportions of the chin vary considerably. Some jut out considerably, while others recede. Often a receding chin is masked by facial hair. Jaws and chins are usually the last aspect of a caricature to be drawn in, in view of their position at the bottom of a head.

Brows and Foreheads

Typically, the plane of the forehead slopes upwards and very slightly backwards at an angle. The sides turn sharply to the plane of the temples. On others, the forehead is upright. The accuracy of this angle can be particularly important to get right if the head is to drawn viewed from the side.

When coupled with the brow, the forehead can significantly dominate a face. Heavily set brows bear down on the eye sockets and into the top of the bridge of the nose.

Caricaturing Features of the Head

When caricaturing the different features of the head, you need to switch on to the fact that the shapes of the head and forehead are great targets. Despite the actual proportions, gross exaggeration works well, but you should be aware that care must be taken not to imply inappropriately, through a distended shape, a particular mental condition or disability.

A significant forehead angle, coupled with thinning hair, lends Itself to exaggeration. Where heads arc shaven, give extra prominence to the features on the facial plane and the ears, diminishing the shaven head on the back plane. This lack of skull adds humour. Do not forget to add the shadow where the hair used to be.

With luck, a person with a very high, almost pointed skull will also have a good shock of thick, wiry hair piled up, even perched on the high dome. Take advantage of this shock of hair. Providing you can capture the line of hair correctly, consider exaggerating it to become the principal feature of the likeness.

The chin and the underlying jaw are obvious targets. Whatever the shape and size of a chin or jaw – large or small, degree of angle, round or pointed, bold, square, macho, weak, receding – there is something to play with. Start with the chin, as this guides you to the bottom of the jaw. A handy aspect of the chin is its position at the bottom of the drawing; it is never difficult to add a bit to the chin if you need to modify or extend it.

The chin has added aspects beyond its shape. It can be smooth, have noticeable features such as dimples and clefts, or recess under the lower lip. There is always the possibility of stubble and 'shadow' in the case of a man. Clefts and dimples are easily missed, especially if you are working at speed. Add them in as soon as you can to retain the likeness.

If the chin is a strong feature, check back on other aspects that you may not have emphasized as strongly as you could. Often, one really bold feature warrants the emphasis of a

Here the head is the main feature but an element of ridicule has been introduced.

Caricaturing thinning hair can exaggerate the forehead.

A shaven head looks funnier if the ears protrude beyond the outline of the back of the head.

The eyebrows, eyes, chin and jaw of this actor, the late Leslie Sands, were very distinctive.

The high pointed skull and shock of hair demand caricature.

Obvious counterbalancing is more common than you would think, very caricaturable, and usually appreciated by the subject.

counterbalancing feature, such as additional work on aspects of the ears or nose. A subject with a large square chin will rarely be offended by such counterbalancing.

Counterbalancing may not work with bearded subjects. Often, a beard conceals a weak chin and your subject may be very sensitive about this area (*see* Chapter 11 on hair).

Move on to the full jaw after the chin. Take care here, as it is a common mistake for caricaturists to give the subject a hefty jaw that they do not have. Do not be tempted to reproduce Desperate Dan. Link your exaggeration to the area around the neck. Jowls, wrinkles or a very full, fat face give you extra scope. Use softer lines and shading if you have time. Sharper, angular features are captured well with heavier definitive lines.

Finish off with the cheeks if they are noticeable. Lines showing the structure and shading can suffice.

EXERCISE: **STRENGTHENING YOUR SKILL LEVELS**

Cut ten photographs of men and women out of a newspaper or magazine. Study them carefully. Look closely at the head, underlying skull, chin, jaw, brow and forehead. These are the aspects on which to practise your ability to exaggerate. Use the medium you are most comfortable with. Only caricature the features/areas covered in this chapter, building on your skills and understanding of Chapters 4 and 5. Include other features, in a less prominent manner, but do not caricature them.

Draw each character on an A4 piece of paper, positioning the centre of the face approximately two-thirds up the paper.

Ask yourself the following questions:

* Is there a likeness? Does the picture resemble the photograph you are copying?
* If not, which are the features that are spoiling the likeness? Is it the features that you are exaggerating, or other features?
* Have you over-exaggerated to the point of losing the likeness?

Some caricaturists exaggerate or distort so much that little remains of the original features. Others frown on distortion as being untruthful. In the main, gross exaggeration and distortion are the province of professionals. The caricature itself has a message beyond caricaturing features. Those seeing the work associate the work with the subject, despite the absence of fully recognizable features.

EXERCISE: **BUILDING CONFIDENCE AND SPEED**

Select one of the simpler caricatures out of this book, any angle. Copy it in the right-hand corner of an A3 sheet of paper. Then time yourself and see how quickly you can repeatedly copy it and fill up the whole page. When finished note the time and, starting with a clean A3 sheet, do it all again, timing yourself. You will be amazed how fast the last ones will be. It is good practice and a lot of fun, and an excellent way to gain confidence and speed. Now try again, using a different angle.

FEATURES: CAPTURING AND CARICATURING EYES AND ASSOCIATED FEATURES

You cannot be reminded too many times that the eye will probably be the first thing that you draw when starting a caricature. You need to put a disproportionate amount of time into learning to draw eyes correctly and to observe their related features if you want to be a successful caricaturist. Try to draw eyes quickly and correctly, first time round.

This is a good place to attempt caricature at an early stage, as exaggeration and distortion of the actual eye is minimal compared with other aspects of the face (unless the subject has a particular expression that warrants it). Instead, take advantage of the features around the eye – eyebrows, wrinkles, sagging lids and skin beneath the eye – which may be ripe for exaggeration.

Always remember that the eyes themselves could be the most important part of your caricature where the element of exaggeration and distortion is significant. It is the eyes' position, shape and 'attitude' that can lead the observer straight back to the likeness and the very essence of the subject, so you need to get them right, straight off.

As far as the eyes are concerned, moving on to caricature is often about observation and dropping detail. The key is to learn by just how much.

Observing the Finer Points of the Eye

Before caricaturing eyes it is important to understand a little more about their different components and to learn what to look for. For their rough positioning on the horizontal line on the oval grid line and their approximate shape either side of the vertical line, *see* Chapter 4. Once positioned, the shape of the eyes is represented as curves above and below the vertical grid line. The space between the eyes is approximately equal to the width of an eye. The centre of the eyeball, the pupil, is on a level with the bridge of the nose.

There is much more to consider once this rough positioning and shaping has been achieved. The shapes are much more intricate. The differences between the eyes of different people can be very subtle indeed.

In noting detail, you need to look for the following:

- Are the eyes light or dark?
- How far apart are they?
- Are they protruding or sunken into the eye socket?
- Are they bright or heavy?
- How great is the angle to the horizontal; which way do they angle?
- Does the subject have a cast or a squint?

At the inner corner of the eye, where the top and bottom eyelids meet, is the position of the tear duct. There is no sharp join at this point. Look how the line of the upper eyelid sweeps across the eyeball down to this point. As it curves in towards the lower lid, it sweeps around the entrance to the tear duct, which appears to be enveloped by soft tissue folds.

The upper eyelid is like a small retractable roof, which concertinas back when the eye is open. In its open position, an edge can be seen, indicating that the eyelid has an element of thickness.

The retina and pupil are spheres in the middle of the eye. How much of the retina and pupil is seen depends upon the degree to which the lid or muscles around the eye cover the eyeball, retina or pupil. They only look like spheres when a subject is wide-eyed in shock, panic or delight. Look closely at the way in which the upper lid follows the contours of the eyeball. The eyeball is tucked under the upper lid and the shape of the eyeball that can be seen, to a greater or lesser extent, depending on the subject, is within this upper lid.

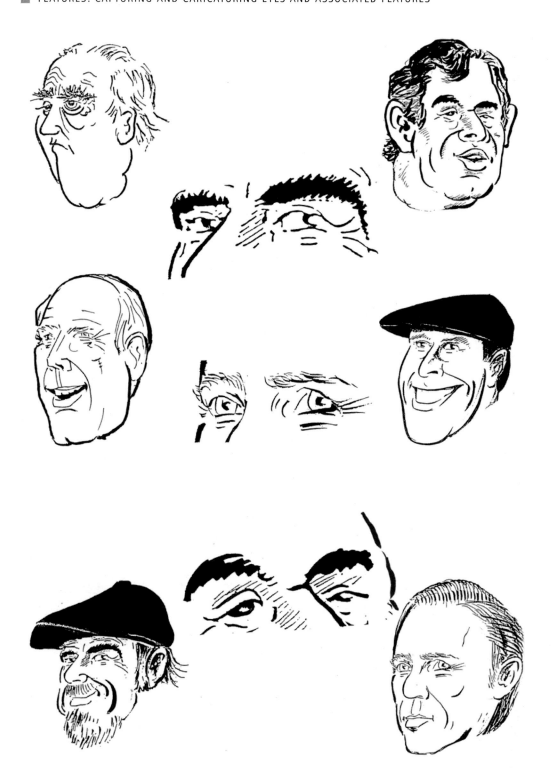

Three sets of eyes – can you spot the subtle differences and match them up to the individuals?

In addition, the visibility of the eyeball, retina or pupil dramatically changes depending on the mood, character and personality of a subject. Age is another consideration, as the muscles slacken with age.

There are two eyes; are they both the same?

Caricaturing Eyes Full-Face

Eyes are drawn in caricature as quickly and as simply as possible, to capture likeness with the minimum number of strokes. Exaggeration and distortion are minimal with a basic

eye compared with other aspects of the face, unless the subject has a particular expression that warrants it. You may wish to play around, however, with the amount of visible eye, the direction of vision, the degree of lightness or darkness, and the softness or hardness of the retina and pupil.

It is possible to break down caricaturing the eye into individual stages:

1. the upper eyelid, from centre outwards;
2. the sides of the retina with a hint of eyeball, including highlights;
3. the bottom eyelid – one or two lines;
4. the inner corner tissues, the tear duct;
5. the eyebrow, the lines under the lower lid;
6. crease lines at the outer edge of eye;
7. eyelashes.

The Upper Eyelid

Providing it is clearly visible, start with the innermost part of the upper eyelid. Draw the shape that you actually see, picking up on the angle of the eye to the horizontal. Reflect its position with a quick line from the centre tear duct area in a strong outward curve. Try and avoid straight lines unless they are there. This particular line of eye is a distinguishing shape, which is different for most people. It is the most important line of the eye relative to its immediate likeness and character. This line, in particular, is not one to exaggerate. Heavy skin folds can obliterate. Find a line close by – a line of the falling skin – to follow.

The Eyeball

Move on to the eyeball, remembering the way in which the upper lid follows its contours. Just a line in the far corner of either side will imply its position. Draw in the curved sides of the retina. Leave the bottom and top of the retina loose. The full retina is not drawn, as the artist cannot see it. The upper lid covers the top of the retina. The lower lid covers the bottom of the retina. Laughter, sadness or other moods and physical influences can all affect the degree to which the retina is seen.

Ignore the pupil at this stage.

Most portraits or caricatures correctly reflect the degree to which eyelids cover the eyeball; only part of the eyeball, the retina and the pupil, is visible. Be careful, as it can take a while for students to catch on to this. Many add in the second curve of the eye then proceed to draw in a large circular retina with a smaller round black pupil in the centre between the two curves.

They represent the retina as a complete circle not touching the upper or lower lid. The position of the eyeball is implied. Avoid this trap, as it represents a big mistake that looks wrong. Look in the mirror to check for yourself.

Now draw in the line of the bottom lid as you see it, with one or two lines.

Colour

There are light eyes and dark eyes. Any retina colour lighter than a medium is represented as white by merely outlining the retina and omitting the pupil. Where the retina colour is darker than medium it can be shown as just black, leaving a white highlight. A quick method to colour the retina and add the highlight is to fill in the retina except for a U-shaped section on its side to the right-hand side. This neat trick ensures that, when the retina colour is added, a reflection is automatically created. It avoids the highlight being overlooked. Both eyes will have the same highlight section in exactly the same place, as the light is coming from the same source. Even at this early stage of the drawing, adding a reflection highlight ensures that the eye has life and sparkle, inspiring the artist to perfect the other complementary features.

Leaving the light-coloured eye white at this stage allows the addition of grey tone to achieve the appropriate shade of colour when the drawing is finished off. It also helps to create the character of the eye.

The pupil is added only to lighter eyes. It is not seen on darker eyes, as there is no contrast with the retina. The pupil size often depends on the subject's actual mood and character. Pupils are drawn very small when a piercing effect is required or slightly larger, particularly if the subject is a woman, for a softer appearance.

If time permits, emphasize the tissue in the inner corner of the eye. Just a dot should do it.

Adding the Second Eye and Finishing the Eye Area

Now you have completed one eye. In full face add the second eye at this point, concentrating on the space between the eyes, which should be equal to the dimensions of each eye. In the profile or three-quarter angle, where noses are more prominent, add the second eye after the nose.

The eye features that have been caricatured mildly to this point can now be heavily augmented by an assortment of lines, at the edges and under the eye. The lids and folds of skin above and below can almost obliterate the eyes or add tremendous interest. Sagging skin can emphasize the open or semi-closed

Subtle changes in the shape of the eye are vitally important in reflecting mood.

attitude. The eyebrows and eyelashes are a given. Lines can be left out to soften the picture. Shadow can be used to highlight protruding or sunken eyes.

If you have captured the basic eye well, exaggerating and distorting in this way will not adversely affect the likeness. The amount of extra detail you add will depend upon the brief and the time available, but a minimum amount of extra detail to retain the likeness is a must.

EXERCISE: **USING THE MIRROR**

In the mirror play around with all sorts of expressions – surprise, puzzlement, laughter, anger – and note how the eyelid and muscles completely change. Note the impact on the eyeball and its component parts and how those changes reflect mood and personality.

Compare the expressions in the mirror with those below. The same effect is achieved but many fewer lines are used. Aim for this economy of line.

Remember: a lightning caricature requires a whole likeness to be captured in thirty seconds. The approach must become intuitive. As soon as pen hits paper and the first lines of the eye are being introduced, onlookers should be commenting on the accuracy of the likeness.

Caricaturing Eyes Three-Quarter View

The eyeball is a round object set in a socket, so, when it is viewed at an angle, part of the eyelid will vanish over the other side of the eye. Adjusting for this angle will give the picture depth and shape to the eye. It will help the sketch come alive. Again, this is not an angle to be exaggerated.

When adding the retina, remember that only part of the eyeball, retina and pupil is visible.

In the natural three-quarter view, the pupil of the eye should be in a position that shows that the eye is looking directly at the viewer, although the face can be looking either to the viewer's left or right. This positioning of the eye brings life to your drawing. If both eyes are aligned correctly, the eyes should follow the viewer whether they walk backwards or forwards past the picture. Achieving this positioning is greatly satisfying for any artist.

One of the most noticeable feature differences at this angle, compared with full-face, is the element of thickness on the upper and lower edge of the lids. In the three-quarter view, these thicknesses are more prominent. Draw a significant curve up and over to represent the underside of the upper lid. Show the thickness by drawing in a second line just below the first line. To capture this thickness start the first line from the inner corner of the eye. These two lines join at the top of the upper lid. They show the underside of the upper lid at the point nearest to the nose.

The lower lid also has its part to play. To represent the lower lid, draw a couple of horizontal lines to show its thickness.

At the back of the upper eyelid, where the eyelid meets the eye socket, the skin creases. These creases from three-quarter angle can be particularly prominent. With age, muscles weaken and eyelids droop, falling heavily over the eyes. In the case of older people, the many folds of skin from above can obscure the clean line of the eye socket. To draw in the creases, add one or several lines running parallel to the first line of the upper lid, and embellish where the skin droops and sags.

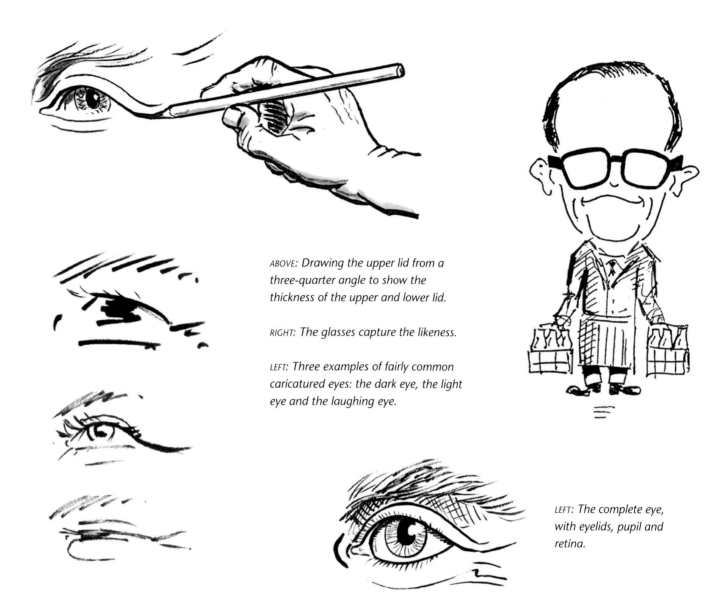

ABOVE: *Drawing the upper lid from a three-quarter angle to show the thickness of the upper and lower lid.*

RIGHT: *The glasses capture the likeness.*

LEFT: *Three examples of fairly common caricaturable eyes: the dark eye, the light eye and the laughing eye.*

LEFT: *The complete eye, with eyelids, pupil and retina.*

Sunken or protruding eyes and the shape of the eyeball are much more noticeable from this angle and in profile, as are eyelashes. Sagging lids and folds beneath the eye are prominent. Again, these additional features are those you are the most likely to exaggerate and embellish. They will enhance the caricature but not detract from the likeness.

Glasses can be a major caricaturable feature; for more on glasses and other props, *see* page 121.

Caricaturing Eyes in Profile

In profile, a few additional aspects need consideration, while others are less significant. The degree to which the upper lid stands slightly proud of the lower lid is more noticeable. The degree to which the eyeball is sunken into the socket is significant. Eyelashes are very visible, as are the number of skin folds and amount of skin on the upper lid.

EXERCISE: **BUILDING UP THE EYE, FULL-FACE, THREE-QUARTER VIEW AND IN PROFILE**

Start by practising to draw dark eyes, with the retina and pupil as one dark spherical blob with a white highlight to the right-hand side just breaking up the edge of the circle. It is easier and quicker. Dark eyes are easier to draw than light eyes because of their simplicity.

Where the eye is a laughing eye and partially closed, it is easier to add dark lines to indicate the retina and pupil with one stroke of the pen. This highlight not only adds sparkle and life to the drawing of the eye but also directs the line of vision from

the eye to the viewer. The technique works well in caricature art. The subject in the picture will appear to be looking at the viewer, even if the body is at an angle.

Fill an A3 sheet with eyes, copying pictures in the chapter. Try the dark eye method and the medium to pale eye method, and note the difference in speed. Practise drawing eyes where the eyeball looks in different directions as well as looking forwards. Finally, try adding in the other parts of the eye, both lids and their creases, approaching the eye full-face, three-quarter and in profile.

Try a degree of caricaturing, concentrating on the additional features, remembering to work only on those aspects mentioned. Tread carefully here.

Caricaturing Eyelashes

Once you have successfully captured the eyes and the spacing between the eyes, it is time to approach the eyelashes. These are often forgotten, yet they are important to add character, life and reality.

Eyelashes are on the front of the upper and lower lid. The eyelashes on a man are not quite as prominent as on a woman. Women use make-up, mascara in particular, to make a greater impact. Brushed lashes are a personal invitation to enhance, exaggerate and create an expression that would not naturally be a feature. The mascara sweeps the eyelashes upwards where they would more naturally angle downwards. You can exaggerate the curl to the maximum, within the boundary of complementing the picture.

Do not forget the lashes on the second eye, especially in three-quarter or profile position. Note that lashes are not always the same on both eyes.

EXERCISE: **CONCENTRATING ON THE EYELASHES**
Repeat the last exercise capturing the full eye, concentrating in particular on the eyelashes.

Caricaturing Eyebrows

Eyebrows are carried at the top edge of the eye socket. They start in line with the eye and extend to the edge of this socket. Almost everybody has eyebrows, and they tend to be light and delicate on the young, and then become stronger and bushier with age, particularly in men. Individual hairs tend to be much longer and rather wispy. There can be a definite and significant

gender difference in the shape, prominence and texture of eyebrows, which is accentuated by age. When drawing people with dark or black skin, notice that in some cases the eyebrows are less prominent on the black skin. Indeed, they are sometimes difficult to see at all.

When drawing a full-face caricature, it is important to ensure that the distance between the eyebrows is correctly represented. The width of this space is usually in proportion to the bridge of the nose. For most people there is a gap between the eyebrows across the bridge of the nose but, in some individuals, usually dark-haired, the eyebrows meet in the middle in a distinctive way. This would be a key feature for achieving a likeness. Often, Asian people with olive skin have quite heavy eyebrows, which are dark in colour and join in the middle.

As eyebrows follow the natural upper curve of the eye socket, their shape in most cases is also curved, but this is not always the case. There are people whose eyebrows are horizontal, while others rise at a slight angle for about two-thirds of the length then fall to the outer edges. In men, this point at which the eyebrow falls is where any bushiness occurs.

Eyebrows are delicate features. Getting them wrong, which is easy to do, could spoil the likeness completely. Tread carefully. Though the temptation can be quite strong, hold back on excessive exaggeration until you are very confident and more skilled.

There are many 'eyebrow' aspects that facilitate caricature:

- the degree of bushiness obscuring the eye;
- distinctive brows meeting in the middle – a key feature for achieving a likeness;
- the painted female line; depending on the brief;
- the position of the eyelid relative to the eyebrows;
- bulging eyes that cause eyelids to be curved or raised; and extra lines.

When caricaturing eyebrows in women one simple curved up-and-over stroke, repeated on both sides, will deliver the required effect perfectly.

Although eyebrows on women can be a very attractive feature they are often significantly reduced. In fact, some women reduce their eyebrows so significantly that they have to be 'painted' back in as part of the make-up routine.

The skin beneath the eyebrow moves, thus altering the position of the eyebrows. Especially when caricaturing live it is important to observe how it moves, and the effect on the eyebrows as it moves is particularly important. They rise and fall, arch and angle, and these movements are also mood indicators.

Finally, note the colour and texture of the subject's eyebrows. Eyebrow hair, like other facial hair, is known as secondary hair. It is different to the primary hair on a subject's head, usually

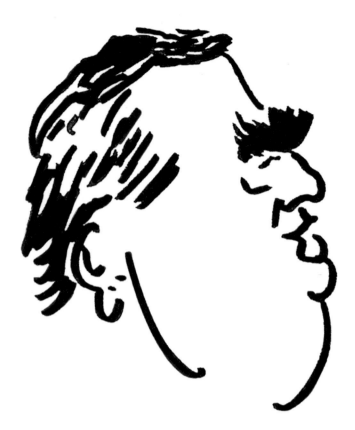

ABOVE: Eyebrows take off! (Denis Healy MP).

RIGHT: Emphasizing the difference in colour tones that can be achieved in a line drawing by varying line thickness.

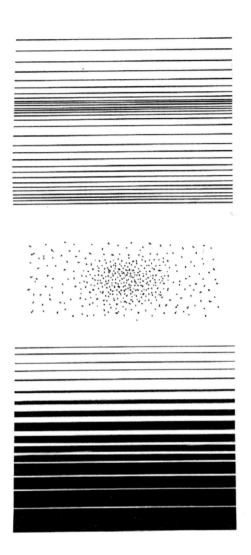

much coarser and stronger. Capture this with coarser, thicker strokes.

Occasionally, the eyebrow colour does not match the colour of the hair on the head. Consider making a play for this interesting feature, emphasizing the difference. Colour differences between the hair and the eyebrows can be indicated by shading or hatching. Use very fine pencil or pen and ink strokes, varying the thickness of each stroke, to achieve this.

EXERCISE: **TECHNIQUES TO STRENGTHEN THE SKILL LEVEL**

Start by copying the example illustrations in this chapter, which includes the section on the basic caricaturing steps. You should be able to reproduce them easily. This exercise will improve or confirm your basic ability to draw an eye.

Using one drawn eye as a reference base, on an A3 sheet copy the reference eye many times, exaggerating one element at a time: the lids, the size of the retina and pupil, the size of the eye itself, eyelashes, eyebrows. This will teach you those features you can change without losing likeness and those which, if changed, risk destroying likeness. It also reinforces the importance of the eyes in achieving a likeness.

EXERCISE: **BUILDING CONFIDENCE AND SPEED**

Copy eyes, as many as you can and as quickly as you can. Use paintings, friends and family and cuttings of personalities in magazines.

Once you feel you are making progress, draw the eyes of well-known people on an A3 sheet. Ask relatives or friends to try to identify them. This exercise is not only confidence-building but again confirms the impact a good drawing of an eye has on getting the likeness.

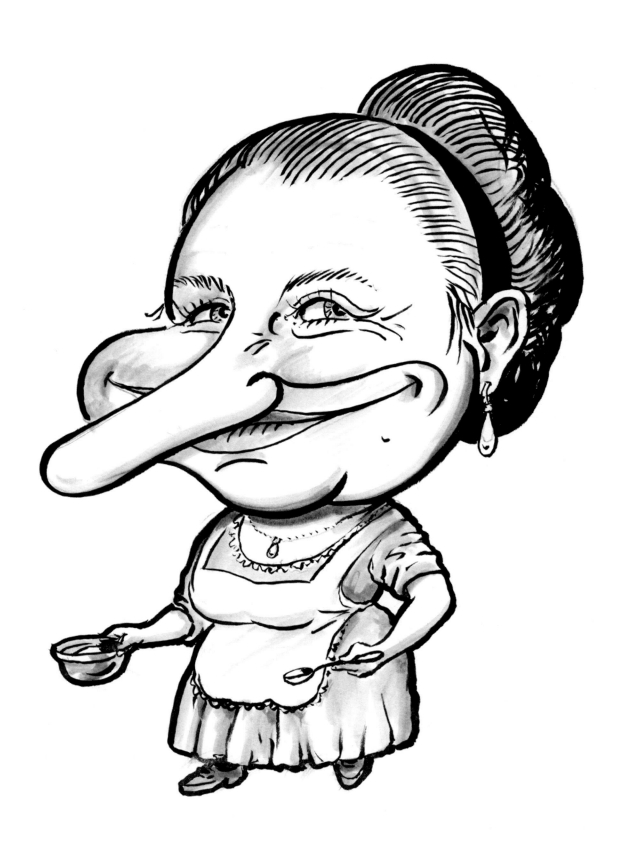

FEATURES: CAPTURING AND CARICATURING THE NOSE AND ASSOCIATED FEATURES

In every corner of the globe, there is a huge variety of noses that have evolved over millions of years. The result of this degree of evolution and diversity, visible on the facial plane, the three-quarter angle and the profile, delights a caricaturist.

It is generally assumed that a caricaturist will always emphasize the nose. Large exaggerated noses are the essence of caricature in the minds of the public. This perception is almost accurate. The sight of a particularly large, unusually shaped or hairy 'hooter' so often sets the pen or pencil scribbling. A nose is often the key to achieving a likeness.

At other times, the nose is the caricature! The profile line comes from the back of the head, over the forehead, down the slope of the nose in one long continuous curve. The subject's whole head is nose; their face appears to be almost streamlined by this feature. Such features are more common in certain parts of the world, and are identifiable traits of some European and Pan Continental tribes. They offer a marvellous opportunity to a caricaturist. Where the picture is the nose, you can add one eye or both eyes, depending on the nose mass, to capture the likeness, but make them much smaller. The ears are moved back slightly just behind the face to accentuate the profile.

Some of the caricatures overleaf show, in profile, that there are primarily three nose shapes: straight, concave and convex. Variations on the three themes arise genetically or through some life event. Since noses are so prominent, accidents tend to happen to them frequently.

All noses vary considerably in length and size. Some are quite short; others slope away in long, graceful lines; some almost touch the upper lip; others appear to merge into the brow and forehead.

Caricaturists often make the fundamental error of ignoring the angle of the nose. The angle of the average nose is about 10 to 20 degrees from the perpendicular.

With a straight or Roman nose the length and extreme angle dominate. Concave noses are classic, turned-up, 'button' noses, which range from the extremely angular and pointed to the chubby and bulbous. By far the most common nose shape is convex. As the skin falls over the bridge, the angle of the wedge-shaped cartilage base, relative to that of the bridge, creates the convex shape.

These variations accentuate or exaggerate the nose before a caricaturist has even begun to draw.

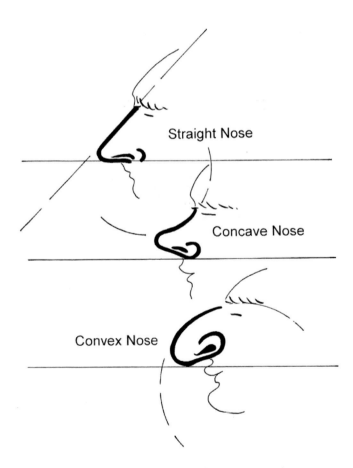

The three prime shapes of noses: straight, concave and convex.

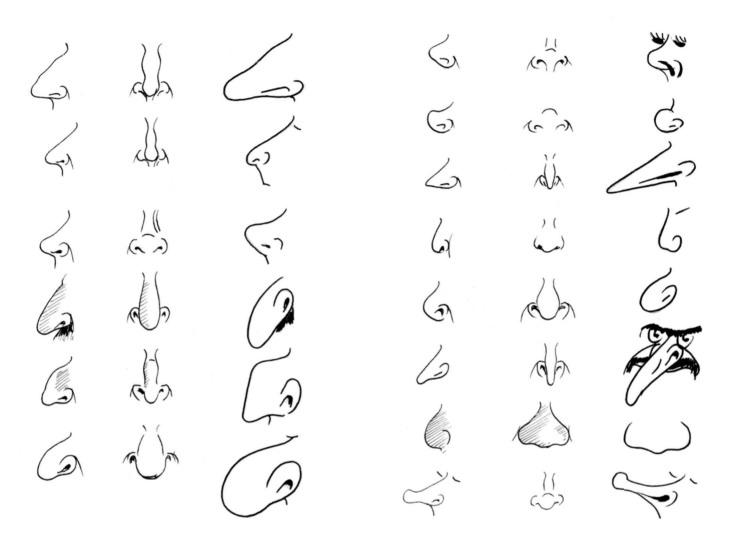

The global variation in noses: illustrated profile, illustrated full-face, caricatured profiles.

Observing Noses

In the oval grid (*see* page 50), the eyes sit just above and below the horizontal line across the oval representation of the head. The second horizontal grid line, which cuts the lower half of the oval, sets the reference point for the bottom part of the nose. The tip of the nose is placed either on or just above that second line. In a stylistic face – a very balanced, featureless face – the width of the nose will occupy the space between the eyes.

A nose is made up of wedges of cartilage attached to the bony bridge where it meets the skull. While all noses are made of these same components, their shape varies according to both the amount of and the shapes of these cartilage sections. The softer nature of cartilage, compared with bone, allows it more easily to alter its shape, creating a variety of expressions, depending on the movement of adjoining muscles under the skin.

From the front, children's noses are usually straight. In the majority of adults, noses veer slightly to the left or the right. It is important to note this small detail. Exaggerate this deviation carefully to avoid distorting the likeness. Distortion has its limits.

Quick sketching is facilitated if the structure of the nose is considered in terms of three components: the stronger cartilage bridge at the top, attached to the skull; the fleshier, fatty bulbous section at the bottom; and the fleshy sections around the nostrils on either side of the nose. These three sections vary considerably from person to person.

The Bottom of the Nose

Whatever the shape of the nose, to some degree it will have both a bulbous end and sides supported by fleshy cartilage. The bulbous section can be wide or narrow, with rounded or flattish sides. The pieces on either side of the nose are either indistinct or rather lumpy. A narrow, flat-sided nose can often appear pointed. Occasionally the bulbous end has a pronounced indent. The cartilage and skin linking the nose to the top of the upper lip has its own shape. In some subjects this linkage is prominent. It may curve downwards or appear much flatter. It is most important that the depth of the space between the bottom of the nose and the upper lip is accurate and that the prominence of the two feature lines, beneath the nose, is noted.

Nostrils

Not all nostrils are visible, but the majority are. Do not overlook them, and note especially their size. They may be long, short, round, oval or flared. Pointed narrower noses often have nostrils that are angled and appear higher at the sides than at the tip of the nose. Nostrils can rise with laughter, flare in anger or indignation, wrinkle the skin on the nose itself; in fact, they can change and enhance character and personality on different occasions.

Adding in the fleshy sides and nostrils to a picture can significantly enhance it.

Facial Lines

Most adults have facial lines running from the area just behind the nostrils to each side of the mouth. They are often called expression lines and represent the underlying muscle structure. One theory is that an infant's mimicry of its parent's expressions, and particularly those of the mother, shapes the underlying muscles defining the facial lines. The lines can be stronger in men than women, and make-up can mask these lines to a degree in women. The lines are much shorter where the face is fuller, and deeper and longer on a narrower face.

Nose Decoration

Nose decorations range from simple rings and studs to jewels. Note the glinting highlights. Do not leave them out unless you

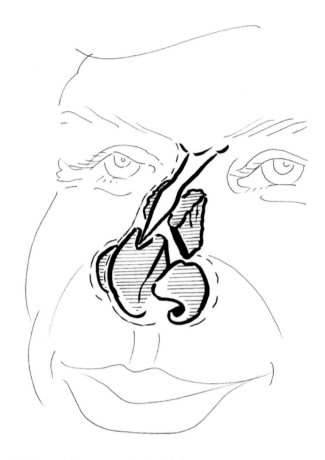

Sections of the nose on the facial plane.

Nostrils: types and in caricature.

are asked to. Some subjects may prefer to remove them before you start.

Caricaturing Noses

It is important to recognize the shape – straight, concave or convex – of the nose very quickly. Capture the whole nose, and avoid the mistake of caricaturing prominent features while omitting the base of the nose where there is a lot of interesting detail.

Caricaturing Full-Face

A full-face drawing picks up much less than a three-quarter view or profile drawing. It is for this reason that the three-quarter view is the preferred view.

Carrying on from the steps used to caricature the first eye (*see* page 65), continue by caricaturing the nose before adding the second eye. The steps are as follows:

1. The contour of the nose.
2. Twin vertical lines and the interest above the bridge of the nose, if apparent.
3. Lines at the side of nose

There are few opportunities on a full-face drawing to exaggerate and distort.

With a convex or straight nose there is scope to elongate and/or stretch the original shape; from the front, it is not difficult to draw the mouth behind the nose. The width of the nostrils will be visible, providing the nose is not too elongated. On a concave nose the nostrils are always more visible.

The bony area around the bridge of the nose dramatically changes with mood and over time becomes lined by expressions of personality. The older subject may have many lines or naturally create furrows and creases. Exaggerate the pinched area with two or three lines, adding shading if you have time. Note how this area can be wider, flatter and almost triangular. Make something of this triangle and its relative position to the triangle of the nose itself.

Blemishes stand out, caricature them with shading just to suggest them.

Only exaggerate and emphasize the nose if the subject really does have a large or unusual nose. There is no point in picking on a small nose, as it will cause the likeness to be at risk. Subjects with small noses can still be caricatured, but the only way you can do this is by making the nose even smaller. Exaggerate all the other features then draw in the

A small nose can be caricatured in a humorous manner by introducing a mere hint of the feature.

small nose. This will emphasize the other features that are exaggerated.

The bulbous, concave, retroussé nose, full-face, is represented by two-thirds of a circle, leaving a gap at the bottom. This is added quickly and simply. The nostrils are then added to the sides. The bulbous, convex nose is a circle with a gap at the top. Flowing circles, which are later shaded, increase the volume of the bulb. Straight noses tend to be more angular but, like the bulbous versions, may have a cleft at the end.

Caricaturing in Profile or at Three-Quarter Angle

The nose is much better caricatured in profile or at the three-quarter angle. Much of the likeness is gained by using the nose in profile. If you are drawing in profile consider extreme

exaggeration, providing you are comfortable that the subject can rise to the humour, and malice or satire is your objective.

Key features to exaggerate are the shape, the visible nostril and the fleshy area around the nostril, particularly the line where the cartilage meets the face. If you are tempted to exaggerate this line, it is most likely to warrant a soft curve around the nostril. On some faces, with sharp pointed noses, this line is angular to the nostril. It is an aggressive line, so you need to be careful how you add it. Sharpening this line can distort the subject's mood.

In direct contrast to the wide and curved prominent profiles are the flat, wide noses of some African and Asian peoples. Exaggerate these noses in a different way. Instead of drawing the nose out, expand it across the face. With this particular type of nose the nostrils will be less noticeable. The nose looks smoother and can be drawn on with one curved stroke.

Where the objective of the caricature is witty commentary or humorous exaggeration, tackling a nose that warrants a more significant comment, when the subject lacks a sense of humour or is too easily offended, requires lateral thinking. The instinct of an experienced caricaturist advises caution and compromise.

There are three routes to achieve a compromise:

1. Going back to the full-frontal approach, which will reveal less than a profile, is a technique that always works. Draw the caricatured shape of the nose all the way from the top of the bridge down to the nostrils. Use one continuous stroke if possible. Once the nose line is finished, emphasize the lines that define the nostrils. This limiting approach forces the caricaturist to hold back, even though he knows that highlighting the profile or three-quarter angle would achieve a far better caricature. This is where the caricaturist's strategic skills come into play. Sometimes it is a matter of producing a good caricature that is *appropriate* for the remit and the subject, not simply producing a good caricature.
2. Counterbalancing a prominent feature in profile with a second feature in profile can reduce the risk of offence. This approach eliminates the need to hold back on the former. Emphasize that large bulbous nose in the drawing then counterbalance it with a wide mouth and its big smile, or a pronounced chin, to 'soften the blow.'
3. Leave out the nose. This works but could risk reducing the likeness. Sometimes, people ask to be drawn, then add 'but not my nose'. Caricaturing a person without a nose is not an impossibility. The other features help. A caricature can look like the person, even without the nose, if other features are right: the fewer the features, the better. Hopefully, at the point of completion the subject will have gained enough confidence to agree to the nose being added as the last step. This is a technique used to ease a subject into the extent of the caricature of the nose.

Sometimes strong features allow you to caricature a person without drawing in the nose; this is TV presenter Anneka Rice.

A subject with a strong profile may well challenge you with the comment, 'I know you'll go for the nose.' This sort of statement gives the green light to the caricaturist. If the comment is made after seeing the drawing – 'I thought you might have gone for the nose' or 'I was sure you were going to make more of my nose' – be brave enough to amend your first sketch.

With certain wide noses it is possible that you will see the fleshy area around the nostril on the far side of the nose when drawing a three-quarter view. Look for it.

Other Aspects

Let nothing be barred – hairy nostrils, lumps, bumps or ruddy colour – if the subject warrants it.

The issue of hairy nostrils is a minefield. Generally, subjects dislike reference to body hair. However, if it is a strong feature it has to be captured, depending on the brief and the sensibility of the subject.

The colour of the nose has its place. Even the most regular, balanced nose may be rather red. Use shading or watercolour wash to get that extra tone and colour into the picture. Make the nose look deeper than the rest of the face. Make colour the exaggerated feature.

Always, whatever angle you draw it from, pay heed to the shadows cast by the nose.

Style and the Psychology of the Artist

Never lose sight of your ultimate audience and the type of caricature you are aiming to produce. Whatever they say, your subject may well be sensitive, and women are often more sensitive than men.

Accept from the beginning that you are probably going to offend, but it is important to understand how far you can go and the value of sticking to the limit or going beyond. Your Aunt Dorothy may never speak to you again, or marital tranquillity may be undermined, but fame and fortune could be yours if your subject is the local politician or that starlet Miss Perfect.

At this point your sporting instincts should come into play. Sporting experiences tend to be better when they involve players of equal stature. Your skills and ability to emphasize, exaggerate and distort will be appreciated more if you pick on a target your 'own size'. Destroying confidence in a fragile, private person will bring little satisfaction, while undermining pomposity, attitude and arrogance, and exposing hypocrisy and sham will do.

Proceed with due caution. Most people are well aware of their features and quite like to see some emphasis on their differences, but you should always be aware of potential repercussions from a caricature.

It is important to judge how far you can go before you tackle a caricature – especially where noses are concerned.

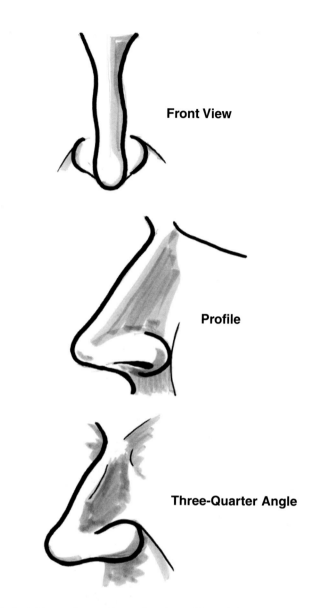

Front View

Profile

Three-Quarter Angle

A straight nose from a front view, in profile and three-quarter view.

EXERCISE: EXTENDING DIFFERENT-SHAPED NOSES
Practise drawing noses using the example illustrations in this chapter. The section on basic drawing should improve or confirm your basic ability to draw a nose.

Down the side of one A3 page, draw three types of noses, in profile and full face, from your imagination: one straight, one concave and one convex. These create a reference starting point. Move across the A3 page, building up the degree of exaggeration, concentrating initially on the main aspects of shape and size. Use examples below as a guide only.

Straight noses are not so easy to exaggerate, but you can lengthen a straight nose to emphasize its straightness.

Concave, turned-up noses lend themselves to caricature. Concentrate on achieving the quick, downward, curved stroke, like a ski slope, from bridge to tip, then exaggerate the angle as the line turns towards the upper lip. This gives the appearance of the turned-up nose.

Caricaturing the convex nose can be likened to drawing a circle. It happens quickly, as the curve is a natural curve.

EXERCISE: CARICATURING NOSES WITH ADDED DETAIL
Once you have mastered the size and shape of noses, move on to add other features. Produce the reference noses again on an

A3 sheet, then reproduce lines of noses alongside them, each nose caricaturing a different feature: the nostrils, the fleshy ends or sides, indents, facial lines, distorted bridges. When you move away from the normal proportions of the face, making the nose several times greater than its original size, you may need to move on to additional sheets. Take care to retain likeness as size is increased.

EXERCISE: **TAKING NOSES ONE STEP FURTHER**

Move on to real noses. Cut ten photographs, male or female, out of a newspaper or magazine and practise caricaturing them. Chose full-face, profile and three-quarter aspects. Beware of friends and family – except for eye study, the more familiar you are with a person, the harder it seems to be to draw their

features. Try the television if you are feeling confident, remembering that faces and features on television are often slightly lengthened or widened.

EXERCISE: **BUILDING CONFIDENCE AND SPEED**

Move on to copying as many noses as you can, as quickly as you can, again using paintings and cuttings of personalities in newspapers and magazines. When you feel you are making progress, repeat the exercise, speedily drawing the noses and eyebrows of well-known people on an A3 sheet. Ask relatives or friends to try to identify them.

All this practice will help you enormously when you are faced with a subject in life, aiding speedy recognition, which is vital to quick sketching.

ABOVE: The concave nose in caricature from three-quarter angle.

RIGHT: A convex nose caricatured in profile.

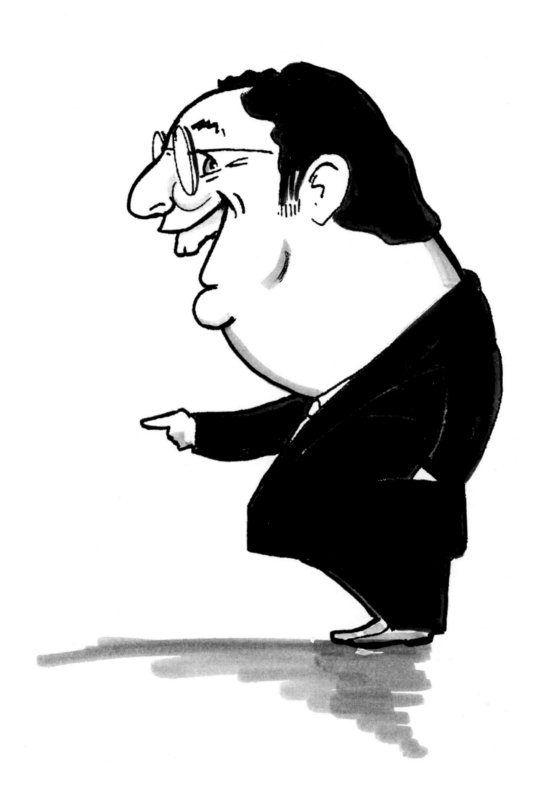

FEATURES: CAPTURING AND CARICATURING THE MOUTH AND TEETH

In general, in portraiture, the mouth is sketched in along with the other features. With caricature, the approach to the mouth is quite different. The point at which you tackle it depends upon the degree of exaggeration or distortion and the shape of the face, but the rules are not hard and fast.

When the mouth is not the focus, it can be added in after the outline has been drawn. On the other hand, when the mouth is the focus of the caricature – perhaps a larger-than-life smile is to be accommodated – the order has to be reversed.

To accommodate a large mouth or big chin, start at the outside corner of the left or right eye, but, instead of bringing the outline of the face down, take it out and around in a big curve.

side, draw the muscles as if they were teardrops on their side. Draw the fattest part next to the circle and taper the teardrop away to the edge of the mouth.

The bottom lip is made up of two teardrops on their side. Join them in the centre and taper them to the edge of the mouth. The outer edges of these tapered portions actually touch the tapered sections above.

Finally, draw an outline around the whole, thus completing the aperture.

Note that large mouths harden a picture and age the subject. With younger faces, too much exaggeration can spoil the likeness.

Observing the Mouth

Refer back to the oval and the grid on page 50. Remember the position of the centralized horizontal line across the oval where the eyes are positioned. The bottom half is divided again to identify, approximately, where the nose finishes. The space between the centralized line and the lower line accommodates the nose. Now, divide the area from the bottom of the nose to the bottom of the chin with another horizontal line. This is the position of the mouth when drawn. More than other features, its position will vary when it is caricatured.

A mouth is made up of five muscular components: three on the top lip and two on the bottom lip. Variations, from long thin mouths to short chubby mouths, are all based on these components, each one of which is unique to each individual.

EXERCISE: **DRAWING THE MOUTH MORE FULLY**
Start by drawing a small circle in the centre where the horizontal line meets the lower vertical line. Slightly above and either

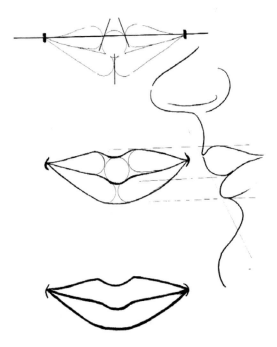

Completing the mouth: the circle, upper-lip teardrops, lower-lip teardrops, line around the whole and profile view.

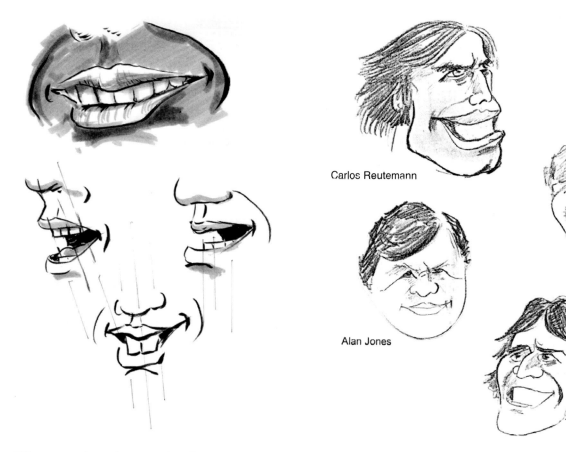

Carlos Reutemann

Mario Andretti

Alan Jones

Nelson Piquet

Different mouths and aspects of teeth. Most subjects reveal the top teeth and extended jaws reveal the bottom teeth.

Four well-known racing drivers all showing the fixed upper lip line: Carlos Reutemann, Alan Jones, Mario Andretti, Nelson Piquet.

Observing Teeth

Teeth are a tricky issue. When viewing a mouth that is speaking, be careful to note which of the teeth show. In most people, some of the upper teeth show, but in a few it is the lower set. If you reverse this tiny detail or miss it altogether the likeness is lost. You may also see the gums if the grin is very large or the subject particularly elderly. Occasionally, more as a mannerism than a feature, the tongue will be seen between the teeth, touching the upper teeth.

Caricaturing Full-Face

Students tend to have problems drawing and caricaturing mouths more than all the other features on the face. The caricature approach deviates from the diagrammatic. The recommended approach to the mouth, after the eye and nose, is as follows, starting with the upper lip line:

1. the upper lips of the mouth;
2. the lower lips of the mouth;
3. the furthest outline of the face (unless gross exaggeration requires a more open canvas, in which case, this instruction is reversed);
4. lines or wrinkles at the corners of the mouth.

The top line of the upper lip, its shape and thickness, is another feature that can make or break a caricature. Whatever you do in caricature, this shape, especially the central section, must have an accurate relationship to that of the subject. It must be added proportionally as if it were in a portrait because it is this upper line that catches the likeness. It may be flat, almost pushed back, large and full, proportionally normal or a curved line with no apparent detail. The line of the upper lip therefore relates closely to the actual.

As the upper line is much more of a fixed line the artist should try to work it in quite quickly. It is important not to labour over the representation. Often the caricaturist will endeavour to create the caricature of a man's mouth

with as few lines as possible. Sometimes, just one line can suffice.

Once the upper line is fixed, in the main it stays in its position regardless of the rest of the mouth moving or extending as it is caricatured. This is particularly the case with a small mouth, but larger mouths could be extended either side if, for example, the mouth is to be laughing.

The tightness and degree of extension of the upper lip shows aspects of mood. Drawing this line can with some subjects be more about mood and character than shape.

There is a gender aspect to this top upper lip line. It is likely to be much more pronounced in women than in men. It is easier to see in women who use lipstick to emphasize the shape of their mouth. Use cross-hatching to highlight glossy lipstick.

Having made the point that the upper lip line is a key feature, the bottom line can be approached with an element of fluidity. The way in which you caricature the bottom lip depends on what the mouth is doing, the degree to which the jaw hinges and, again, mood and character. The bottom lip offers scope vastly to exaggerate the shape of the mouth and creates the most exciting expressions.

When you are drawing very quickly and the subject is a woman, it is a common error, taking into account the comments above, to be tempted into drawing the bottom lip too wide, completely distorting the whole picture. There is, of course, considerable room for 'artistic licence' and exaggeration, but you should be careful.

If capturing the mouth is too difficult, limit the problems by drawing the subject laughing. The broad grin that accompanies laughter to some extent helps to mask any errors in proportion.

As well as laughing, mouths pout and pucker, giving the caricaturist many more aspects to play with. Concentrate on each individual aspect and its own shadow in turn. Avoid highlighting the facial lines on the upper lip on older women. Bring in the way some men talk out of the corner of their mouths.

Constantly watch for reflection of mood in every tiny expression of the mouth as the shape of the mouth subtly or significantly changes with the mood of a subject. The following six positions of the mouth imply mood. Couple the mouth changes with aspects of the eye to reflect aspects of mood, personality and character. On occasion this character change is quite dramatic.

Finally, take advantage of gummy smiles and girlish giggles that show the tongue.

RIGHT: *The laughing mouth can change proportions and exaggeration takes over.*

BELOW: *A classic bottom lip: singer Kiki Dee.*

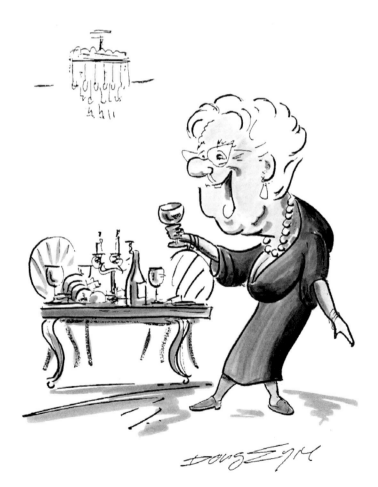

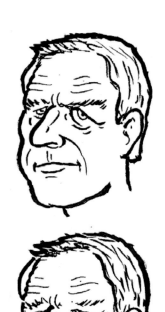
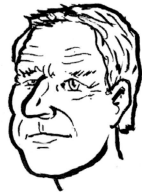
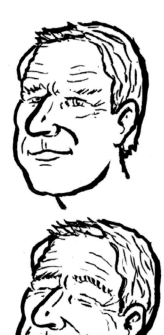
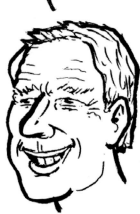

Six positions of the mouth and the interplay of the eyes to reflect mood, from sullen to laughing.

Caricaturing in Profile or at Three-Quarter Angle

There is a profile view to the mouth. In the vast majority of faces the upper lip is set back from the nose and the lower lip is set back from the upper lip. When drawing a profile, a light line, drawn at an angle from the tip of the nose in front of the upper lip, defines where the lower lip will go. This angle line varies from person to person. The line would be reversed where the lower jaw, lips or teeth protrude.

In the caricaturing of the lower facial features, exaggeration often forces a change in the classic position of these features. It is often the mouth position that changes most. For example (*see* below), caricaturing the chin may force the mouth up the facial plane, which in turn forces the position of the eyes nearer the forehead.

If you are caricaturing a mouth in profile, remember the profile check line and the position of the lips. In many cases, the bottom lip is behind the top lip. The lips may be less visible, their fullness less noticeable in profile, however, the section from below the nose to the upper lip is more pronounced. This distance varies from person to person, and it is very important for your caricature to ensure that this line is correct. Even when the other facial features change, expressing different emotions,

BELOW: The position of the mouth cannot follow the classic rules in relation to the grid due to exaggeration of the chin.

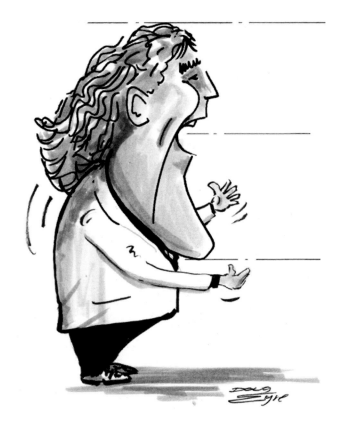

82

this distance hardly changes. On most occasions the change is unlikely to warrant caricature, as it will make little difference to the finished drawing. However, there are a few subjects – for example, ex-Prime Minister John Major – on whom this space between the upper lip and nose is absolutely fundamental to the caricature.

Caricaturing Teeth

Of all the features, the teeth are the most likely to spoil a picture. Caricaturists do not, however, have to put teeth into pictures in detail – indeed, sometimes they leave them out completely, simply leaving a white space where they would be. Do whichever looks better or is easier. If you wish to add teeth but have difficulties, a line can suffice.

On occasions there may be a particularly good reason – odd shapes, broken teeth or buckteeth – for adding in the teeth, and leaving them out would make the picture wrong. In such cases these are the targets to go for.

Some people with large protruding teeth have a jovial character – maybe one necessitates the other – and there are several celebrity examples that confirm this.

Finally, extra large teeth make a subject look extra happy. It does work.

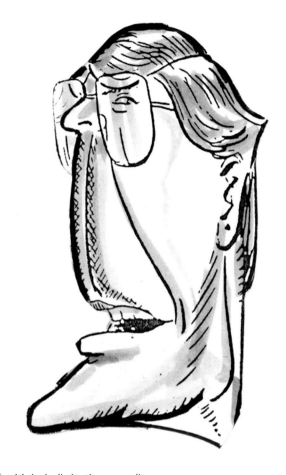

John Major's distinctive upper lip.

EXERCISE: **CAPTURING AND CARICATURING THE MOUTH**

Practise by copying the illustrations from magazine and newspaper cuttings to identify other suitable subjects. Challenge your skill level with difficult subjects. Time yourself in repeating drawings, aiming to increase speeds.

Mouths are difficult, but you must not shrink from the challenge; practise them full-face, in profile and from the three-quarter angle. Chose illustrations of both men and women to copy and study.

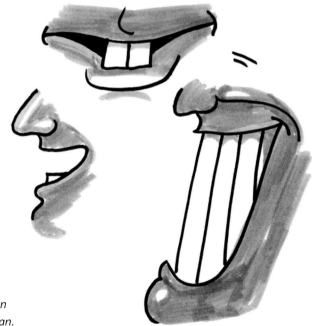

Go for teeth when and where you can.

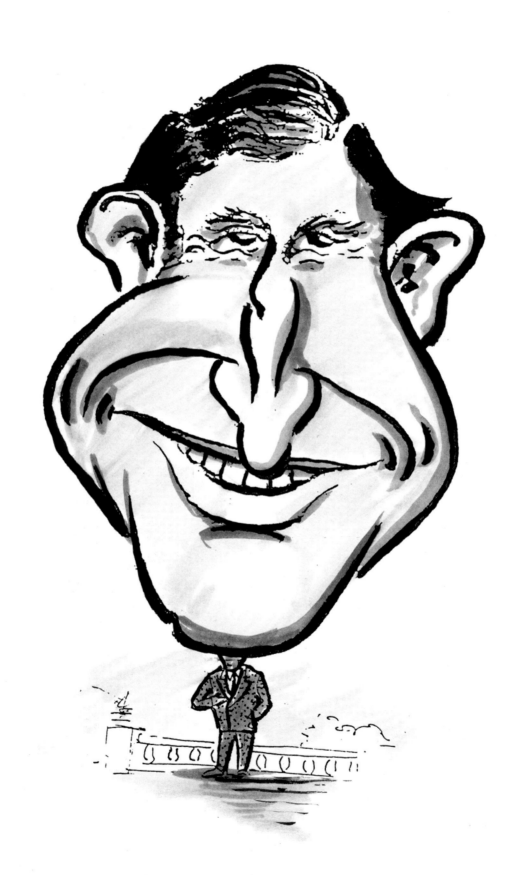

FEATURES: CAPTURING AND CARICATURING THE EARS

There are a variety of ear shapes, but basically only two categories of ear that are of real interest to a caricaturist – those with or without lobes and those that stick out rather than lie flat against the head. Get the lobes or the angle of the ears wrong and the whole picture looks wrong but otherwise ears are more forgiving.

However, there are a few key points to notice before you start.

Observing Ears

It is not often that ears attract attention, partly because they may be hidden by the hairstyle, particularly in women. Even if they are visible, other features such as beards or hair can cause them to be overlooked. When looked at specifically they may be found to be quite unattractive.

The ear consists of three parts – the outer, middle and inner ears – but it is the outer ear, the bit that collects sounds from the environment and funnels it into the auditory system, that is of interest to caricaturists.

Examples of different ear shapes, sizes and thicknesses.

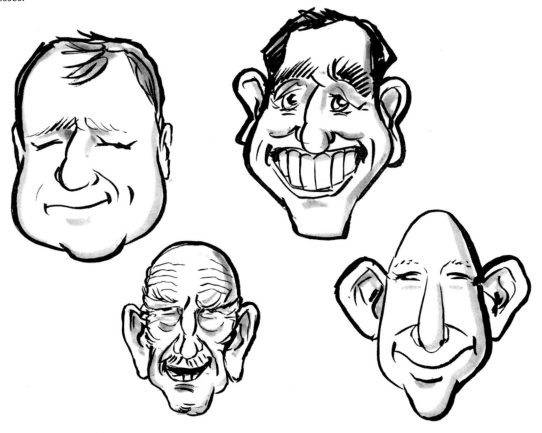

The outer ear may be composed of three parts but we can only really see two – the two flap-like flexible structures on either side of the head and the external auditory canal.

What catches the eye most is:

• the degree to which the ears stick out
• the size of the ears
• the overall shape of the ears
• the thickness of the outer rim
• the ear lobes
• hairiness inside the auditory canal and outside on the ear itself.

Make a mental note of any of these features for the caricature.

In general, from all three views, the position of a subject's ear lies at the side of the oval with the top of the ear in line with the top of the eyebrow and the bottom of the ear level with the bottom of the nose.

Although all ears have the skin-covered cartilage rim, lobes and auditory canal, these component parts vary considerably in size and shape. From the frontal view, look past the face and down the side of the head to pick up the outline created by the cartilage outer rim. It may be a smooth curve. There are, however, ears that display a wandering curve – in and out – giving a pinched look to the middle section. The degree of this pinching can vary considerably.

One important part of the ear that must be in the correct place is the actual aperture that receives the sound. It is a small but important point.

Caricaturing Ears

Although ears are prominent features and can add a lot of humour they will not define your caricature. Draw a perfect eye then add in the ear and you have your caricature. Work the other way around, and draw a perfect ear but fail to capture the eye and it will never look like the subject in a million years. You will fail to capture the essence of your subject.

It is no wonder, in view of their potential ugliness, that caricaturists often pass over this difficult part of the head with an indicative squiggle. Adding ears to a caricature takes practice. The ear shape is quite complex. Often it is the reason why a caricaturist will try to get the overall shape right and merely add a squiggle to reflect the inner. Don't just think of this squiggle as necessarily indicative of a lazy artist, but rather a quick and effective way of illustrating the general image of the ear when other features are more significant. It can be a way of overcoming a level of unnecessary complexity that would not add to the picture. On most occasions a good caricaturist squiggle, picking

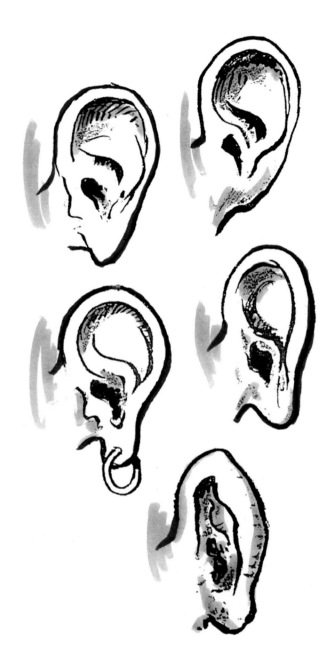

Examples of caricatured ears with and without lobes.

up on the basic features, will in fact be a very correct representation.

In most cases ears do not feature significantly in caricatures, but when they are to be added work at getting the proportions and size right. If you do have the time and inclination to tackle the ear it can be a most satisfying exercise.

You might add the ears if they stick out, are pinned back against the head or have prominent earlobes – then you can have a field day!

Always start by quickly assessing whether or not the subject has ear lobes. You can have great fun with them. Their length is

a key feature. Fascinatingly, the proportions of the human ear change dramatically with age. As a person ages, their ears become larger and longer. As they become longer, the bottom lobe can extend beyond the base of the nose. The rule of thumb is that the longer the ears are, the older the person.

Protruding ears need careful handling. If you are doing a three-quarter profile rather than full face, do not forget the protruding ear on the far side.

Rather than stick out, some ears are so close to the side of the face that they are hardly visible. This trait often accompanies a fuller face, yet it is not the full face that creates this illusion.

Look out for the 'boxer' ears that are crumpled, damaged, also known as the cauliflower ear, but always bear in mind that although some people are amused by and comfortable with their distinctive ears (for example their long lobes or particularly prominent or crumpled features), yet others will be far more sensitive. Again remember to consider the effect of your caricature and the sensitivity of your brief.

EXERCISE: **CAPTURING AND CARICATURING EARS**
Again follow the approach set out in previous chapters. Practise by copying the illustrations in this book, and use magazine and newspaper cuttings to identify other suitable subjects. Challenge your skill level with difficult subjects. Time yourself to repeat drawings to increase speeds.

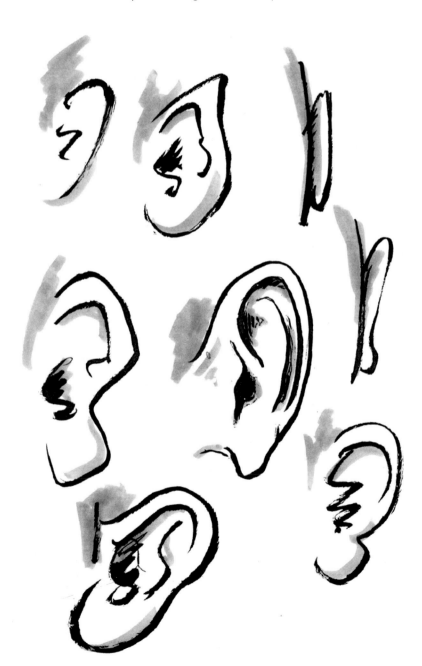

Examples of caricatured ears, flat against the head and prominent.

FEATURES: CAPTURING AND CARICATURING THE HAIR

Observing and Drawing Hair

Hair is a major feature to tackle for two main reasons:

1. it often defines the shape of the head and could, with some subjects, be a defining feature for the likeness. It could be the most important part of the whole picture after the eyes. The hairline must be right as this has an impact on the head, brow and forehead shape;
2. the hair texture and the hairstyle both define the overall shape of the head, especially when fashions of the day support a variety of both male and female hairstyles.

Start by capturing this overall shape in your mind. Try to imagine the contours of the skin underneath the hair. With some people the hair may very thin on top, and you may see the scalp grinning though. Recall the skull shape unconvincingly hidden by two or three thin strands of hair.

Observe all the aspects of hair: its texture, every strand, how it is growing and how it is cut, the style, the shadows it creates on the face, its waves and highlights, both added and natural. Note how the hair frames the head. The hair alone can distort the other features of the face. Quick sketching captures this general shape, texture and the dimensions of the hair and hairstyle, all of which can be an interesting and varied challenge.

Studio work affords more time, allowing the artist to add the fine detail of hair. If the texture of the hair is very fine, use a harder pencil with a finer line tapering away to nothing. Bring your strokes down from the head to the point at which the hair touches the skin.

Caricaturing Hair

The appropriate time to caricature hair varies, depending on the hair's prominence and the speed at which the artist is working. If the hairstyle or texture has no interesting features, put it in last. If it is not particularly noticeable you may choose not to caricature it at all.

As soon as it becomes obvious that it will make a significant contribution, and is vital to the likeness being built up, partially draw the hair in quickly, using a soft pencil, a light touch and minimum lines. This helps to get the balance right.

Finish and fine-tune the hair at the end of the picture when you have completed the other features. Loosen your wrist to achieve flow for wavy hair, and use swirling circles to capture curly hair, particularly for big Afro-hairstyles. Fatter, short stokes should be used for close-cropped hair and dark, long, direct

Hair can be a defining feature, dominating shape.

Tom

Wild hair can create quite lively effects.

strokes for capturing long hair. Make sure the shadows follow the direction of the hair.

If drawing a female face, partially hidden by a curtain of hair, falling diagonally across one eye, capture the hair quickly as it is so defining.

Take note of the colour of the hair so that you can get in the appropriate degree of shading. If the hair is very white, put in a shaded background emphasizing the whiteness of the hair. If the picture is in colour, use a colour wash (*see* page 24).

Tackling hair immediately after doing the eyes can buy time at an important stage of the caricature. It may be just seconds but they are valuable seconds of much-needed time, which will allow the artist mentally to absorb other features that could be emphasized, exaggerated or distorted.

It is possible to capture a likeness with eyes and hair alone. Such a beginning provides total freedom for the artist to add in character and personality by making a statement through the other features.

Facial Hair

Facial hair can be seen on the eyebrows (*see* page 68), nose,

cheeks, ears, neck and around the mouth area (moustaches, beards and sideburns). These are unlikely to be missed.

If facial hair, such as cheek hair or sideburns, is worn as a feature, do go for it. The subject is making a statement, so there is no need to hold back! However, you should be more sensitive in the case of nostril hair.

Moustaches

There are several styles of moustaches: handlebar, fu manchu, toothbrush, pencil, bushy, trimmed. These are great for caricaturists but they can present quite a challenge, for a variety of reasons.

The larger, drooping styles have a downward shape, which runs contrary to the upward lines of a cheerful face. The caricaturist needs cleverly to distort the jaw and surrounding features to counterbalance the interaction of the two lines. Additional exaggeration of the eyes, including additional laughter lines, will assist.

Styled, well-groomed moustaches are relatively easy to draw, while the small upper-lip style of moustache is very easy to miss, as are black moustaches on a black face.

All types of moustaches imply aspects of character.

Beards

A beard can be a nuisance, as it may force the caricaturist to concentrate on the more visible, less subtle features. A person wears a beard for a number of reasons. On occasions, the beard's shape and texture are a delight to caricature, adding considerably to the overall picture. Exaggerating a beard is, however, rather obvious. Beards can and do, on some subjects, act as camouflage, masking some of the important features of the face.

Fashion beards or designer beards, which are often mere hints of a beard, are very easy to overlook, especially with pale or grey hair colourings. Watch out for them.

Designer stubble can be represented by shading and crosshatching.

One of the psychologically complex aspects of a bearded subject is that they often think a caricaturist is home and dry because of the beard. They believe they are very easy to caricature. This perception is just not true. A beard blurs the individuality of a person's character, and this can make it much harder to draw out mood, personality and character on paper and through observation. Experience has shown that beards on naval personnel and sailors, professional or amateur, tend to indicate a certain type – outward-going and larger-than-life.

EXERCISE: **STRENGTHENING THE SKILL LEVEL AND BUILDING CONFIDENCE AND SPEED**
Take time to understand hair and visit a hairdresser and a barber. Look closely and understand texture and the ways in which hair falls. Read college textbooks on hair.

LEFT: Concentrating on the classic RAF moustache and beard.

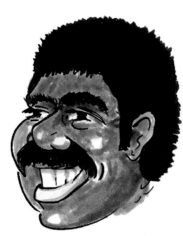

ABOVE: Beards in caricature.

RIGHT: Do not miss the dark moustache on a dark face.

Sketches of types of beards.

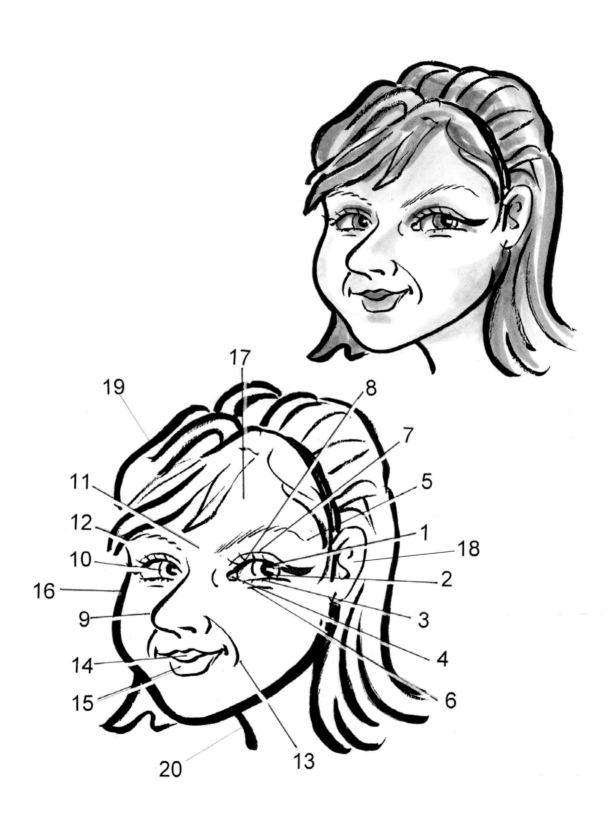

GOING LIVE

Chapters 4–11 cover the structure of the basic features, how to draw and caricature them, and what aspects to look for. The final caricatured face derives much from the interpretation of each feature. Features are chosen to identify each aspect of mood, character and personality. Each one is tackled in a specific way. Once an understanding of the basic features has been achieved, however, there is much more to cover – the facial lines creating expressions, the neck, adding a body and body parts, props and minor features and shading – and these issues will be explained in Chapters 12–17.

At this point, it is important to embed the main aspects of caricaturing, and you should now practise drawing a full face in detail. Rather than subjecting innocent people to your early renditions, use photographs initially. Both live work and work from photographs have their place, but photographs do bring their own difficulties. They are rarely clear as to emotions and character, they can be stiff, and they do not reveal all aspects of the person in the round. Using them at this stage is a pragmatic approach and, as soon as the comfort factor sets in, alongside confidence, you should aim to move on to 'live' work.

You are now at the point of completing a whole caricature, bringing in all the aspects of line, shape, proportion and perspective. Follow the advice given in Chapters 4–11 and over time you will develop your own approach and style. My own twenty key steps for a full detailed live or studio caricature are as follows:

1. the upper eyelid, from centre outwards;
2. the eyeball completely finished, with reflection in place;
3. the bottom eyelid – one or two lines;
4. the inner corner tissues, the tear duct;
5. one eyebrow;
6. the lines under the lower lid;
7. crease lines at the upper edge of eye;
8. eyelashes;
9. the contour of the nose done in one sweep;
10. the other eye, repeating steps 1–8 above;
11. twin vertical lines above the bridge of the nose, if apparent;
12. the other eyebrow;
13. lines at the side of nose;
14. the upper lips of the mouth;
15. the lower lips of mouth;
16. the furthest outline of the face;
17. the forehead;
18. the ear;
19. the outline of the hair;
20. the neck – added last of all, to facilitate the addition of the body, if this is required. The caricature reduces at this point. (A smaller body that is disproportionate to the head is part of my own style.)

Shadows, including those implying recesses, hairstyle and hair colour, complete the picture.

It is important to clarify that all these steps are happening within approximately one minute.

When they start, most students produce work that exhibits an element of stiffness (see the comparison examples overleaf). You need to work hard at overcoming this aspect of your drawing; forget straight lines for now, and allow every line to have a soft curve and graceful flow to it. This does not mean that ultimately your style will not be more angular.

Studio Exercises

It has taken me many years to acquire the skill of getting all twenty steps done in about one minute, to a client's satisfaction. Do not expect to read the book in a week and arrive at the same destination.

The more you practise in the studio, from photographs and live subjects, the quicker you will get there. After considerable studio practice, you can attempt a live subject.

EXERCISE: **IN THE STUDIO**
Loosen up by drawing circles, of varying sizes, very fast on an A3 page. It helps you to free up your line.

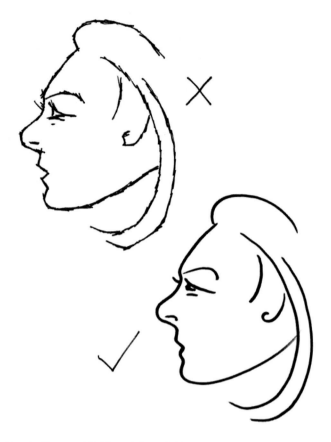

Aim for flow and fluidity of the solid line; take the line for a walk.

Take a large photograph of a person taken from a three-quarter view. Choose a subject without spectacles and a beard initially. Follow the twenty steps carefully.

The eyes are the most important feature and are therefore the first to be studied. Quickly absorb all the other features. Mentally arrive at your finished picture. When you have this picture firmly fixed in your mind, stick with it. Do not deviate from it. The first ideas are always the best!

Practise sketching while sitting and standing. Working standing up gives some people greater freedom of movement and flow. Experiment to see what works best for you.

Live Caricaturing

Placing the subject is a personal choice. The distance between the subject and the caricaturist should be within 1.5 metres, whether working from life or in the studio. However, if you are working commercially and you are asked to caricature a person who is unaware of the commission, you may need to keep your distance. You should be able to draw someone within 3 metres.

To obtain a good three-quarter view of the subject's face, the right-handed caricaturist should stand slightly to the right of the subject's eye line. The subject should be looking directly past and above the caricaturist's left shoulder.

At this early stage, if the subject is wearing glasses, it is a good idea to ask them to remove them while the eye is drawn. It is better to attempt to capture the eyes without the reflection of the glass. However, because the spectacles are important to a correct likeness, you should ask for them to be replaced when you have completed the eye. Add their shape and a hint of their design in afterwards.

Practise speed. When you start to sketch a person in caricature from life, time is always against you. Not all caricaturists, professional or amateur, put themselves in situations where they have to work to time.

It helps when live subjects are standing and talking to others. This approach frees them physically, takes their mind of my task and allows me to glean much about their personality and character from their interactions.

Identifying and Honing Artistic Memory

As time goes by and experience is gained, facial information slips into the subconscious, is memorized and more quickly assimilated. You will, after a while, find you have learned to create a mental picture of the finished caricature. This new skill, acquired through experience, is absolutely crucial to the speed at which live caricatures can be completed. (Not all caricaturists work at speed from life; *see* pages 149–155 on commercial work.)

With the aid of terse notes, I have in the past held as many as eighty visual images in my head for studio completion the following day, following a major live caricaturing event. Hogarth did not go out sketching as such; instead, his method was to imprint a scene – the lighting, the colours, and the arrangement of figures – on his inner eye and make his drawing back in the studio. He must have developed an extraordinary detailed visual memory.

Visual learners prefer graphs, pictures and diagrams. They look for visual representations of information. You may like to check out if you are a visual, sensory, intuitive or verbal learner. If you are not a visual learner it could have an impact on your ability to caricature at any professional level.

EXERCISES: **IMPROVING VISUAL MEMORY**
Whether you are a visual learner or not you should try to improve your visual memory if you wish to caricature very

quickly and work in both the live and studio environment. There are a number of tricks that help to improve visual memory. You will need help for this one.

Cut out and collect photographs from magazines or newspapers of people with significant features, such as designer glasses, beards or jaw angles. Ensure they are all of the same size, colour or black and white, but not both. Number them from 1 to 100 on the back. Get someone to show you the first fifty photographs at the rate of one every ten seconds, then pair up the photographs, one shown and one unseen. Go through the pairs, identifying which of the two photographs you have seen before.

Dropping the Detail

It is only in caricature that artists abstract, simplify and exaggerate. These are three unique skills that are not used by other artists. To maximize this group of skills it is important to recognize and fully understand the general shape of the face, and each feature in isolation. Be comfortable with the face from the viewpoint of a draughtsman, using standard guidelines and measurements. Once you feel reasonably comfortable that you know where things go, you can let go and really get going.

Dropping detail is essential when you are working at speed or if it is an element of your particular style.

When working at speed, only the very few most important features will come into play, and will be required to capture the right likeness. An experienced caricaturist will look for only three features to capture first; the eyes are likely to be one of them. It is common to see around 100 facial lines but with caricature only five or six, maybe fewer, will enhance the picture. This means that most faces, when caricatured at speed, do look a little younger. The bare essentials are captured in a way that is initially imagined, with other features being added later.

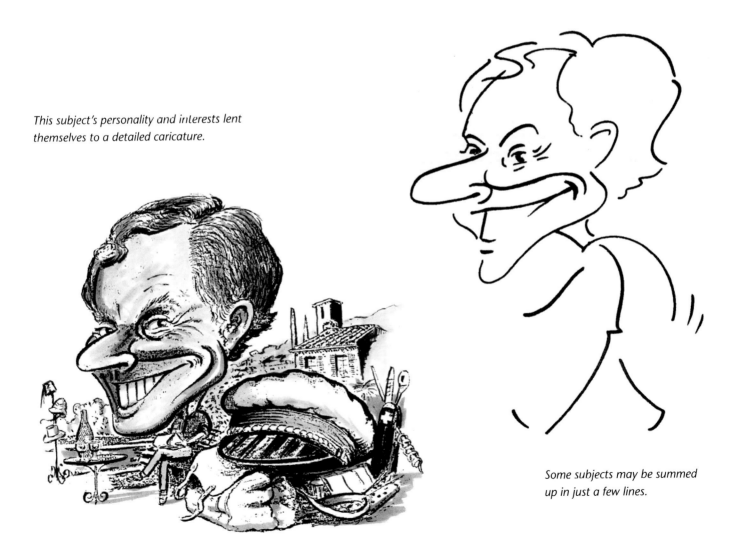

This subject's personality and interests lent themselves to a detailed caricature.

Some subjects may be summed up in just a few lines.

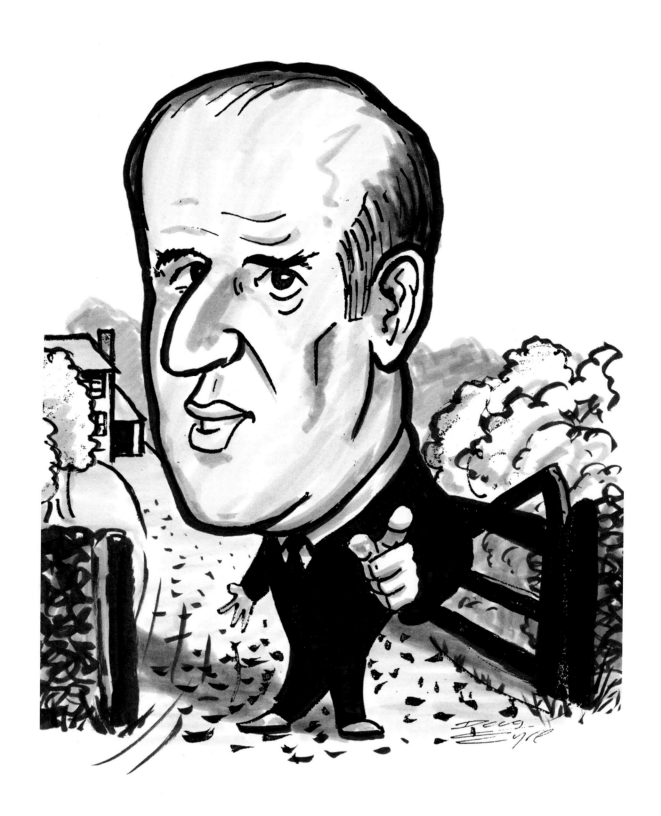

CAPTURING AND CARICATURING FACIAL LINES AND EXPRESSIONS

Facial Lines

Da Vinci's Mona Lisa has few facial lines and this is one of the factors that imparts that fresh angelic quality to her image. Pleasant, jovial, round, smooth faces, with nicely curved outer lines, are a bonus in two respects:

1. their roundness provides additional scope, a larger canvas for the features;
2. the larger canvas helps in the speed of application.

However, in many subjects the neutral, almost dull, character of the face, without or with very few lines, negates these advantages.

It is much harder to capture the face, mood, character or personality with a face that lacks lines or in which the lines are less pronounced, such as younger or Oriental faces. Lines may be non-existent in children, which explains why many caricaturists avoid working on children's faces.

Unlike their subjects, caricaturists love lines, which are excellent features to work with. If you look hard at mature, older faces, hundreds of lines become apparent, often quite prominent. They come down from the eyes in a smooth curve, they wrinkle, they join, and they overlap. Those in the lower half of the face falling on to the lower jaw, coupled with diagonal lines falling from the outer edges of the mouth, make interesting combinations.

Wrinkles around the eye, or 'laughter lines', are thin creases in the skin around the under edge of the upper eyelid. When a face is smiling, lines from the nose slightly swing around underneath the cheek and then drop down, usually with a dimple to the side. Study laughter. Notice that, the more the jaw opens in order to laugh, the more of the cheek rises and the eyes close. Very often all you need to add are two, quick, almost horizontal lines, to form a laughing eye. Watch people as they laugh and you will see just how small the eyes become.

It is possible to grossly exaggerate a larger-than-life character in a crowd using the mouth and a few lines around the mouth.

The other added features are minutely small in comparison. It is the lines around the mouth that create the caricature.

Loose skin below and to the outer edge of the eyes creates other lines. Lines in the skin on the forehead or just above the bridge of nose between the eyebrows also change as the face muscles move according to mood. Facial lines either side of the nose, which run from behind the nostrils to each side of the mouth, are often called expression lines. They are an expression of the underlying muscle structure. These lines can be stronger in men than in women as make-up in women masks them to a degree. The lines are much shorter where the face is fuller, and deeper and longer on a narrower face.

Use lines and wrinkles to underpin expression.

For the caricature artist, the more lines the face has, the greater the scope. They make for a little extra work but the

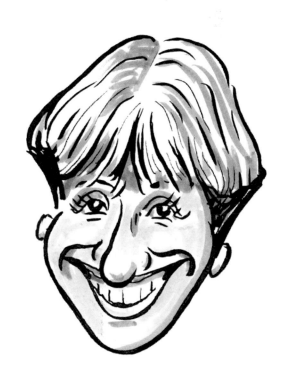

Facial lines can make all the difference: Victoria Wood.

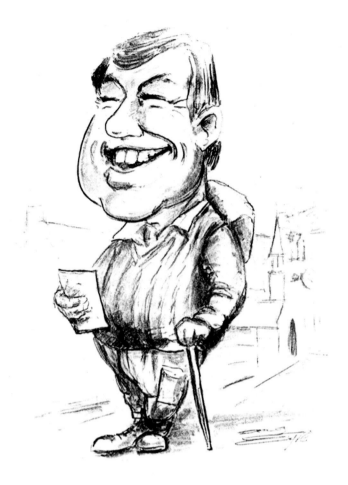

ABOVE: The older face character and lines go together: the late Sir Michael Hordern.

LEFT: The rounded character and full face give a larger canvas to work on.

Prominent laughter lines around the mouth.

Doug Lloyd

The lines around the mouth create the caricature.

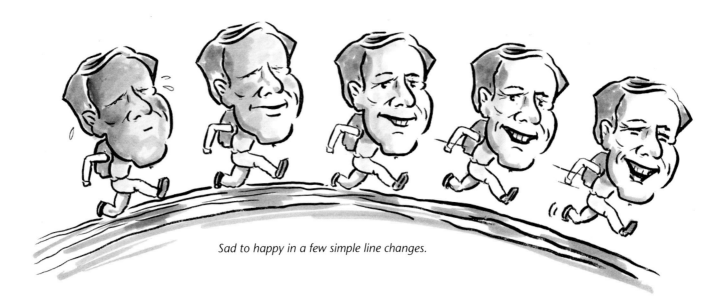

Sad to happy in a few simple line changes.

impact on the likeness can be fantastic. Take advantage of them but do not try to capture them all. Pick six to eight of the most effective – those that really do add to the caricature – out of the many.

The mouth is the starting point on which to concentrate in order to capture expression. It creates so many aspects of expression. Tease out the variations between a pleasing smile, extreme laughter and the very sad. Visualizing a smiling subject brings to mind a mouth turned up at the outer edges, but this does not apply to everyone. Some people turn their mouths down even when they are smiling, providing an added challenge for the artist.

Remember: the occasions on which you would want to reflect sadness are few and far between. Equally, not everyone wants a picture of himself or herself portraying an ear-to-ear toothy grin. Keep the balance.

Use lines to change expression. The sadness reflected in the face of the sad character is changed into happiness and brightness, the personality from dull to interesting, through the addition of as few as six lines.

Where more than one person is being caricatured, by using line and shade well, to capture expressions, it is almost possible to capture conversation. The observer might almost believe that he can understand what the subjects are saying to one another. Communication between subjects can be brought alive in this way.

When drawing facial lines, treat them softly. It is easy to spoil a sketch by using too heavy a hand. If, however, lines are extremely deep, the opposite technique comes into play, and you can use a much stronger pencil or pen stroke. Feather out with a lighter stroke towards the lower end, to taper out the line.

Adding your chosen lines does require careful consideration. Without them the expression is lost but many subjects would rather not see them. Sometimes, conscious preening distorts a person's real self. Recognizing the 'pose', a caricaturist may take this as a green light to expose the underlying character and personality in the final result. If, on the other hand, the brief requires a different product – a less natural smile, in keeping with a public persona or a detached role – perhaps holding back is warranted. Fewer lines, a slight smile and a stronger pose may be in order. If the end product is not a commissioned caricature, the 'gloves may be off'. Use your judgement as to how far you can go (*see* Chapter 19).

Using lines to capture expression, once it has been mastered, will become firmly fixed in the memory. You will eventually find that lines can be added to a caricature almost subconsciously.

Facial Expressions

The interpretation of a feature should also attempt to capture mood, character and personality. Each slight feature or facial line change can have a dramatic impact on the facial expression.

Mood can be apparent from the lines of the eye, eyebrows and mouth. It is possible with caricature to capture the subtlest of mood changes, more so, perhaps, than in portraiture. The flick of a line can do it. The examples below, all quick sketches drawn from life, depict the different moods of jubilation, happiness and cheekiness.

The line of a pronounced jawbone beneath the facial muscles and skin, as well as stature and stance, all feed the perception of a strong character. The examples overleaf, of lightning sketches from life, depict aspects of character such as pride, arrogance and cunning.

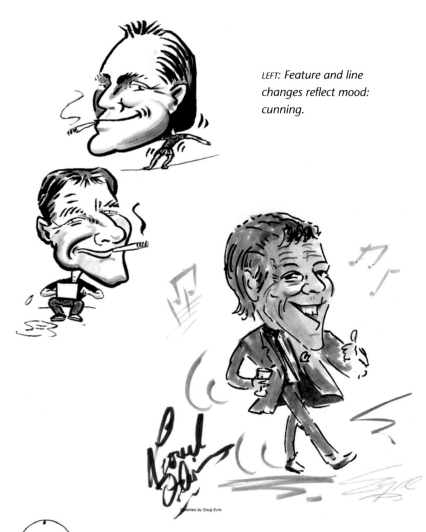

LEFT: Feature and line changes reflect mood: cunning.

ABOVE: Feature and line changes reflect mood: pride.

RIGHT: Feature and line changes reflect mood: pride and flamboyance (Lionel Blair).

Feature and line changes reflect mood: vulnerability.

ABOVE: Feature and line emphasis reflect mood: jubilation.

BELOW: Feature and line changes reflect mood: cheekiness.

Nick Brock

ABOVE: Feature and line emphasis reflect mood: happy contentment.

The impression of personality is picked up from the lines around the eyes and jaw, and the shape of the cheekbones. These examples of lightning sketches from life, depict certain aspects of personality.

EXERCISE: **CARICATURING EXPRESSIONS**

To practise caricaturing expressions, start with a rough pencil sketch of the whole head, reflecting exactly what you see. At this stage do not worry about the accuracy of your draughtsmanship. On completion of the head, begin to experiment by altering the mouth and the eyes to reflect the different moods, character and personality. Refer to the examples given in this chapter.

Copy the above facial expressions over and over again, preferably on a large single sheet of paper. This sort of practice will help you to form the faces with clarity and simplicity.

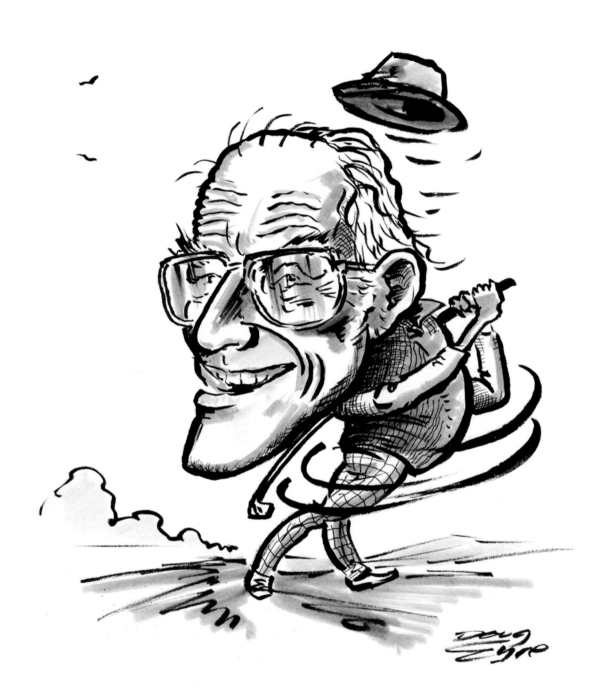

SHADING AND CROSS-HATCHING

A black line or pencil picture can look a bit flat, even if the likeness is very pleasing. Shading or cross-hatching adds life and movement to the sketch, giving lift and dimension to the picture.

Shading

Add simple shading if you are working 'on the spot', as there will be little time to add more detail. You can use much more detailed shading in studio work.

If your subject is facing left, you shade to the right; if he or she is facing right, you shade to the left. Start by imagining the light is coming from your left and add the shading to the right. Keep it fairly simple. A few action lines, if needed, should be added using bold strokes of the pen.

Use about three or four tones of grey on the picture if you have time. Start with the warm pale tones, with pale grey shading. As a guide, your grey strokes need to be about one-third of the thickness of an arm. Keep the same thickness throughout the drawing, remembering to keep to the same side. Move on to slightly deeper tones when the lighter lines have been added. Use them only where they are needed, for example, to represent shadow under an arm. As light mainly falls downwards, protrusions cast a shadow. Use the flip of a brush pen to create the effect. Try it with the shadow beneath the eye sockets.

To obtain delicate smooth shade lines and to soften edges, use either very light strokes of the pen or brush, or, if you are using pencil, rub the line with your finger for the softest of effects.

There are a number of key points to remember about shading.

With full shading, in three dimensions, action lines can imply speed.

Brush strokes can be flipped in to capture shadow.

The soft shading effect can be created with three tones of grey.

Medium-grey is used here to create the body shadow on the ground and highlight the shadow of the hat on the body.

- if the picture is going to be in monochrome, use any one of three tones of grey: pale, medium and deep;
- once the sketch has dimensions, shading starts to develop shape and depth, starting to bring the picture to life;
- medium-grey enhances the picture. Use it to touch in areas such as creases in clothing, add the contrasting colours of garments or deepen shadows where one item of clothing crosses another. Add only a small amount of shadow underneath the actual lines. Continue to add small bits of medium-grey where you feel they are needed. Medium-grey can also be used for putting a body shadow on the ground;
- be very careful when adding deeper tones. Only use them if it is really necessary to the picture;
- the overall effect should be improved greatly by shading. Do not overdo it. Learn when to leave the picture alone. If this work is being done in the studio, learn to leave it for a while, come back to it, and view it afresh before adding further or deeper shading.

Hatching and Cross-Hatching

Hatching and cross-hatching are more complex, ancient shading techniques. Using a thin pen, a series of parallel, circular or diagonal lines can be drawn in order to create a textural effect.

Hatching

Use the edge of a pencil to draw a series of parallel or intersecting lines closely together to create light tones. To achieve depth of colour, simply vary the height, width and density of the lines. (*See* page 39 on pen-and-ink hatching.)

Cross-Hatching

Similar to hatching, cross-hatching can be achieved by drawing two or more sets of parallel lines, crossing each other at an angle to create both colour and texture. The closer the lines are drawn together, the darker the textural colour effect. This is an excellent technique to use when drawing a face, as circular cross-hatching following the oval of the face shapes the face.

Complexion and Colour

In this book all colour is achieved through shading techniques. People's skin colour is varied and, to different degrees, depending on the birth colour, can noticeably change for physical and emotional reasons. Laughter may highlight colour, shyness may instigate rosy cheeks, and excessive tea drinking causes a condition that results in a ruddy nose. Complexion can add another dimension by capturing emotion.

Shading can imply a colour change linked to mood or emotion.

Cross-hatching can be used on the body and clothes.

Two for One!

CARICATURING THE REST OF THE PICTURE

The Body

A caricaturist working live quite rightly spends most of the very short time available capturing the likeness of the face. When the body is to be added, it is easy to forget that, if the sketch is going to ring true, stance, pose and physical demeanour need to be considered. These aspects of an individual are just as important as the head and face.

Despite the energy and effort that have just been expended on drawing the head and face, the job is only partially done. Quickly move on to the body. If your brief involves many caricatures (at a golf event, for example; *see* Chapter 22), bodies may have to be completed after all the faces are drawn. Make notes, in pencil, on each picture, of stance, pose and actions, as well as hair colour and clothes. These little *aide-mémoires* are vital back in the studio regardless of the power of your visual memory.

When moving on to complete the body, use your imagination first. Look and take a deep breath, resisting the urge to jump right in. Ask the subject to move around a bit – this buys time and allows you to note their stance or pose when they settle. The thoughts that tumble into your mind may be many and varied, but it will pay to be absolutely mentally clear about the full picture. Think about what your subject is going to be doing in the picture. Use your imagination and your understanding of character and personality.

Are you seeing stance or a pose? What does the stance or pose communicate?

What size should the body be? The body is unlikely to be in proportion to the size of the completed head and facial features, unless you are working on a very large canvas. The body will almost certainly be smaller, but that does not mean that it has to be pedestrian. It can be exaggerated in its own way. It should have movement and energy. An exaggerated small body can still display a wealth of character.

Is the body a major part of the caricature or completing the picture? When the subject has a very large body, there is always the opportunity of reversing the whole process. The body is the

caricature and the head becomes the size of a pea – it can be very entertaining. Equally, there are bodies and stances that are so powerful in their own right that they communicate fully without the need to see the complete face. The caricatured body communicates all.

It is often thought that people look like their pets. Curiously, people can resemble animals and birds. If a wise old owl or a 'twitcher' is what you are seeing, consider that approach.

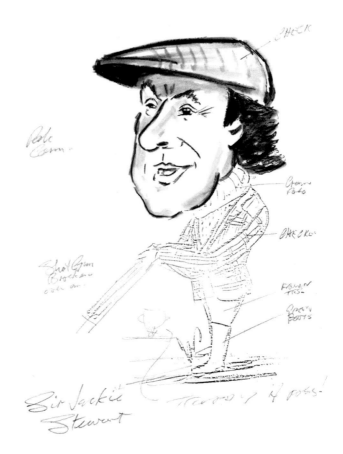

Often, aide-mémoires *can be quickly added on a work in progress when caricatures are completed in the studio: Sir Jackie Stewart.*

Sometimes the body becomes the caricature.

Even if you add a small body it may contain a wealth of detail and imply character.

Even without a face or feature this character is undoubtedly an American trucker.

You can see the wise old owl in this gentleman.

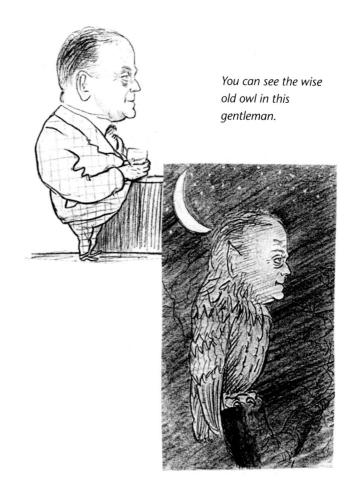

Are there other items to be added into the general picture? If there are other items they may need to be sketched in before you can determine the body size. All aspects of the picture must relate to all other aspects, although in a caricature they do not all have to be in proportion.

Note the angle at which the subject is holding his or her head. Is it inclined or tilting? Take the lead from the subject, as this is a critically important part of the immediate likeness. Take care when choosing the aspect of the body to the face and head. Few people recognize themselves from the full profile or three-quarter angle.

Exaggerating the elongation of a tall person and making a short, fat person rounder and fatter will effectively capture the likeness.

If the body is clothed, top to bottom, hat to shoe, must look right within the caricature. 'Looking right' in this case does not mean accurately drawn or detailed. Whether the clothes are drawn smart or shabby will depend upon the theme and the activity you have been asked to draw. Sometimes a subject will ask to be pictured in a fanciful way, projected into a dream activity, a world away from reality.

If you are adding a small body on an exaggerated head the neck reduces down at such an angle that there is often little to be seen in any aspect of the caricature. Two lines with no detail will often suffice. When the subject has low collarbones and a particularly long neck, this may be exaggerated. If the subject is just tall, extend the neck and drop the shoulder line right away. If the subject is round-shouldered, when you are drawing a full-face view, this can be exaggerated by leaving out the neck, lowering the head to the shoulders. This is technically incorrect but will achieve the right effect. The muscles in the neck can be exaggerated on a hefty, strong, character. Finally, always remember a man's Adam's Apple, which can be indicated simply by a small line.

When these details have been speedily taken into account, you can dash off a very quick sketch. Aim, with as few strokes as possible, to capture the whole picture, as accurately as you can. If this first sketch is correct, it will be apparent immediately.

When working live, the feedback is instant, and you may get a subject who claims, 'That's not me. I don't stand like that!' This sort of public attention is to be avoided, as it undermines public confidence. It is worthwhile correcting without a murmur. Smile nicely and act quickly. Fortunately, when working on the body, a smaller part of the picture, mistakes can be altered, although it does waste time.

It is always advisable in a live situation to try to match your work to the subject's expectations. The limit to which you can grossly exaggerate and distort the caricature is again set by the personality and character of the subject and, sometimes, by the support of the crowd, who may be on your side when a troublesome subject becomes unreasonable. Occasionally,

Sometimes the body can be captured in just a few lines.

either onlookers or the subject himself will give you licence to go that one step further. Be brave if you can, but always be aware of the bigger picture. You may feel that you have carte blanche to cut pomposity down to size, but it will be your last commission if the subject was the company's major client! Keep on track, and do not allow others to goad you in an inappropriate direction.

There are three simple rules to follow:

- if you are in a real hurry, caricature the head and shoulders only, and leave off the body. If you are booked for two hours the last few pictures are always a problem, with a queue building up as everyone wants a picture. Drawing head and shoulders only will help you to deal with such a situation;
- keep it simple – a few lines will be powerful enough to create the right body effect, especially if they add movement;
- if the brief requires flattery, use body stance and movement to widen the shoulder and lengthen the body; for women, slim them down slightly and enhance the shape of the hips.

Is this position a stance or a pose?

Stance or Pose?

Does the body position communicate personality or gender, the environment where the subject is found, or the activity in which the subject is engaged? Is the subject relaxed or 'on show', natural or contrived? What is the body position communicating? It will help to pick up on the reasons for stance or pose if you can, but there is no time for decision-making or discussion over stance. If the subject has a difficult stance, be careful – it may be a medical problem such as an artificial limb.

Men often stand with their legs apart, weight on one leg, the other out at an angle, accompanied by one hand in a pocket and toes pointing slightly outwards. Other men stand with their legs slightly apart with equal weight distribution, toes straight or pointing in. Stance and personality tend to go together. As a generalization, the former indicates a more open, more confident type – usually someone who is smart, self-aware and knows just what they look like. The latter might indicate someone who is quieter and perhaps more easily ruffled. Watch out for the jangling of change in the pockets, as this is a sign of nervousness.

Whatever the reason, take care not to make your subject look awkward in a live, commercial environment unless the character is larger than life and it is part of the 'show'.

'Pose' is a more appropriate noun to use in relation to women. Women tend to pose more than men, with feet together, and hands consciously clasped or possibly clutching the handbag. Whether they are graceful or not, poised or garrulous,

THE ART CLASS

The art class, capturing the interaction of the group.

still or dynamic, caricaturing their pose can add humour as well as authenticity. Like men, women also put their weight on one leg, but they have a few more positions in their repertoire. Check it out for yourself.

Stance can also relate to the size of the physical frame; possibly, extra weight is an influencing factor on the personality too.

The way in which you reflect what you observe – whether it is done on the spot or back in the studio – is up to you. In caricature you can depict stance, pose, and leg and arm positions however you like. It is the added element that depends on you, your brief and your bravery.

Make the reluctant subject look more animated by subtle changes in stance and clothes, adding subtle lines that imply additional movement.

Group Pictures in the Studio

Unlike a group photograph, a group caricature will usually represent people doing something. The way in which you handle a group depends on the way in which the group comes together in real life. Sometimes, the commission involves groups of people who never are in the same place at the same time. Sundry client photographs sent to the studio enable individual caricatures to be produced, but the real challenge is to create the collage, bringing in the relationships as well as the features.

With a live group picture, the important chemistry and interaction are there to see. The stance or pose, the angles and gestures of the bodies speak for themselves, depending on what the people are doing. With well-executed creative expression, achieved through caricature, line, shade and cross-hatching, it should be almost possible to capture conversation and to understand what two or more figures people are saying to each other, without any text.

Additional Movement

Adding movement brings in life, which is vital to both caricature and portraiture. It magically lightens a finished picture.

Encouraging physical movement in the reluctant or shy helps to relax the subject in a live setting. This approach is particularly useful when he or she has been press-ganged by a company to be in a picture (this is not uncommon). It can make light work of a difficult job, pleasing both the subject and client. This can be achieved with very few alterations (*see* overleaf).

When your brief is to depict the subject, who may be a personality, involved in an activity – a ball sport, motor racing, acting or even making a speech, for example – the impression of additional movement becomes very necessary to the picture. There are simple ways to make an object look as if it is moving. Angled double lines or several short lines on either side of the

object will achieve a slow forward effect. Circular, explosive or starburst-type lines behind the object infer that it is moving very fast towards the observer.

There are several other ways to create the impression of speed:

- the exaggeration of the arms and legs;
- the use of props – for example, a hat flying backwards off a head makes the head look as if it is moving forwards;
- ties, coats and hair flying in the wind imply forward movement at speed.

Such cartoon-type lines are essential to bring the caricature to life and as such are an important part of caricaturing.

Hands

Of all the features to draw in caricaturing, hands are probably the hardest. Caricaturists and cartoonists rarely have time to go into great detail when it comes to drawing the hand, especially if a quick caricature is needed. The secret here is to master drawing the hand correctly through studying figure drawing, then adapt the skill to caricature. If you can draw a hand convincingly the step on to caricature is easy.

LEFT: Lines and body movement can create a slow forward effect.

RIGHT: Exaggerate the lines even more for the fast forward effect.

BELOW: Hands drawn from life – the caricature is achieved with just a few strokes of the pen.

Having mastered the hand, knowing the shape to be achieved and imagining the correct image, sketch in the shape with just a few lines. Provided the shape of the hands can be mentally linked to the final composition, the picture should be acceptable. Make sure you have captured the way in which the subject has positioned the hands, and any gestures, especially the more flamboyant ones.

It is helpful to note a few of the more common poses for hands used in caricature:

• the outstretched arm with the palm of the hand facing, fingers apart, often used when the subject is speaking to you;
• one arm dropping down, the back of the hand facing out, the other hand very often in a pocket (a popular stance for a man);
• hands folded or hands behind the back;
• knuckles are often noticeable on the steering wheel of a car;
• when hands are holding items, ensure that you have left the right amount of space between the fingers.

Women tend to hold their hands together in front of them, which means that the back of the outer hand and two thumbs are commonly seen. Alternatively, the hands may be holding something: a case or handbag, a handrail or the handlebars of a bicycle.

In the majority of cases, the fingernails should be left out.

EXERCISE: **DRAWING HANDS**

You need to study hands carefully from life and sketch them from many angles. Practise sketching those in this chapter. As before, group as many practice sketches as possible together on one sheet of paper. Draw other hands, even your own, in different poses. If you hold a cup in your left hand and look in a mirror, the reflection will show the cup held in the right hand. Using the mirror, you can draw with your right hand an image that looks as if it is a right hand. Most people are right-handed and most pictures will involve a subject doing something with their right hand.

Once you have a feel for hands and how to draw them, drop the detail. Simplify your lines for a caricatured hand.

Arms

Arms vary considerably between the sexes and the age groups, in terms of length and thickness, hairiness and smoothness. Take a line from under the arm to the wrist to establish the proportions of an arm. Usually the length between the underarm and elbow is equal to the length from the elbow to the wrist. If the arm is hanging by the side of a body the tips of the fingers are roughly mid-thigh in most people. The span on the arms is roughly equal to a person's height.

Arms are worth studying, particularly the underpinning muscles. Learn where the muscles form under the skin and how they look when they are under tension. With extremely well-developed arms, draw in the muscles, using strokes that are as strong as those used for the outline. With smoother, less muscular arms, apply shadows in the right places. For caricature to achieve the right effect, this should be sufficient to capture the look of the arms.

The commonest poses for hands in caricature.

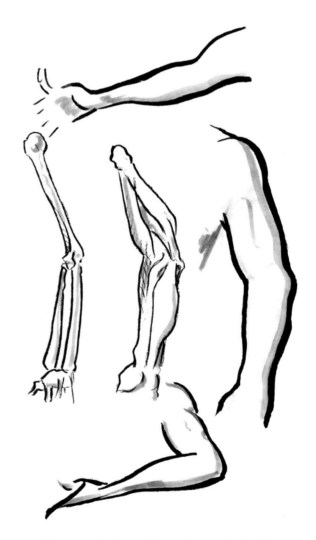

Aspects of the arm and the underlying bones and muscles.

Knowing where to put the arm is important. One area to consider is that point where the arm meets the wrist and hand. The drawing line of the arm curves and flattens out as it approaches the hand and falls over the wrist before reaching the bones of the wrist. This is where the shadows fall. Observing such fine detail is vital. The upper arm and the elbow are the parts of the arm found most commonly in caricatures.

EXERCISE: SKETCHING THE WHOLE ARM
Practise sketching the whole arm, from the shoulder to the tip of the fingers.

If you draw a person playing golf or tennis, where the body is turning within an action, take note of the back of the forearm and the underside of the other arm. These are the most visible aspects. Note also the position of the elbow and the way that the muscles flex with rapid movement of the arms. If the subject asks to be sketched in the gym, perhaps lifting weights, hugely exaggerate his arm muscles, if not the whole body.

If the arms are particularly long, hairy or freckled, be sure to caricature these features.

EXERCISE: PRACTISING DRAWING ARMS
Practise drawing the examples of arms given here and applying them to different bodies with as few action lines as possible. See how life-like you can make the subject's arm movements.

Legs

For advice on the stance and positioning of legs, *see* page 110.

The caricatured leg should be approached in the same way as the forearm, by learning to draw a proper leg first.

EXERCISE: DRAWING A PROPER LEG
The front of the leg is relatively simple to draw, and it is the back of the leg that has the shape. Start your drawing with this area. With one continuous line draw the outline of the back of the whole leg, including the calf, which is the muscular part of the lower leg running into the back of the knee. Observe the thickness of the thigh and the tendons behind the knee. The calf narrows in slender curves towards the ankle. The ankle should always be shown when producing a quick sketch. Now draw in the front of the leg as a simple line to the knee and a simple line from the knee to the ankle, which extends out to the foot.

Use long, smooth, continuous lines when caricaturing legs unless the subject is a beefy rugby player, in which case short,

Quick caricatured sketches of arms.

Caricatured arms in action or under stress.

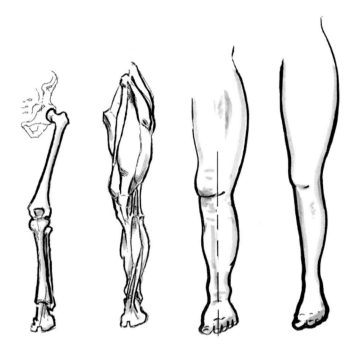

Get a feel for and learn to draw a leg. Go for the basic shape.

rough strokes are more effective. If there is limited time available just quickly draw the leg in outline, but make sure you get the outline shape correct.

Pick out the knee with its shadow just below the kneecap. Let this be the main leg feature that is caricatured. Use shading to add the leg muscles.

Legs roam free in public only when playing sport, relaxing on a beach, or wearing a short skirt or short trousers, and studying legs from life is not always possible. When they do appear, you should notice the vast difference between the great, muscular tree trunks and the thin, spindly ones.

Large legs are easy to exaggerate and caricature whereas pencil-thin legs lack shape. Thin legs are like cartoon legs and do not contribute to a likeness at all, but they do sometimes have their place and may, with their knobbly knees and disproportionate feet, amuse the onlooker.

Think about all the opportunities there are to exaggerate legs: tall people with long legs, stockily built people with shorter legs, moving legs, long curvaceous legs. They will all come into your caricature drawings at some time.

Feet

Feet are, like hands, with their many little bones, quite a complex part of the body to draw realistically. However, in

caricature it is not necessary to represent every detail. Most subjects will have their shoes on, but, even when drawing shod feet, you should not forget the detailed underlying structure – the bones, muscles and sinews of the actual foot. However, unless the foot is bare, you are only really interested in the foot's basic shape and attitude.

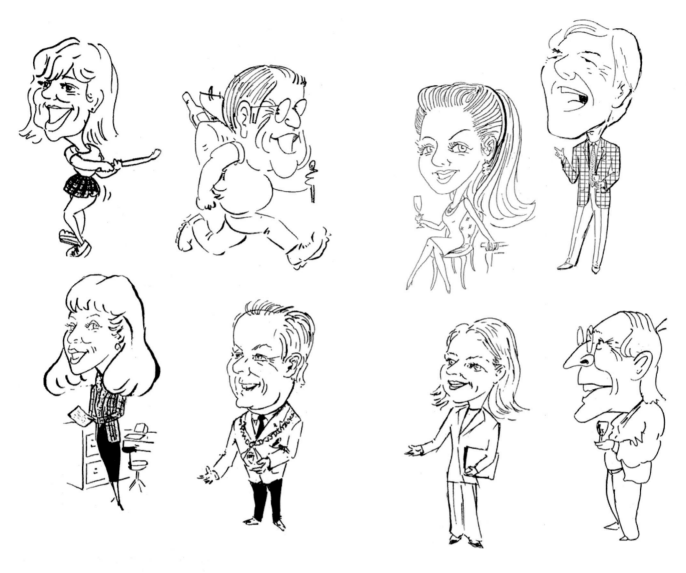

ABOVE: The commonest poses for legs in caricature.

LEFT: Capture the spindles
and the tree trunks.

This basic shape still has a slight degree of complexity: the ankles, the size and length, the top of the foot, and toes when a woman is wearing strappy heels in the summer. Simplify all these aspects by using just a few angles or curved lines, depending on your style. Make them convincing, ensuring that they are correctly positioned in relation to the body. Once the ability to caricature the shape of a foot is instinctive, the correct image will come very quickly.

Often, successful caricature lies more in the conveying of the movement or position of the foot rather than the detail, especially if sportsmen are being drawn. Exaggerated foot positioning and movements can add humour, make a point or reveal character: the sprinter too quick off the block, the confident business woman revealing diffidence through the position of her feet, the boxer's triumphant, wide-apart solid stance in victory, the footballer's soft, confident stroke of the ball.

Before you start to caricature a bare foot in detail, look at the foot from different angles. In the main you only ever see your own foot looking down from above. Study the general side view and shape of the foot. Note the prominence of the arch. Now study the general shapes – the angle of the toes, the gaps between the toes under weight, the angle of one toe to another. When drawing feet it is important that the big toe is on the inside, the second toe is almost as long as the big toe, the smaller toes appear to curve back at an acute angle and the small toe is visible as a fleshy lump before the line returns towards the heel. Make sure both the anklebone and the degree of muscles on the face of the foot are clearly shown on each foot.

If feet need to be added quickly to a caricature, understanding the basic shape will stand you in good stead.

Artefacts

All sorts of other items may be added into the general picture if required. They may or may not have to be reproduced precisely. One large artefact will be handled differently from a number of small objects, which could be merely hinted at with quick lines. A large object will need knowledge and more precise representation.

The way in which the foot works in caricature – the angles and shapes that can be used.

The same picture with shoes on the feet.

117

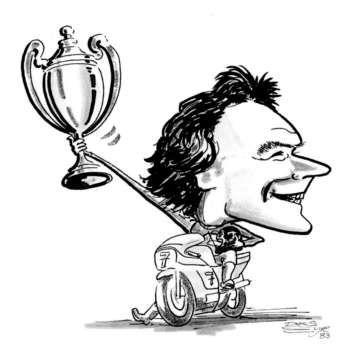

If you can, add the motorcycle: Barry Sheene.

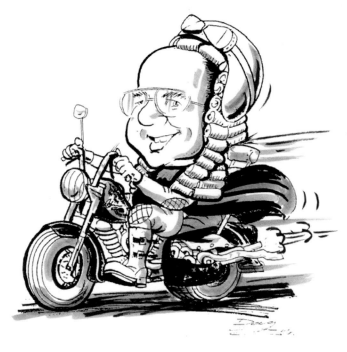

Magistrate, Harley and toiletries – all in one!

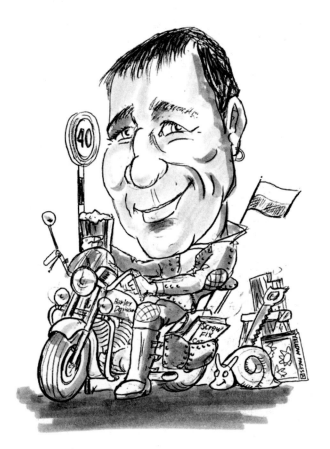

Harley, pint and DIY.

Remember, if you are caricaturing live and adding artefacts afterwards, you should roughly position and sketch artefacts on the page before drawing the body. This determines the amount of space available and, therefore, the body size. In this scenario you have a choice about size: bodies can be sized relative to the artefact(s) or caricatured completely out of proportion, and vice versa.

Artefacts support the energy that goes into capturing character, and there is usually a tremendous range of possibilities. Try to stick to one theme.

When a magistrate who has spent a lifetime working in the toiletries industry (above – note how the wig is a composite of toilet rolls) asks to be drawn riding his Harley, it is not appropriate simply to guess at what a Harley looks like. Harleys are frequently requested. Character Two (left) also loves his Harley, likes a pint and is keen on DIY.

Experienced caricature artists producing full caricatures with a significant amount of additional detail lay out the picture fully in their mind before putting pen to paper. Students should decide for themselves on the extent of their artistic ability, stick to the artefacts they know initially, then increase their repertoire, evaluating the percentage of the paper they will need before they start. The wider your repertoire of artefacts, the quicker you can produce a live caricature, and the more you will amaze the crowd and please the recipient. If, for instance, the subject has a favourite car that he or she would like in the picture, it should closely resemble the right make and model.

Over the years, I have built up a mental database of all sorts of objects that I might be called upon to draw. Styles change, so the memory bank has to be regularly updated. Possessing this sort of repertoire will give you a leading edge and pay certain dividends.

In studio sittings, chat with the subject early on to establish what, if anything, they would like to be doing or would like to have in their picture. In studio work you can take the time to study references if the additional objects are not already in your repertoire.

Sometimes the imagination has to bring together in one picture many tenuous aspects of a subject's life: in one example (*see* below), I had to represent a successful business background, an ability to beat off competitors, many leisure pursuits, a desire to win and a strong sense of fun. It was agreed that the subject would be drawn as a spider, thus achieving the brief to capture features, personality and character, including the multifaceted aspects of his life. The bicycle was the starting point on which I hung the whole concept together.

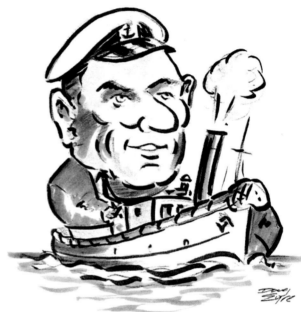

If you add a boat, get the shape and details right.

The many facets of a character's life and personality captured as a spider on a bicycle.

MAJOR PROPS

There are a number of common props that are closely associated with the body itself, and you must look for these when eyeing up your subjects. If a prop is a part of the subject – his glasses, a musician's instrument, or a particular car – it must be in the picture. Why not caricature it, too? If a personality is known for a skill – for example, a chef for his cookery programme, a TV gardener – you can add the appropriate artefacts and caricature them.

Glasses

If appropriate, make the glasses the main feature of the caricature. Play on the position of the eye relative to the glasses. The eye peeping out from a corner will create the impression of liveliness and energy, while eyes peering over the top of a pair of glasses will give a more studious, intellectual image.

To appreciate the extent to which glasses can make a difference, study the works of 'Spy' and other *Vanity Fair* artists. Glasses – spectacles, monocles, pince-nez, nose spectacles, or half-glasses as we call them now, often with a neck cord attached – featured particularly heavily in the caricatures of this publication. In some cases, the introduction is a mere indistinct impression. In others, the glasses are fully exaggerated, and serve to define the person concerned. These portraits are a particularly useful source for studying spectacle fashion.

The manner in which a frame is worn, held or suspended is part of the caricature. Note where the frame sits on the nose, how a pair of glasses is flourished in the hand, whether they are parked above the hairline, out of the way. Do not forget to add the sides of the frame to the picture; they are easily overlooked.

Take into account the shape and thickness of the lenses, remembering that the lens can magnify the eye and thus change the appearance of the iris and the pupil. Where the glasses are large, the lenses can also magnify the area below the eye, emphasizing lines, bags and wrinkles. Adjust your facial lines and upper cheek area accordingly, especially in a detailed drawing.

A simple spiral line is sometimes used to portray particularly thick lenses.

Even the most professional artist, when concentrating on quick drawing, may note the glasses but miss their interesting design features. Learn to observe well to avoid spoiling the picture for such simple oversights.

Artists developing their skills should draw the eyes, then add glasses.

Warts and Blemishes

Blemishes are not exactly a prop, but they must be considered – with care. This can be a tricky area. Their addition or omission can change a whole picture. If you do not add blemishes, the

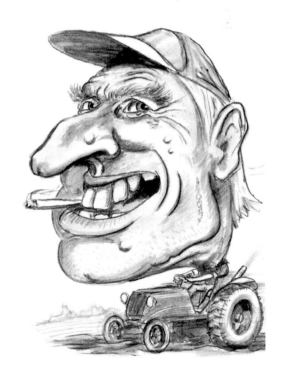

Warts and all – this needs care!

picture will not reflect the person you are drawing; however, subjects are obviously sensitive to their presence and may prefer them to be ignored.

The trick to handling them is merely to hint at them, to add realism rather than attract the eye specifically to the blemish. This step is executed primarily by adding shading. Take a pencil. Lightly add in the hint of a blemish. Avoid emphasis unless, of course, it has been highlighted before, as it may well have been in the case of a personality.

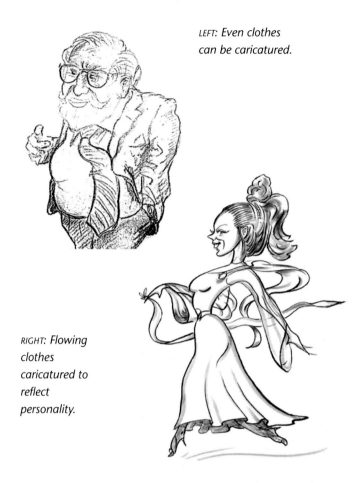

LEFT: *Even clothes can be caricatured.*

Shoes

When first observing your subject top to toe, note the type of shoe that is being worn. Do not forget to check out the size too. Just a quick glance should be enough to retain that detail in your memory. Many different styles – high wedge-shaped shoes, knee-high boots, sandals, trainers, cowboy boots – lend themselves to exaggeration. There are many more and you can have fun with them all.

You do not need to go into great detail. A quick couple of lines can capture the essence of the style, from the fine lines of an elegant lady's shoe or a pair of sandals peeping out from under a long gown, to the mud-clad Wellington boot of a country dweller.

RIGHT: *Flowing clothes caricatured to reflect personality.*

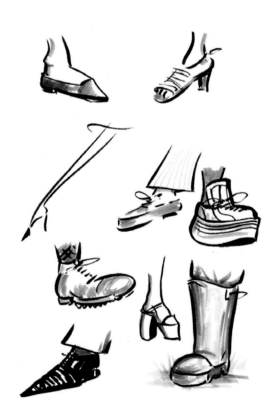

A range of caricatured shoes, in a few lines.

Clothes

Clothing is another area where speed and accuracy count. Capture whatever is being worn around the neck area first, because of its close proximity to the head. Now look at the rest of clothing to identify interesting items such as unusual belts or a particularly striking pattern on a dress. With men's clothing the width of the trousers and the fashion (flared or straight), the shape of shirt collars (buttoned-down or not), are noticeable areas. With women it is a matter of the fashionable or unfashionable, both of which speak volumes.

EXERCISE: **LOOKING AT CLOTHING**
Use magazines, newspapers and other mechanisms to pick up on the link between clothes and occasion. Become aware of the 'uniform' attire among spectators of different sports, and get to know the stripes of some of the major football clubs. Occasionally a caricature will involve historic costume; while you need not know the detail, a feel for shape helps.

Clothing is one of those areas, when you are working live, that the crowd will pick up on. There is always one who will try to catch you out.

One of the useful aspects of clothes is their ability to help in creating the impression of movement. A coat flowing out the back or a tie whisking over a shoulder can imply running for a bus. Such additional lines contribute to the fun and immediately indicate movement, even before 'go-faster' lines are added.

Do not neglect the important features of cloth, such as its ability to add to harmony of line by its flow around the body. Simple lines added strategically – a wrinkle near the ankle, a dart near the bust line – will reinforce body actions or areas. Be aware of the fact that some garments crease easily while others are almost crease-free. Exaggerate weave and texture: carry laciness across almost into character, highlight rough tweediness alongside the strong, more rural type, embellish slinkiness in association with a beautiful blonde woman.

Hats

Hats provide an easy means by which to add movement – a hat shown flying off the back of a head will indicate a significant amount of speed – but they are useful in other ways, too.

Today, people do not wear such a wide range of hats as they might have done in the past. One of the most commonly seen is the American baseball cap with its long peak, which lends itself perfectly to caricature. Quickly draw over the top of a nose and exaggerate the peak; it takes only six lines to draw one. Follow the sequence in the example (see below) and see how you get on. Most hats can be drawn with no more than six lines, but you should take time in the early stages of a drawing to note all the details, especially in a lady's hat.

On a practical note, adding on a hat, in a live environment, can be fun and quite entertaining. You can really impress the crowd if your subject suddenly tells you he would like be seen as a cowboy and in three seconds flat you have endowed him with a convincing ten-gallon stetson.

Drawing a character dressed in military uniform is a more serious task. If it is part of a live event, accuracy plays second fiddle to entertainment. However, when commissioned to produce a detailed caricature portrait of a high-ranking officer, detail is all-important. You will need to research every aspect, including the differences between military-style peaked caps. It is most interesting to compare one with another. If the cap style is wrong for a particular uniform, your picture will probably be rejected.

It is worthwhile researching and drawing a number of types of hats and committing them to memory for future use. Eventually, a point is reached at which sketching the hat is so quick, onlookers will be astounded. Every time the particular style comes into play your personal challenge will be to ensure that it has been done using the minimum number of lines.

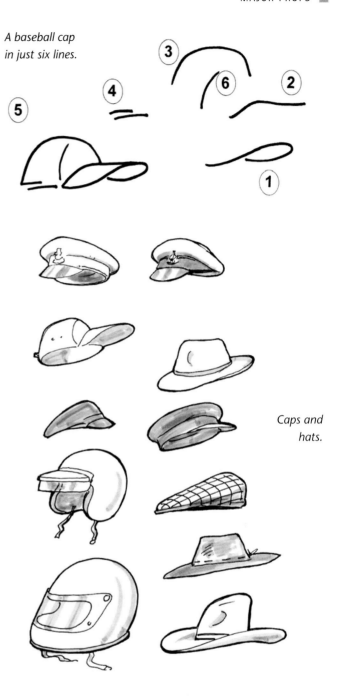

A baseball cap in just six lines.

Caps and hats.

There are many types of hat that appear in caricature pictures from time to time. Study the different types and practise drawing them.

Jewellery

Ensure you capture the likeness of any jewellery – watches, bangles, large rings, earrings – as closely as you can with just a few strokes. Do not leave out the glinting highlights that come from it.

SPOTLIGHT ON OTHER KEY CONSIDERATIONS

Proportions

In art, the size, location or amount of one part or thing compared with another is governed by certain regular proportions. On the face, the eyes are set halfway down the oval (*see* page 51), the bottom of the nose is usually as wide as the gap between the inner corners of the eyes, and the mouth lies roughly halfway between the end of the nose and the chin. Caricaturists play with proportions and sometimes the mouth may be placed just above the usual line, for example. When looking at caricatures it is still important to use the age-old method involving thumb or pencil, to cross-check any proportion within the caricature as you are producing it.

Positioning on Paper

Mental visualization of the whole picture is vital *before* pen or pencil hit the paper. This principle applies whether you are working in a studio or live. Although there is less time in live caricaturing, composition, proportions, perspective and appropriate use of the whole piece of paper are still important, even if there is only a split second to consider each aspect. Where work is live, the head is the main feature, so it must take up most of the paper. Using the one-third/two-thirds principle, it should be positioned two-thirds up from the bottom of the page, leaving room for the exaggerated small body underneath.

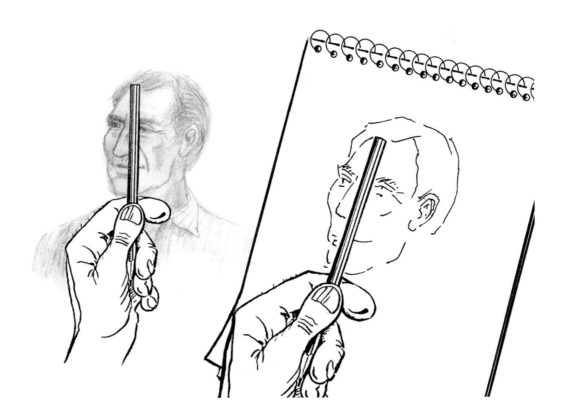

Measuring proportion.

In the studio, new work or finished live caricatures may require artefacts to be added as part of a more detailed picture. It is very important to consider the balance of the whole. When adding artefacts, ensure there is enough space to play around with the layout. If there is access to a fine-quality line printer make copies in different sizes of the head, body and artefacts. Offer them up to suit the surrounding detail. This approach will give you much more flexibility in arriving at the finished picture. It is essential if a collage is being produced and it is to be meaningful.

Think and work through layout concepts away from the crowds or the deadlines so that decision-making becomes instinctive when you need it.

Line Quality

The secret to line quality is line variation, and it is line quality that distinguishes an average drawing from a special drawing. Where the effect is needed, lines should be strong, emphasized and reinforced with shadows, and softer, gentler lines should be added to ensure the contrast. It is this variation of line that, along with the likeness, gives the picture its life.

Many caricaturists, particularly renowned artists, develop a style clearly based on line variations. Two major examples of

Simplistic harmony of line to create an image.

caricaturists who have understood the interaction between style and line variations are Hogarth and Searle.

Hogarth

Hogarth talked about the 'line of beauty' in his 1753 book *The Analysis of Beauty*:

> 'It is to be observed, that straight lines vary only in length, and therefore are least ornamental. That curved lines as they can be varied in their degrees of curvature as well as in their lengths, begin on that account to be ornamental. That straight and curv'd lines join'd, being a compound line, vary more than curves alone, and so become somewhat more ornamental. That the waving line, or line of beauty, varying still more, being composed of two curves contrasted, becomes still more ornamental and pleasing, insomuch that the hand takes a lively movement in making it with pen or pencil.'

Searle

Searle wrote about the conflict between his angular, jagged pen and the paper: 'Quite suddenly I began to draw. I had been scribbling forever. Now it took shape and I became, first fascinated, and then obsessed, with what it was possible to do with pen and pencil. No one paid much attention to this, nor to the fact that the drawings were immediately grotesque.' (Ronald Searle, *In Perspective*, his 1985 collection)

Searle's incarceration in a Japanese prisoner-of-war camp is said to have been a key influence on his bleak humour and the jagged style afforded to each scratchy, angled line. Angle defines his work; repeated angle forces the linear energy into each drawing.

Over time, a caricaturist finds his or her prime line strength and variations and effects to suit their chosen style. Experimenting to achieve a style and preferred medium is to be commended.

Harmony of Composition and Line

Harmony of line and flow is the secret to a pleasing picture. It has to be worked at but it does come naturally with experience. If there are two opposing angles on a picture it creates conflict within the picture. This may be the desired effect.

Caricature showing the harmony achieved in a few lines.

A practice piece – trying this one gives students great confidence.

In a minimalistic caricature, harmony of line is vital. There are so few lines that every one must flow through the body being drawn and interlink harmoniously.

EXERCISE: **ACHIEVING FLOW**

Most would-be caricaturists struggle with a lack of flow. There is stiffness in their approach. Continuously practise loosening your style by drawing circles in a continuous circular flow on paper. Learn to harmonize one line with another until the pen glides effortless over the paper.

Study and copy the practice piece above right, remembering that, to achieve real harmony of line, you must be sure of your proportions.

Handedness

The importance of handedness may not have occurred to you before now but it does have a bearing on speed and delivery.

If you are right-handed, the right drawing arm easily pivots from the elbow. It is easy for the hand and pencil or pen to move in an arch. It is easy to bring in the nose when drawing a line curving from right to left, for example, when drawing a profile.

EXERCISE: **EXPLORING HANDEDNESS**

Pencil in right hand, draw a simple profile caricature, bringing in the forehead, nose and chin in one continuous stroke. Accuracy is not the main goal of this exercise. Note the ease with which the pivoting arm moves. Now try the same profile drawing with the left hand. Ignore the fact that the standard of the drawing will be inferior. Note the awkwardness of the continuous stroke as in this instance the arm cannot pivot.

Does it matter whether you are left- or right-handed? Certainly, the handed approach to drawing a caricature determines the ease with which the curves and strokes are created.

If you are right-handed, you should be aiming for a left three-quarter view, with brows, nose and chin featuring heavily. Your strokes or line should go from top right to bottom left. If you are left-handed, you could work bottom left to top right in a natural arch. However, if you are left-handed the right three-quarter profile will be much easier to work with.

Think about handedness and work out the most comfortable approach for you to achieve the necessary speed and accuracy.

Introducing Humour

What a profession or hobby! Your raw material is all around you in the people you encounter every day, either in person or through the media, and every caricature has the potential to be comic and to create laughter. In caricature the humour is understood. It is said the more a person laughs the longer he lives and, indeed, many caricaturists seem to achieve the full century with all their faculties intact! Laughter and caricatures go together, but you should keep in mind the darker side to human nature.

Humour links to the ability of people or situations to invoke feelings of amusement in other people. It encompasses any form of entertainment that creates such feelings, or makes people laugh, or feel happy. Caricaturing introduces humour in several ways. The very act of caricaturing, like watching someone slip on a banana, is amusing to others because it is happening to someone else. The interaction of those in the crowd, with one another, and with the subject being caricatured, may cause a few laughs. The picture on the paper or screen should, if exaggeration is involved, amuse. And there may be some good banter between the subject and the caricaturist, as the latter tries to put the former at ease.

Use humour in the drawings and in the relationship between yourself and the sitter, and use the crowd where you can. Amusing a wider audience through the newspaper or magazines might even buy fame and fortune.

Most artists are aware that humour within the caricature involves the mouth, eyes and facial lines, to the point that the whole face can light up. It is less common for them to be aware of more subtle humour – the slight, more detailed facial changes that arise from a witty remark, for example, associated with dry humour. Look for these very slight facial and body

A humorous situation.

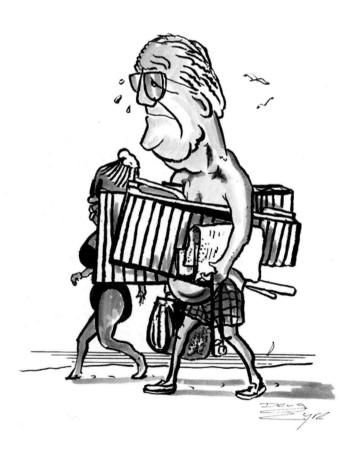

Humorous caricature verging on the cartoon.

changes, as they communicate a great deal about personality and character. Although they are small, they should not be missed.

Malice, vindictiveness and gross distortion cause laughter in their own way. Be mindful, however, that this version of humour is more about doing to others and in some cases is not far removed from bullying. At its extreme, it is a form of vengeance – a less attractive manifestation of humour – and likely to offend. While offence may be the artist's motive, the subject may be too sensitive to deal with it. A public figure might be fair game but real vitriol against a private individual should be carefully considered. The question is: does absolutely anything go?

Remember that not everyone has a sense of humour – that very fact can spur a caricaturist on.

Capturing dry humour is difficult to do.

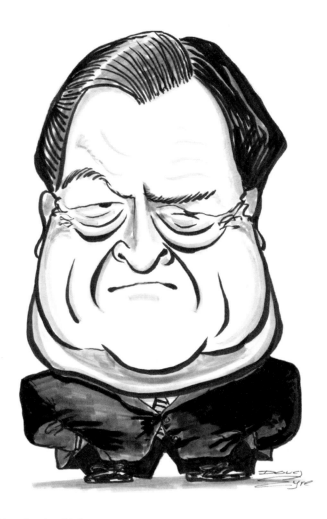

How far should the caricaturist go? Are there boundaries? This is John Prescott MP.

IMPROVING OBSERVATION OF TYPE AND UNDERSTANDING OF PERSONALITY

Ralph Sallon was born in December 1899 and formally retired from caricaturing in 1991 only, as his daughter pointed out, 'because he was knocked down in a road accident'. He died in October 1999 just short of his centenary. His long years of caricaturing had led him to the conclusion that 'the art of observing is to forget yourself': 'The art of caricature is not to think of yourself in relation to anyone else but to think of the other person only. Your whole personality must go outwards, never inwards.'

Unpacking the Component Parts

Personal characteristics such as shyness, pride and cunning may appear obvious, but many people learn to manage such traits. Insecurity may be hidden by a strong clear voice, and deviousness by a clarity of speech and communication.

To unpack the component parts, first put the subject at their ease by talking to them. Such distraction helps the subject open up. Introducing a third party can help the subject to relax even more and open up even further; this would be the preferable route. If you are caricaturing live, ask the subject to talk to someone close by, to distract the concentration from the actual act and allow a degree of detached observation.

While the subject is chatting to the third party, you are multi-tasking, picking up on features, physical and verbal clues. The mouth and the eyebrows are very quick indicators of mood; body language is equally revealing – hands and arms can be tightly crossed in defensive mode or relaxed and open; the first few sentences or a pose can reveal pomposity.

Remember, a good caricaturist will be sketching a feature (usually the eye, which is the launch pad of an accurate caricature), observing and chatting simultaneously. This is where you are aiming to be eventually. Lightning, almost subconscious,

analysis of the component parts of the subject's character is a learned reaction that comes only after years of practice.

Analysing Each Component of Personality

To relate to a person and build any sort of bond you must ensure that you show that you are enjoying their company. Looking bored, tired, disengaged, even if you are, loses you the opportunity.

Try to establish three elements of personality to reflect in the picture, no more. More, in most instances, will overload the picture and slow you down.

To break down barriers and get to know the subject in the short period of time available, ask simple, non-threatening, open questions. They will reveal a great deal about your subject.

Open questions are questions that help to gather information and qualify it, leading to further questions, while establishing rapport and trust. They usually start with 'What', 'Where', 'Which', 'Who' and 'When', and require a fuller answer. On the other hand, questions starting with 'Are' or 'Do' are closed questions, generating simple 'Yes' or 'No' answers.

For information gathering, try the following questions:

- Where do you live?
- What do you do?
- Have you any children?
- When you are not working, what are your hobbies?

Qualifying but not probing questions might include the following:

- What is it like to live here?

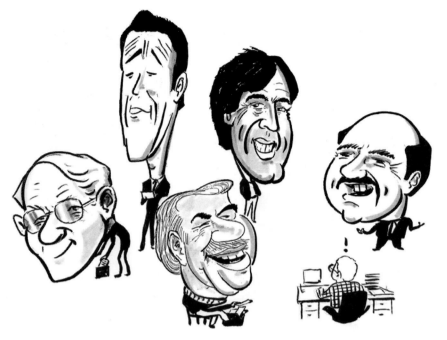

Categories and types: salesmen.

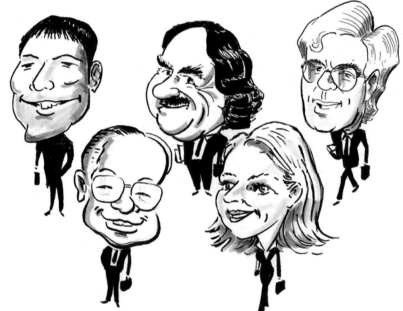

Categories and types: executives.

- Have you always done the job that you do?
- Which schools do your children go to?

In order to establish rapport, trust and credibility, try some of the following questions:

- Did you get involved in ... ?
- What did you say then?
- What did you think of ... ?

Be interested in the responses. Be careful of probing questions, such as 'How?', 'Why?', 'In what way?' or 'Tell me more about ...', as they take a long time to answer. They may be used in the studio but not in a live situation, as they distract too much from the drawing.

EXERCISE: **USING OPEN QUESTIONS**

As you go about your everyday business, make an effort to engage with others using open questions. At the same time, observe their mannerisms, body language and reactions. For many this is instinctive, but others are rather introspective and not used to observing and engaging openly. Try your open questions on friends and family; you may even unpick new

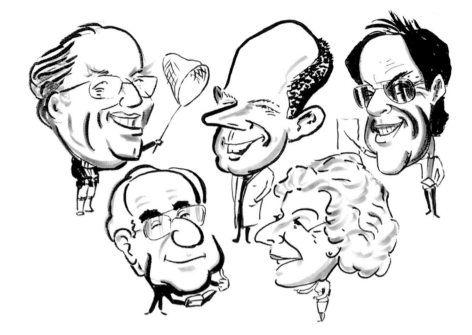

Categories and types: academics.

aspects of their character and personality. Your own interpersonal skills should improve. Test out the different physical and emotional responses when you ask open and closed questions. Remember to 'drop your self', and become 100 per cent interested in others. Keep looking for visual and character pick-ups.

Cross-Referencing to Previous Experiences

Experience cannot be learned or bought. It is achieved over time by practical contact with, and observation of, facts or events. For the caricaturist, it is the build-up of events or occurrences that leave an impression on him.

Experienced caricaturists will tell you that most people have a look-alike. If they are in full employment, working with thousands of subjects a year, they have probably 'met' all the characters they draw before. Caricaturists, particularly those who work live, find people do fall into categories: similar types, similar characters and similar personalities. A whole industry has been built up around personality and character profiling for the recruitment industry: Myers Briggs, Belbin, Keirsey are three such approaches. Without dipping into detail, everyone knows the signs of an introvert and an extrovert. Everyone is familiar with the idea of the obsessively picky personality, the ambitious, focused salesman and the pompous academic.

Typecasting and personality assessment is made easier in part in the twenty-first century as more and more people are required to work within the required bounds of company or occupation profiles. Caricaturists call on their vast library of acquired observations and interactions to make the task of caricaturing quicker and easier. They can cross-check any new experience to this vast library and this speeds up the whole process.

As well as look-alikes there are people/types who share similar physical or personal characteristics. The way a person looks, speaks and behaves all contribute to the type; judgements cannot be made on the features in isolation. Just look at a group of schoolchildren and then remember your own school days and your own classmates. You will see many of the characters from the past are still around today: the swot, the 'goody two-shoes', the know-it-all and the young careless kid.

Such familiarization is invaluable, especially when producing 'on-the-spot', lightning caricatures. You will find that you will be able to move forward with sound confidence based on a degree of 'knowing the type'. Caricaturists hone their observational skills to the point that they are right more often than they are wrong in this lightning assessment.

Keep practising and you may experience this for yourself.

Packing the Detail Back in the Box

At some point your own personality will influence the finished product. You will make a judgement and decide how personal objectives, acquired perceptions and observed traits should be overlaid in the production of the finished subject matter. The goal and the end product must be clear. You are at a crossroads at this point and you may have to ask yourself some searching questions.

YOUR OWN PSYCHOLOGY

Some say caricature art developed late because man's tension towards man usually resulted in aggression. Only when injury from distortion was seen as a joke could it develop. Others say it was a natural result of a surfeit of serious fine art. The joke was that when it did first become an art form it was not wholly appreciated as it was seen as a form of fun and play rather than fine art.

As art moved from the imitation of nature to the revealing of character, so caricature moved on to looking beyond the perfect to the imperfect – distortion and inner ugliness.

We saw in the introduction how as caricature emerged as an art form over the centuries, it oscillated, mischievousness becoming malice and vice versa. For many caricaturists, subjects become victims. Caricature thus became a powerful weapon.

In caricature, the artist has this opportunity to alter his model. He or she can distort the subject, play with the features, substitute a subjective vision. This 'power' and talent can lead down several roads. The victim may feel wounded, and not consider his caricature as the innocent play of transforming features. In fact, this interpretation may also be experienced by others. If the caricature fits, the victim can be transformed permanently in our eyes. He is not only mocked or unmasked, but actually changed, carrying the caricature with him throughout his life and even throughout history.

From the many examples in this book, it is clear that where and how caricatures are produced varies considerably. There is a vast difference between sitting in a studio and referring to photographs to create exaggerated line drawings, and lightning live on-the-spot caricaturing, and then again cold-blooded, calculated, gross distortion of both feature and technical accuracy in the name of comment or exposure.

The former, the studio sittings and exaggerated portraiture, will be very acceptable to the majority of people. Live work is very amusing, entertaining and highly appreciated by most people at the time and in the main after the event. The latter, the cold-blooded, calculated, gross distortion, can be highly appreciated by the public, if not the target, whether the exaggeration and distortion is right or wrong. This very fact that a caricature can distort beyond recognition yet be highly appreciated is the subject of much debate. But it is not always the case – move outside the audience's comfort zone, and showing unfairness or inappropriateness could in some quarters be very damaging personally or professionally.

Any caricaturist, amateur or commercial, needs to have a feel for the subject's tolerance level and their public's mood. A caricaturist needs to know his or her own limits. There is often balance to be struck.

Distortion of features can be used to make a comment about a subject.

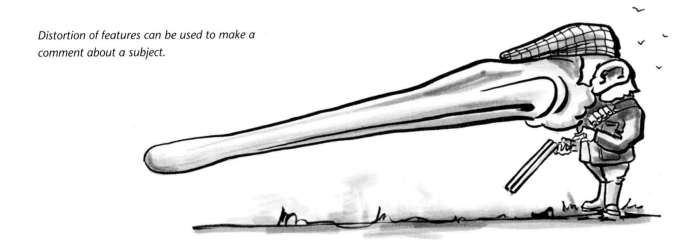

Know Yourself, Your Objectives and the Risks Around Them

Once a caricaturist has mastered sufficient draughtsmanship to underpin a caricature and the art of caricaturing, he or she is ready to set off on a personal journey. As a first step it is wise to have clarity and focus around your objective when caricaturing a subject. It is time to identify the range and scope of work you wish to do and the style in which you will deliver your work.

Knowing the focus of your talents is important.

Are you setting out to:

- make someone feel good, or look good? Do you wish to draw out the best aspects of your subject? Do you want to make them feel really good about themselves?
- make a personal 'remark' about some physical or personality trait associated with that person?

- pick on some physical attribute that instantly facilitates recall of the person?
- highlight a hidden trait that you personally feel is important to reveal?
- make a personal statement, representing a commonly held belief?
- make a political (whether with a small or capital P!) comment on a person's attitude or belief?
- shock or reveal?

What are your intentions – humorous exaggeration or precision cruelty? Just how unkind can you be with the medium you are working in? Even more importantly, how unkind are you willing to be? Your subject, whatever he or she may say, will be conscious of certain features and you have to make that judgement whether to play for them or not.

There is a personal journey to be made. Finding a medium and style that suits is down to your own personality and motivation.

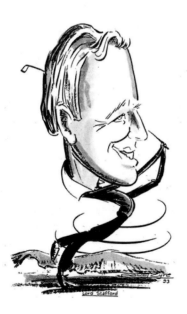

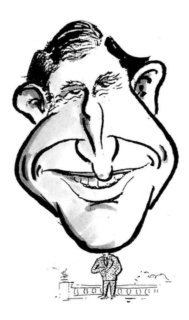

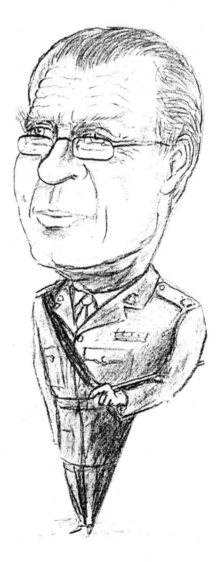

An example of exaggerated physical characteristics.

Will you remain objective or will you allow your own bias to show through? Is it your bias you will reflect or that of public opinion? Over a time period will you contribute to public opinion, moving from objectivity to helping to determine public opinion through your work? Are you prepared to move beyond recognition with your distortion?

It really is worth looking inwards before you start and having a clear understanding of what you are about and the range of opportunities open to you. Have you thought about whether your observation is in step with others? Have you measured your own personal or professional risks around the finished product? Are you familiar with the equalities legislation? Will you overstep legal or cultural boundaries?

Assuming you have observed clearly and learnt to deconstruct and reconstruct well, it is now your choice as to which direction to follow and much will depend on your own personality and the life experiences and life chances that have shaped you. I am not suggesting that you rein in on your direction of travel – just think about it when you are ready to start caricaturing and remember the old phrase that 'he who pays the piper calls the tune'. Take care not to overstep the brief in a commercial situation. On the other hand if the brief is to overstep the mark then the accountability is only to yourself, to your own philosophy and drivers. You set your own boundaries.

The Psychological Evolution of Caricature Beyond Recognition

This occurs on two occasions when verbal communication of key features leads inadvertently to distortion. A good example occurs when the police ask eye-witnesses to study photographs or visualize the faces of criminals. The resulting picture is to a certain extent a caricature. In such instances anti-caricaturing is to be preferred but difficult to achieve.

A second curious phenomenon can occur when a personality's position is such that he or she is caricatured regularly. As popularity changes, increases or decreases, so the extent of exaggeration and distortion can change. I am confident a clever mathematician could correlate the degree of popularity to the degree of exaggeration of key features.

At its extreme the caricature no longer looks like the personality. On occasions the caricature no longer looks like a person. Gerald Scarfe is well known for such super-portraits.

Is it that we are recognizing the characteristics and personality in a setting more than the exaggerated image? On such occasion, have we moved from recognition to some other form of communication? Over the centuries many have railed against such distortions, saying they are not caricature; however, in the widest sense the transformation, ambiguity and distillation of the caricaturist is truly visible.

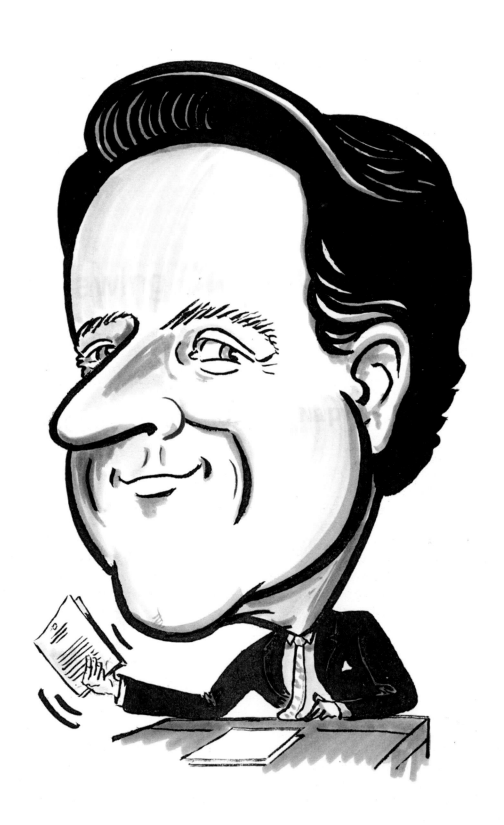

CARICATURING AND POLITICS

The history of caricature art (*see* pages 12–19), an ever-growing awareness in the public, and the multimedia deluge that surrounds us all necessitate a quick comment on the relationship between caricature art, cartooning and politics.

Many people do not appreciate that political (with a large 'P') caricaturing is only one aspect of the caricature art form. Each caricaturist has worked out a distinctive style for his message: angular, geometric, curves. Some work quickly to deadlines, while others spend weeks in the studio. Corporate entertainment, display and presentation, gift art and pure caricature art occupy thousands of caricaturists, worldwide, daily. In addition, harking back to the engravers' print shops of the mid-eighteenth century, there are an increasing number of amateurs amusing themselves and their families through caricature. The commercial outlets for caricaturists are expanded on in Chapter 22. Here we take a brief look at political and social caricaturing and cartooning.

Satirical caricaturing is said to have had its origins in early Dutch work. Hogarth's extraordinary artistic talents were harnessed to his moral persuasion (*see* page 14) and political corruption and social hypocrisy were at the mercy of his pen. Gillray's despising accuracy took the satirical political art form beyond Britain and was embraced by, among others, the French. It played a major role in the Revolution and the downfall of Bonaparte. It even pricked the pomposity of the French art world: the dizzyingly excessive display of thousands of paintings and sculptures at the Salon exhibitions in Paris and its all too self-important visitors were a prime target between 1840 and 1900. Nast, the father of American political cartooning, played politician and critic, setting opinion and reflecting it, and influencing the vast array of political comment in the twentieth century.

Newspaper cartoons, the popular visual means of putting complicated social and political situations and issues of the day across to the people, have made caricaturing and cartooning close bedfellows. Caricature is in some ways only a part of the main feature in cartooning. Caricaturists mainly work within the traditional format, although some are now straying into the linear, strip cartoon world. However, caricature and cartoon each in their own way do the job of poking fun at pomposity.

Today's printed savagery can seem mild compared with that of the eighteenth and early nineteenth century, but standalone works can be significantly crueller.

Cartooning and caricaturing in the press can be seen as a rather negative occupation, but they serve the greater good well, exposing those aspects of politicians, national and international, who might be working other than in a serving capacity. Caricature, which is so good at capturing character and personality, is a big part of pricking the bubble. It is ideal when either or both, cartooning and caricaturing, work to positively undermine a day job done badly or a social ill not addressed. The relationship between politician and caricaturist is never an easy one, but it is rare to meet a politician who does not wish to be noticed in some way.

Often through the caricature the public will pick up details that are not widely known except by those close to the politician. Such details can reveal motive and personal drivers. It is important that such aspects are widely known as they often have an impact on decision-making.

On many occasions, aspects of caricature within cartoon or standalone are linked to a news story. Caricaturists these days do not create the story, as Nast did in his day, although the recent French caricatures of Mohammed proved an exception to this. Cartoons do necessarily campaign or reflect personal opinion, unless they are part of editorial and that editorial is known to reflect the newspaper's policy. Rather, cartoons are required to succinctly comment.

Whether an independent caricaturist/cartoonist is tied to a newspaper's policy will depend upon his or her own arrangements. The independence shown by some, like Low, was heroic. His employer Lord Beaverbrook of London's *Evening Standard* tolerated Low's politics, even though they were at odds with the newspaper's own, because of Low's rating with the public. According to Lord Beaverbrook, 'His caricatures were the most important element of the newspaper.' Low's caricatures of Baldwin, Chamberlain and Hitler dominated the day during a period when a larger-than-life propaganda machine was emerging.

Cartoonists and caricaturists work for an increasingly worldly-wise public, as a huge range of media shapes the public view of

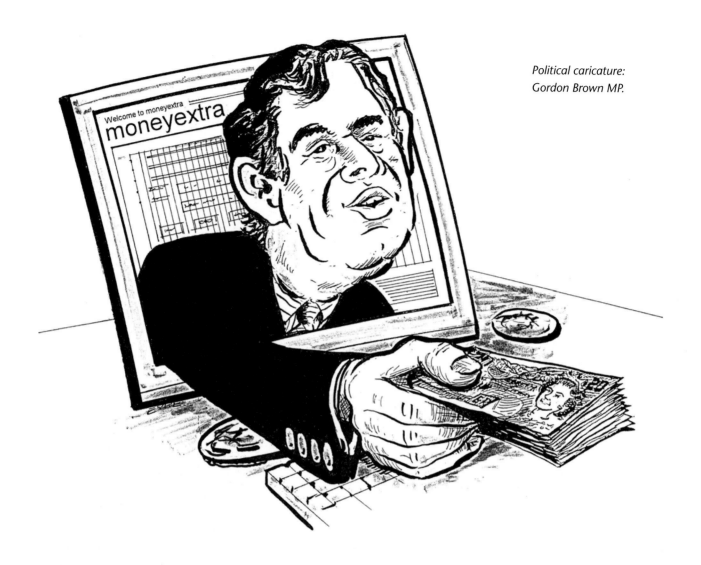

Political caricature:
Gordon Brown MP.

politicians and personalities. The pressure to make a difference at a political and social level in the current climate seems greater and the outcomes from the work seem less instantly radical. However, like water on a stone, quietly and confidently, it goes on undermining as appropriate. (Increasingly, when it is deemed inappropriate, an element of the public articulates its own views. Scrutiny and challenge of cartoonists and caricaturists in the political and social arena is certainly more visible today.)

The big difference between the caricature element and the cartoon element relates to aspects of creativity. The cartoon element requires the creative idea to come from the story, the headline, and politics of the day. The caricaturist has all the creative canvas presented to him in the face and body language plus, in the case of the politician, the journalists' hints of rumour and innuendo currently in the air. The caricaturist then reflects through representation of character and personality, while theme is the driver for the cartoonist.

Some cartoonists are not particularly strong caricaturists. Once the public accepts a defined image it becomes the subject and the cartoonist can use it again and again within the varying themes. Others have a real knack. They run with the stories and adapt the images, benign at first, when public opinion is behind the policies, gradually metamorphosing over time, as dissatisfaction turns to anger and downright disrespect. The transmogrification of Tony Blair's caricature in the British newspapers, between 1997 when he took office and 2007 when he left office, is a classic example.

The time pressure is another element to consider when working in this area. Some caricaturist/cartoonists are part of the team putting the newspaper together, while others simply send material in through the post or online. Either method is as pressured as 'on-the-spot' work, but demanding in a different direction. It is the pressure of a different deadline. It is easier for the caricaturist, to a certain extent, as the face is in the memory, warts, character defects and all. They are often known and

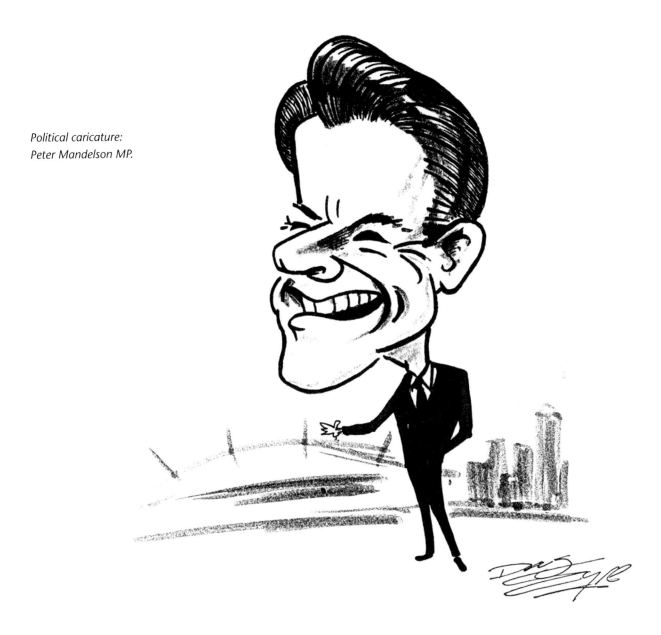

Political caricature:
Peter Mandelson MP.

practised. But each new story requires fresh observation – hair-styles change, facial lines appear and disappear. And the story line influences the finished product; stance, body shape, clothes, props may all need to be added.

When the picture is finished, with or without a caption, it should speak to the reader. Caricature, cartoon and the written word each have an important intertwined role in ensuring that those who engage in strategic thinking remember it is for the purpose of serving the people and that they are only custodians of a role for a period of time.

In this age of global communications, it is not surprising that political caricaturing in its widest sense moved on to stage, television and, eventually, puppetry. In the mid-1970s, Peter Fluck and Roger Law, Cambridge art school graduates, began producing puppet caricatures for magazines such as *Time*, *Stern* in Germany and *The Sunday Times*. This eventually led to the creation of *Spitting Image* in the 1980s, a more malicious and vicious take on the TV ridicule of the political classes in the late 1950s to mid-1970s. No one, not even royalty, escaped. Caricatures in the living room became a weekly event. Unfortunately, replicating the trends of the eighteenth century, the political edge was ultimately blunted and the hard-edged satire gave way to the weaker lampooning of personalities.

WORKING LIVE OR IN THE STUDIO

The major difference between working from life and working in the studio is usually the amount of time available. When working outside the studio, accuracy and completeness are still demanded but within a tighter timeframe.

Working from Life Outside the Studio

Achieving Speed

Ideally, working from life, capturing a good likeness and completing a caricature to a high standard happens over a very short, intensive period of time. The caricaturist needs to develop lightning speed. An appropriate length of time for a professional caricaturist to allow, when working live, from the time of eye contact to a finished drawing, is about ten minutes. This may be broken down as follows:

* thirty seconds to capture the likeness;
* three to four minutes to finish the face and sketch in the body, including some shading; and
* a further five or six minutes to add background items.

The whole process is dynamic, on the move. For the caricaturist, each contact with a subject is physically draining because of the intensity.

Of course, beginners and students will take longer to produce their caricatures, but their speed should improve with practice. It is not difficult to practise increasing speed.

EXERCISE: INCREASING SPEED
Take an A3 sheet of paper. In the top right-hand corner of the sheet draw one caricature of a recognizable person, either from life or from a photograph. It is much easier to increase speeds if you are only concentrating on one face.

When you have completed this first picture, photocopy the sheet about six times. These sheets are now your templates. Use each sheet to reproduce the picture in the right-hand corner many times over, all over the page, getting faster and faster. Disregard the first sheet and repeat the process again. Draw as fast as you can. Continue on the next sheet. Keep going. Do not worry if the likeness is not accurate; your aim here is to increase your speed. Eventually, speed and accuracy will come together.

Accuracy

It is equally important to work on refining accuracy. It is not just a matter of likeness, but also picking up on mood, character and personality. However, you should work first on capturing likeness.

Checking Likeness

There are a couple of good methods for checking likeness:

1. view the image through the mirror. Holding the picture up to the mirror, you will be amazed how imperfections will show. This method, used by artists over the centuries, can even be used on your sketchy outline based on the three features (see the exercise below);
2. use a reducing glass (see Chapter 2).

EXERCISE: INCREASING ACCURACY
Start by working on the three most distinctive features of your 'recognizable person', capturing them in thirty seconds. Try over and over again using your template, each page having one caricature in the top left-hand corner.

Be disciplined with yourself. After thirty seconds, stop. Ask yourself whether you have really captured the three main features.

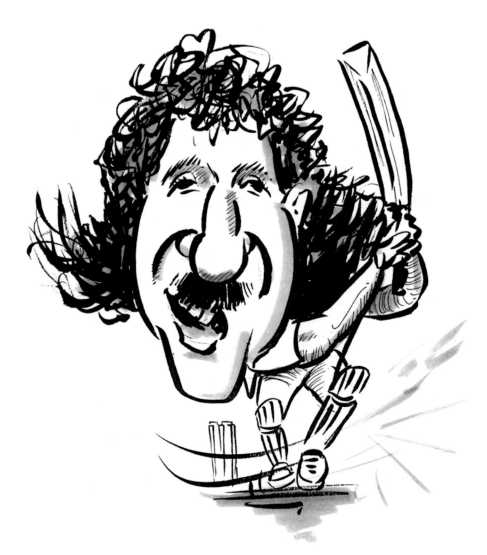

Cricketer Ian Botham.

Once you have mastered your one trial subject, move on to family members, newspaper photographs and personalities on the television; three features only, within thirty seconds, is your initial goal.

Practise whenever and wherever you can.

Assessing Mood, Character, Personality

Very simply, mood is transient, varying from day to day or moment to moment, while character is deeply embedded. The nature/nurture debate will run for ever. Personality can overlay character. Learned response, necessary stance, can heavily mask character. In others, personality and character are as one.

In order to assess *mood*, use your visual and verbal skills.

Quickly look at the facial lines and the body language, and talk to the subject. Consider self-esteem, responsiveness and the level of communication.

Assessing *character* uses your verbal skills more than your visual skills. It is a question of fundamental human principles: honesty, behaviour, ability to make a positive contribution, as well as standards, values, driving principles and moral code (which vary from country to country, culture to culture), ability to work with others, and much more.

Occasionally, visual signs – posing, the state of the clothing, body language towards others – clearly expose character.

Personality can overlay and mask character. The fingerprint can be achieved naturally or through learned behaviour. The need to overlay character can be driven by several motives, including a need to fit in, to be assimilated into a company culture, to be liked, to deceive, who knows.

The golf caddy.

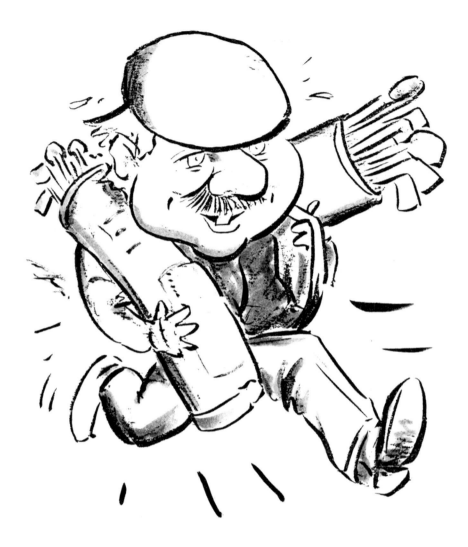

When attempting to assess all three – mood, character and personality – you need to refer to your own previous experiences, and trust your judgement if you think you are ready.

EXERCISE: **MAKING ASSESSMENTS**

Develop your abilities to assess mood, character and personality by observing faces without pen and paper whenever you are in company. Work on mentally summing up all three in thirty seconds. For some, this will be a natural skill. For others it will come with practice. Similarly, everyone has the ability to listen but few take the time and trouble to do so or learn how to do it well. Observe and it will come. *See* Chapter 1: invest the time and the skill will follow.

Check out your assessment with others if you can. Then take every opportunity to practise converting features, through a thirty-second sketch, into mood, character and personality.

It is very apparent when watching a live caricature taking place

that, for that brief period, the relationship between the subject and the caricaturist is extremely intense. The caricaturist must capture the subject in their sight to the exclusion of everything and everyone else around, before the essence of mood, character, personality and likeness escapes.

Do not be disappointed if you cannot at the early stages achieve that degree of intensity and speed. It will come with that all-important practice. Professionals have honed these skills over some time.

To be a successful caricaturist, either professional or amateur, you need to be able to caricature live. Live work is also extremely satisfying, despite being hugely tiring in view of the degree of concentration required.

Mimicry

When caricaturing live there is a tendency subconsciously to mimic the person being drawn. This is similar to the mimicking

of accents in conversation. It is important to be aware of yourself, the subject and the interplay between the two in caricature.

When drawing a large person I tend to feel 'large', while drawing someone small can make me 'shrink' a little physically. The same applies to facial expressions. It is all part of channelling the energy that goes into a successful caricature and helps to create a life-like picture. This subconscious mimicry is not deliberate and I do take care to manage any signs of it, but I also allow it to be part of my style.

Mimicry can be extremely valuable. If you laugh a lot and are happy you will get a cheerful response from most subjects.

Working in the Studio

Studio work may involve working from life or from photographs. The fundamental differences between the two work scenarios are time and interaction. Often, caricaturists in the studio are working only from photographs, notes or memory. In such circumstances, the adrenalin rush from the interaction and the pressure from the necessary speed are missing. The skills of speedy translation, enhanced and honed by years of studying signs of mood, character and personality, can be less critical (although this is not always the case).

Working from Life

When a subject comes to the studio for a live caricature the tendency is to produce two or three more serious sketches of the person before moving on to caricature. Each sketch builds upon the other. This preface to live caricaturing enables the essence of the subject's mannerisms and personality to be more fully extracted.

As the commission involves working live there is a temptation to think of the interaction as the same as that between a caricaturist and his subject at an exhibition or conference. It is not. In the studio, there are none of the pressures experienced when there is a crowd of people waiting to be drawn. The studio experience affords the caricaturist much more time. There is no desperate need to execute the work as fast as possible in order to entertain the spectators. It is a different buzz, and the intensity of interaction is different.

When the sitter arrives at the studio, your first task is to put them at their ease. It is important to create an informal and friendly atmosphere. Talk about anything in a light-hearted way, bring humour into the conversation and observe the animation in their facial features. Note any mannerisms.

Next, move on to talk about the job in hand and build up a profile, which expands upon their background.

Once you feel your subject is relaxed, begin drawing. Start with a few simple serious sketches, from different angles, using a small, hand-held pad. Make little sketches of individual parts of the face in the margins of the pad – these are your notes, to which you will need to refer as you go.

If you are drawing the left three-quarter profile, make sure that the light is coming from over your right shoulder, creating shadows to the right-hand side of the subject's face.

Although you have set him or her at ease, your subject may still try to pose. This can mean that they will not be smiling. If you have already made your notes on the small pad you can easily draw in the mouth smiling and the eyes looking cheerful. In this way, your early preparation will be reaping benefits.

After you have completed this first step, it is a good time to say something amusing, in order to watch the movement of the face and check your drawing. If you manage to make your sitter laugh, you can study the teeth (and make notes on your small pad). Hopefully, by now you will have all the details you want down on paper in note form – eyes, hair, nose, eyebrows, wrinkles, expression, eyelashes, angle of head, ears, cheekbones, type of glasses if worn, general shape of face, and so on – everything you need to produce a good caricature.

When you have completed your caricature head, photocopy it and use the photocopy to discuss with your client in greater detail the other items that will feature in the finished picture. You can scribble them in on the copy to show how you plan to arrange them. Once this is done, your sitter can leave the studio.

You can now complete the picture in your own time. Once you are completely satisfied with the result, you can show it to two or three people, no more. Take note of any criticisms but remember that too many critics having their say can cause as many problems. Keep alterations to an absolute minimum and stand by your original as much as possible. Signing the finished work is very personal to the artist so choose the position for your signature carefully.

Present your finished artwork, either in a suitable glazed frame, or allow the client to arrange their own framing. If you are presenting it unframed, it should be mounted, using a suitable complementary colour for the mount board. If the picture is in monochrome, use a warm grey. If the caricature is in colour, choose a tone that will harmonize with the background tones.

Your work should always be presented in a clean and tidy way, and the best way of doing this is to place the mounted caricature in a presentation folder. Cut a sheet of black paper just over twice the size of the finished mount. Neatly fold the black paper in half. Place the picture on to the right-hand side of the sheet. Attach the mounted picture to the black paper folder

WORKING LIVE OR IN THE STUDIO

using a little adhesive or double-sided tape. Fold over left to right the black paper to form a cover to keep the work clean. Place an artist's name and address label either in the centre or bottom right-hand corner of the cover.

Working from Photographs

Working from photographs is not easy, despite what many people may think. The common perception is that working from photographs is easier because the work is produced at leisure, with the time both to develop and correct and the opportunity to use technical aids.

While you may be able to capture a likeness from one photograph, capturing character from a photograph is very difficult. Before you start the commission, ask for a few photographs of the subject: a full-face, a three-quarter view and, if possible, an 'off-guard' snapshot taken at a recent social event, to pick up relaxed character clues. A picture showing the back of the head can be very valuable, too.

The photographs should be of a good quality. Ask for photographs taken in good lighting, as shadows will significantly mask features. You are looking for clarity and reasonable sizes. If possible, all (and at least one) should be a good size. Even a picture of the subject within a picture is more than helpful; a shot of the subject in the background of a group, unaware of photography taking place, can illuminate natural expression and character.

You do need the range of photographs to achieve a good likeness, and you should not attempt a commission without them.

EXERCISE: **IDENTIFYING THE THREE MAIN FEATURES**
Arrange the photographs you are given so that you can see at least one good-sized photograph and all the other photographs at the same time. Identify the three main features of the subject, making a few notes before you start.

DOUG EYRE

Caricaturist With a difference!

EXHIBITIONS

- Corporate Events
- Conferences
- Company Functions
- Presentation Portraits

- Illustrations and Paintings
- Company Golf Days

ONE STEP FURTHER: COMMERCIAL CARICATURING

Introduction

Clearly, the style of a caricature will very often depend upon the reason for it. It can be the result of a commercial commission given to the artist or a spontaneous artistic or socio-political inner drive. Either way, there are many different commercial opportunities associated with caricaturing, including the following, which will be covered in this chapter:

1. exhibition work;
2. conference work;
3. corporate golf tournaments (and other sporting events);
4. corporate portraiture;
5. group caricatures;
6. entertainment for private and corporate clients; and
7. book illustration.

The order of this list reflects my own experience in terms of the commercial value of the various work streams. As a rounded artist, I also produce standalone art, mainly in acrylics. There is no doubt that my style owes a great deal to caricature and harmony of line. Portrait work is produced in a medium to suit the commissioner.

Newspaper, journal and magazine work, which is often socio-political in approach, is another commercial opportunity. For more on this, *see* Chapter 20.

There is also an increasing market linked to lifelong learning, with older students wanting to learn how to caricature.

Exhibition Work

Caricaturists are sometimes employed at exhibitions to attract potential customers to company stands. Like all such offerings, the popularity of this kind of caricaturing is cyclical – for several years it seems to be all the rage then it is seen as rather 'old hat', only to reappear with a new generation.

In a large exhibition hall all the exhibitors are competing for the attention of every visitor. The challenge is to attract the customer on to the stand and retain his or her attention long enough to engage them in the benefits of the product being exhibited. The more industry-specific the exhibition, the more likely it is that, externally, to the visitor, the range of products on show will appear similar. The value of keeping a visitor on a stand long enough to showcase a particular offer is even greater.

A caricaturist can use eye contact to engage with the crowd, and attract potential customers on to the stand as they draw them. Cooperative working with a product specialist allows the initial contact to be turned into a sales opportunity.

There is a delicate balance to be achieved, between capturing a likeness at lightning speeds and caricaturing a subject.

The object of the exercise at the initial stage is not caricaturing. It is using caricature to make eye contact with potential customers. It is about engaging potential customers in the process of the production of a likeness. The next step is engaging them with a product. Finally, the caricature comes into its own as it is retained as marketing material. There remains a direct association between the positive experience of being caricatured and the company name.

If you work too slowly, the potential customers will lose interest and move on. If the resulting caricature fails to look like the subject you have not only disappointed but also probably disengaged the potential customer. The degree of exaggeration must be just right – amusingly recognizable will hit the spot, while heavy emphasis of features will probably lose the day for all but the most outward-going personality being drawn. For this reason this type of work is in the main more a lightning sketching opportunity than a full-blown caricaturing event. By concentrating on the other aspects of the person, their hobbies and interests, adding a body and representational associated features, the sketch can be embellished but without any risk of offending.

For many years I have used my electronic print board to great effect in this environment. The challenge is in operating on such

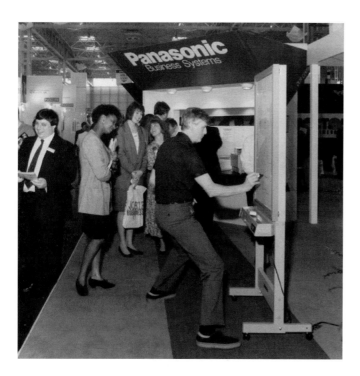

Caricaturing live at an exhibition.

a large screen so close to the subject; it leaves very little room for error. Most other caricaturists use pen and pad.

Over the years, hundreds of exhibition visitors have been attracted to stands selling all sorts of products, in all industry sectors, and millions of pounds worth of additional business have been achieved through the presence of a caricaturist. In the most successful combination, the caricaturist becomes part of the company team. The physical appearance of the caricaturist matches the company colours or a company theme. The interaction between the sales team and the caricaturist is both planned and practised.

The caricaturist should stand or sit on a high stool with sketchpad and easel, pen and pad or electronic print board actually on the stand, so that the visitor has to enter the company space as the picture is being drawn. Using a logo on the paper ensures every picture handed to the visitor is associated with the company and the occasion. Both anecdotally and evidentially it appears that the sales value continues long after the event. The caricatures, displaying the corporate logo, are very often framed and displayed on office walls.

Like stand organizers, you will be subject to rigorous timings for set-up and dismantling. Ignore security guards and their rules and regulations at your peril!

As each finished likeness is shaded and signed, the picture also becomes an excellent marketing tool for the caricaturist himself. Every exhibition I have ever done has led to a great deal of further work. Whatever style, tools, medium and materials

are used, the key to success is representing the company in a professional manner – and, indirectly, promoting yourself in the right way.

Conference Work

Conference work can be similar to exhibition work. You may be asked to work on a stand in the main hall attached to a conference, in the same way as you would at an exhibition. Alternatively you may be asked to be there for the conference organizers, on your own stand, to sketch the delegates for entertainment purposes during the day.

Conferences can be very serious and demanding for delegates. If you are contracted to entertain – to give delegates light relief from the rigours of discussing tropical diseases, the challenges of climate change, new surgical techniques or the electronic future of the world – you have a greater licence to entertain. Delegates at conferences fall into many categories but you can be sure that, among the specialists and lobbyists, there will be personalities that enable you to work at full flow, unpicking personality, character and features.

You should not need much space or equipment. A socket for lighting and your electronic print board, if you have one, and a stool are usually sufficient. Your location is critical. If the organizers have not already determined your workstation before you

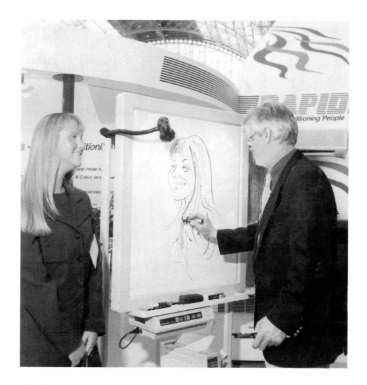

Working at a conference.

arrive, you may want to guide them towards the most productive sites to maximize the entertainment or commercial value. For entertainment, you should look at the refreshment areas; being close to one of these is a real advantage, because of the number of people congregating there during breaks. They will provide many target subjects, although you should not caricature those who are actually eating nor should you distract delegates from lunch or important conversations. Position yourself at a very visible point just to one side of the refreshment area.

If you are asked to entertain in the main hall rather than being on a stand, and you have a choice, request a position at the top of an escalator, just inside the entrance, so that you can catch people going in and out.

Adhere to the increasingly tight rules and regulations set by security, and never overrun your timings. Remember that you are an adjunct to the main conference, either supporting the main organizers or a particular company. And do not forget that, all the time you are representing the organizer or the company, you are also indirectly promoting yourself.

Sean Connery at a golf event.

Corporate Golf Tournaments

Corporate golf days are becoming increasingly popular for sales or team-building opportunities or as a thank you for clients or staff. A caricature artist is often asked to record such events, and to produce finished pictures of the guest players for presentation in the evening.

It is important for students to appreciate that this kind of commission is not for the faint-hearted. It is probably some of the most demanding work that a caricaturist could be asked to undertake. Your skills are tested to the limit, on the spot, at great speed, and outdoors, in all weathers. In addition, you are working with subjects who are at their least responsive – they are there to play golf, not to have a picture drawn. Sometimes you may be called upon to sketch all the people connected with the organization, not just the golfers.

Equipping Yourself

Clothing depends upon the time of the year, but it is best to have to hand warm, all-weather clothes, even if you think you may not need them. There is a fair amount of waiting time between all the teams teeing off and golfers reappearing on the ninth hole. Clothing that blends or matches with the corporate theme will be appreciated, and remember that most golf clubs insist on a certain level of smartness.

As a surface to rest on, a shoulder-slung drawing board is ideal (*see* Chapter 2). Use a pile of paper rather than a

pad, as there will be no time to detach individual sheets from the pad.

For a large tournament (say, sixty to eighty golfers), you will probably need an assistant to continually check names against the original order of play.

Doing the Work

Start caricaturing on the first tee; do not even consider another position. Make sure you are on the tee half an hour before the first players arrive.

Ask the organizers for a list of golfers indicating the order of play, and keep it on the top of your paper pile. This list is vital, as naming each picture is usually a prerequisite for the evening presentation. Be aware, however, that golf teams do not always arrive at the first tee in the correct order of play, and here an assistant can be really helpful.

Having overcome the challenge of identifying exactly who is teeing off, there will be little time available to capture the subject's face, and to make quick notes about their main features and clothes and colour references (should colour finishes be required). Speed is of the essence. This is a most challenging commission. Capturing features takes precedence. Interestingly,

Working at a golf event.

capturing character is somewhat easier than in other situations – the challenge of the first tee does reveal character very quickly.

Any golfers whom you failed to capture to your own satisfaction on the first tee can be seen again on the ninth tee. You will need to be even more discreet at this stage of their round, as you risk being a very real distraction.

It is most important that you ensure that the name of each player is pencilled in the corner of each sketch.

Finishing Touches

Leaving aside the occasional need for corrective actions on the ninth tee, after everyone has passed through the first tee you should move away from the course, and retire to a mobile studio or corner of the clubhouse to finish off your caricatures. At

this stage you can add colour if required, a body, any noticeable clothing or accessories, and of course the player's name. Most players prefer their name, in neat lettering, in the centre at the bottom of the drawing. Do not forget to erase any pencil notes you made on the first cut of the sketch.

Time to complete is always short. Completed and often framed pictures are normally required as part of the evening reception and presentations.

On several occasions I have been required to complete eighty pictures in the studio the next day. The challenge then is to hold all eighty faces and stances in the memory and recall as each picture is completed. This is a skill that comes with a lifetime of caricaturing.

Corporate Portraiture and Group Caricatures

During your career as a caricature artist, or as an amateur, you will almost certainly be asked to produce a picture that is more than a caricature – a combination of caricature and portraiture. Commercially, the subject may be a retiring chairman or president of a large organization, team or club. An amateur might be asked to do a picture of a family grouping. Such jobs can be extremely rewarding but are very demanding.

There are two main styles: those depicting the personalities, usually with diminutive bodies, and those that require additional illustrations depicting some of the subject's achievements over the years. Sometimes, future activities planned in retirement may be included.

If the subject or subjects are aware of the commission and, perhaps, of a forthcoming presentation, there may be the opportunity to draw the first sketches from life. Access to the place of work or home, access to the subject and the opportunity to do some caricaturing from life, will all be very valuable in picking up the character and personality of the subject.

General Group Portraiture

Collage mini-caricatures of a group presented in a variety of ways, always with humour and life, are very popular artistic records.

Everyone has seen a group posing for a photograph, sitting or standing with strained fixed smiles, with the photographer shouting, 'Say cheese.' The photographer has several opportunities to capture the group, but it is difficult to represent everyone accurately in terms of both features and personality with the click of a shutter. It is difficult with a photograph to add life and the result can be stiff.

Caricaturists have a wonderful opportunity to work with each individual, drawing out smiles and personality, movement and spark, through observation and, if working from life, interaction. You are not likely to be able to sketch each person from life, but you should draw from photographs only if you have to.

Treat each picture of each member of the group, whether drawing from life or a photograph, as an individual drawing. Draw heads and small bodies (the bodies are for reference later). At this stage, keep the sketches as simple as possible: black line only, not too much detail, no shading and just a rough outline of the hair.

The angle of the head is all-important; if you get this wrong you lose the immediate likeness. For quick reference later on, give every black-ink sketch a light vertical pencil line through the centre, then erase the part of the line covering the face to leave a short line to the top and bottom. This will enable you to align the faces correctly when making up the collage.

Using a copier, reduce these images sufficiently to match your finished picture. Cut out around each individual head, then spread them out on an A3 landscape sheet of white board or paper. Study the heads carefully and choose the position of each individual to sit harmoniously within the overall picture: taller ones to the back, shorter ones to the front, thinner ones to the sides, and so on. Before you start to group your individual head sketches into a collage, you must be clear in your mind of the look of the finished picture.

Corporate portraiture.

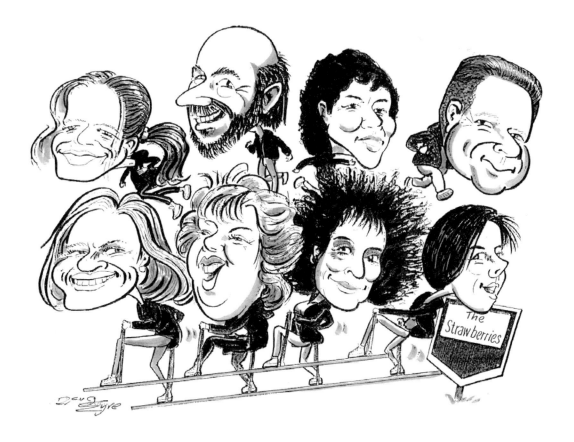

Group caricature.

Once you have established the position of each head, fix them with a temporary adhesive so that you can reposition them, making alterations to the overall picture as necessary. Now copy the whole sheet three or four times. One sheet will be used to work up to the finished drawing, while it is useful to have the other sheets to hand for roughing out ideas.

The next step is to sketch in the bodies, adding each body to the relevant head and any required background. Finally, once you are satisfied with your work, ink over the existing faces in more detail and add shading in grey tones or colour. Additional illustrative or cartoon background, perhaps related to the activity that brought the group together, may be added at the client's request or the caricaturist's suggestion. Use the attributes, artefacts and references that you have already captured in your original individual drawings as much as you can. Do not allow this additional embellishment to detract from the group picture.

Caricature with Illustration

This type of work, in which the illustrative aspect is key, is one step on from general group collage caricature work. It is more likely to be used where a single caricature is the focus.

The technical challenge here is to merge caricature with illustration, colour work and technique. It is important to strike the right balance between the subject, the subject's current status and his or her various past and future activities. There is a risk of overshadowing the caricature, which could unbalance the commission.

The subject is unlikely to have known the artist before the commission, so gathering a range of information from a range of sources before work begins is invaluable.

Establish before you start from the commissioner of your assignment the degree of exaggeration and humour that is appropriate for the finished picture. The illustrative aspect of the picture, in conjunction with the caricature 'portrait', can be extended to bring in considerable humour, on occasions bordering on cartoon, but only with the agreement of the client.

Working with a Sitter

The subject may well be very busy, with little time available for sittings. There are a number of key points to remember when working with a sitter:

- your smart, tidy appearance will give your sitter confidence;
- a friendly approach will put your sitter at ease;

- another person in the room can distract and relax the sitter, to your advantage, revealing hidden depths in the sitter and allowing unguarded personality to come to the fore;
- taking notes, especially colour reference notes, will help enormously. If possible, take some photographs, too;
- on completion of your sketchy notes, promptly move away from the subject, if possible to an outer office or nearby room, to finish your portrait sketch;
- glance again to check which is the best likeness to use in your final portrait, then return to the studio to complete the whole picture.

Working from Photographs

For a surprise presentation, you will depend entirely on as many photographs as the the person commissioning the picture can supply. Liaising with the people close to the subject or subjects – family members, associates, PAs or secretaries, by phone or directly – enables you to gain as much background information as possible. The rest will be down to you in your studio. I have had commissions where one photograph has been missing from a group, but discussions led to a close understanding of feature, personality and character, and a good match in the finished caricature.

Entertainment for Private and Corporate Clients

Caricature usually brings a smile to people's faces. Both amateurs and professionals may be asked by companies and private clients to attend parties and functions to entertain their guests. The amusement is provided by the finished caricature as well as by the actual act of caricaturing. An artist may be asked to move through a crowd making random caricature sketches of people of his own choice, or the host may prefer him to be located in one place where the guests can watch, be entertained and join in the fun of sitting for a picture. The degree of fun often depends on the licence to caricature. It is important to know right from the start what is required: simple humorous, inoffensive sketches or full-blown character assassinations?

The commission is normally for an agreed fixed fee, to draw for a set period of time. Caricaturists who are new to this type of work should be aware that the finishing time is the finishing time, and stop. If you are doing a good job there will always be someone pleading for you to do 'just one more'. If you oblige,

a whole line of people will suddenly appear, waiting to be drawn. It is best to announce the end of the session about half an hour before it is due.

Occasionally, clients will ask the artist to work when people are seated at the dining table. The subjects are then sitting at a different level to the artist, looking downwards at their plates, or turning away from the artist, talking to other guests. Their heads are often too low to see full-face or at any other angle. Both the subdued lighting of the houselights and candlelight throw awkward shadows and complicate the interaction by obscuring the artist's line of vision. Even the action of chewing conspires to complicate the artist's task.

Artists need to find ways around these obstacles. Arrange with the management to have access to an office-type chair with castors the day before the event. Using such a chair overcomes the different levels and allows the artist to 'scoot' around, dodging the service staff.

Have your drawing board illuminated so you can at least see your paper as you draw. An illuminated drawing board will be a tremendous help.

Draw all the features except the jaw and mouth until the subject has stopped chewing, then add them in.

Hand out the drawings as you go. It is a good idea to hand them to someone sitting two or three places away from the subject. This allows others to remark on the picture, raises laughter and increases the value of the drawing. The subject will be aware of the laughter and comments before the picture even reaches him, and those who are next in line to be drawn will be more engaged with the whole process.

Whether working standing up or from a chair, always arrange for a glass of water or a soft drink to be accessible before you start. Once the catering staff get going you could be overlooked, and caricaturing crowds of diners is thirsty work.

Very often the artist leaves before the end of the evening. If you want to do this gracefully, find a safe place before you start for all your other equipment – coat, pens, spare paper, briefcase, in fact, anything not on your board – preferably on the exit route. When you stop, you should move decisively away from the event, and avoid passing through the crowd, laden with belongings.

Some artists work the streets. They tend to have regular spots where they set up and entertain the crowd. Some are talented students honing their skills, and deserve all the encouragement you can give.

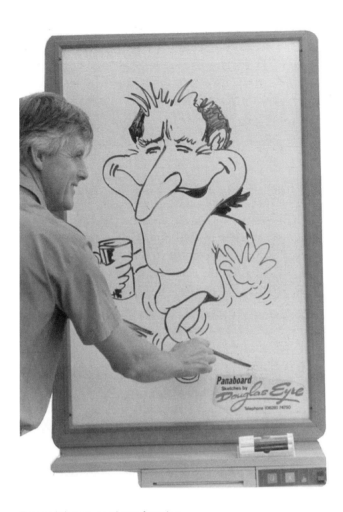

Entertaining at a private function.

Book Illustration

As far back as the early nineteenth century, writers such as the Brothers Grimm have used capricious and often cruel caricatured figures to depict characteristics in both humans and animals. Illustrations for books often include caricatures of a character or characters within the book. Even when all the illustrations in a book are the work of one or more illustrators, in a studio, designers or publishers may engage the services of a caricature artist to provide accurate likenesses for some of the figure work. In most cases, photographs are supplied for this purpose.

CONCLUSION

By now you should have a feel for this ancient, historic and richly rewarding art form. You should have begun to appreciate the fact that every caricature you produce will depend on your basic drawing skills, your acute observation skills, and your own character and personality. Day-to-day moods may influence your own outpourings.

As with all art forms, a major key to success is getting life and energy into your finished work. Never forget this point. You are aiming to produce a work that speaks to others. A good sketch, portrait or caricature communicates, and you can almost hear its message, or hear the subject talking. You are not just producing a drawing, but capturing several moments.

A caricature aims to capture everything that happens in a few split seconds: the situation, the humour, the stance and the response. This instant feedback is hugely rewarding for the artist and instantly recognizable by the subject.

Caricaturing is a fantastic way of earning a living, enjoying your fellow man, and getting a point across or making a point. In my own career, life and work have blurred into one, and I can barely contemplate retirement. The detail in this book should support you on your own journey, to discover and perfect your own style. Work especially hard on dropping detail and concentrating on the key features. If you want to succeed, to be the best, think carefully about the following aspects of caricaturing:

- letting go;
- exploring atmosphere;
- looking and listening;
- visual acuteness;
- imagination;
- being clear about your own values;
- pen being extension of self;
- making a line go for a walk; and
- finding your own 'line of beauty'!

BIBLIOGRAPHY

William Feaver, *Masters of Caricature* (Weidenfeld and Nicolson, 1981)

Edward Carl Johannes Wolf, *Rowlandson and His Illustrations of Eighteenth-Century English Literature* (E. Munksgaard, 1945)

Ronald Paulson, *Volume 1: Hogarth A Modern Moral Subject 1697–1732* (James Clarke & Co., 1992)

Consulting eds. Stan Smith and Professor H.F. Ten Holt, *The Artist's Manual* (MacDonald, 1985)

George B. Bridgman, *Constructive Anatomy* (John Lane, The Bodley Head Ltd, 1973)

For more information about the author and his work, visit www.dougeyre.com.

INDEX